THE HANDBOOK OF
DRONE PHOTOGRAPHY

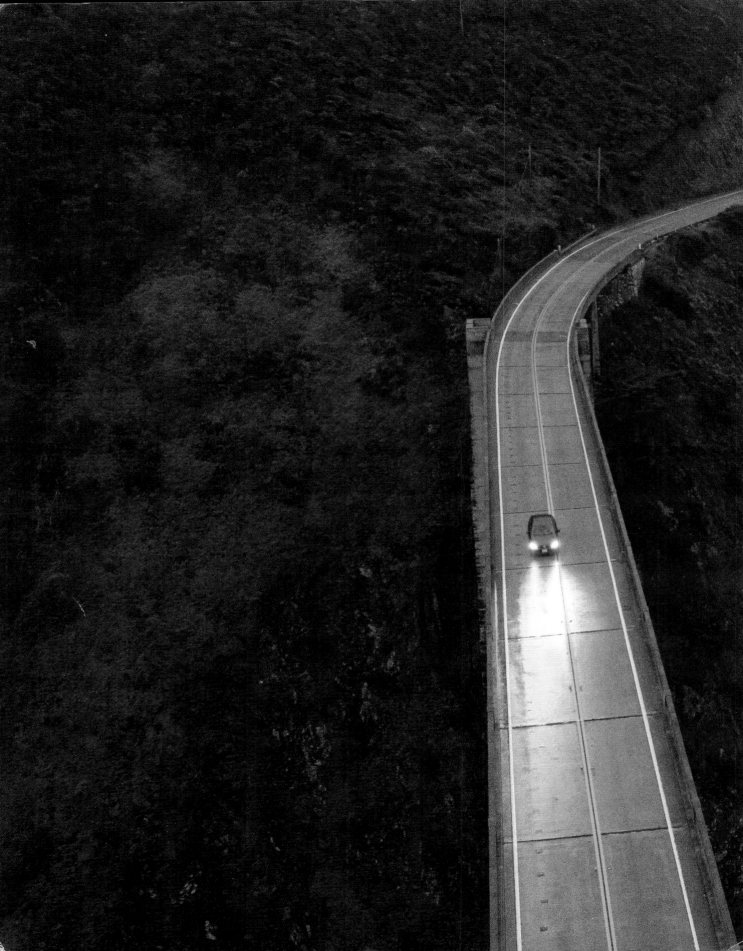

THE HANDBOOK OF
DRONE PHOTOGRAPHY
A COMPLETE GUIDE TO THE NEW ART OF DO-IT-YOURSELF AERIAL PHOTOGRAPHY

CHASE GUTTMAN

SKYHORSE
PUBLISHING

Dedicated to my mom Lori and dad Peter, who have blessed my life with their unwavering kindness and unmistakable love. To many more wonderful memories.

Forever thankful to Bill Wolfsthal and Tony Lyons of Skyhorse Publishing for their unrelenting faith in me, Nick Grant for his tireless hours and gracious efforts bringing this book to life, and Fabrizio La Rocca for his generous artistic guidance.

Deep appreciation for Kyle Foley, Arland Whitfield, and the Skyworks Project for selflessly fueling my curiosity for drones and Syracuse University and its photojournalism program for helping me to explore my artistic impulses.

Eternal debt of gratitude for my loving and supportive family, who have not only made this journey possible, but have sprinkled my life with countless moments of sheer joy and immense splendor.

Skyhorse Publishing books may be purchased in bulk at special discounts for sales promotion, corporate gifts, fund-raising, or educational purposes. Special editions can also be created to specifications. For details, contact the Special Sales Department, Skyhorse Publishing, 307 West 36th Street, 11th Floor, New York, NY. 10018 or info@skyhorsepublishing.com.

Skyhorse® and Skyhorse Publishing® are registered trademarks of Skyhorse Publishing, Inc.®, a Delaware corporation.

Visit our website at www.skyhorsepublishing.com.

10 9 8 7 6 5 4 3 2 1

Library of Congress Cataloging-in-Publication Data is available on file.

Interior layout and design by Nick Grant

(title page) The drama of Bixby Creek's famous deck arch bridge has inspired countless car commercials.

(contents) Teal hues glow in the Vermont sun as slabs of rock are harvested from the world's largest deep-hole granite quarry.

(last page) Author photo by Drew Osumi

Print ISBN: 978-1-5107-1216-4
Ebook ISBN: 978-1-5107-1217-1

Printed in China

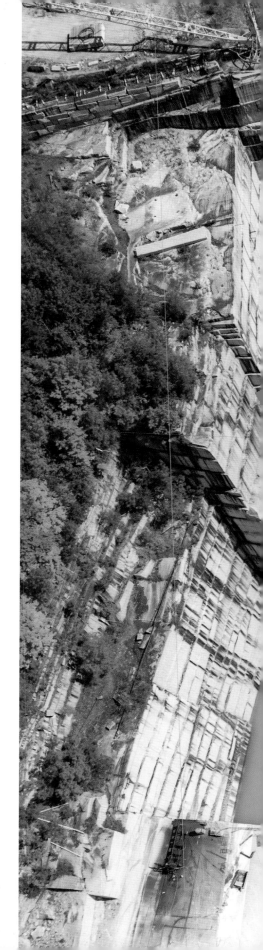

Contents

Introduction . 1

Getting Started . 3

 GALLERY ONE: Explorations 11

Up, Up, and Away 33

 GALLERY TWO: Waters 41

Lighting and Exposure in Drone Photography . . . 75

 GALLERY THREE: Pathways 81

Composition in Drone Photography 119

 GALLERY FOUR: Patterns 127

The Process . 153

 GALLERY FIVE: Places 156

In the Know . 191

INTRODUCTION

Gaze upward. There's new technology hovering on the horizon and it's making a dramatic ascendancy. Drones are an artist's dream medium. They allow us to explore a scene while discovering the unseen. The photographs and videos that we create are no longer constricted by human limitations. The introduction of these exciting new tools enable us to redefine contemporary imagery by giving individuals the opportunity to appreciate the breadth and scale of their world. With this incredible technology, our creative minds can take flight.

From the dawn of civilization, the skies have enchanted our imagination; they beckon to us when dazzling stars twinkle across the crystalline night, and intimidate us when ominous clouds unravel a precipitous downpour. Flight is one of mankind's prehistoric fascinations, that over millennia has eventually spawned some of our species' most significant inventions. From balloons and gliders, to planes and space shuttles, each passing generation of humanity has found itself less bound by gravity than the one that came before. Homo sapiens, once limited by the strength of the feet beneath

them, are now exploring far-flung celestial bodies our ancestors could hardly imagine.

The story of humanity's journey toward the heavens parallels the story of photography and its evolution. At the dawn of photography nearly two centuries ago, cameras were fixed firmly to the earth. Lengthy exposures were then needed to render the faintest of images on light-sensitive material. Experimentation with arduous chemical processes essentially made the first photographers more inventors than artists. However, as images became increasingly durable and photography further refined, the skies became an alluring new frontier for photographers to capture a world unseen by the masses. Aerials introduced a greater visual vocabulary to the photographic medium. Its initial innovators worked in mid-air hot air balloon darkrooms and affixed photographic equipment to flying pigeons. Over the course of many decades, photography transformed itself from a rare visual commodity reserved for the wealthy or the ingenious, to a staple of our daily sensory experiences—a visual medium democratized by ubiquitous

camera phones that fit neatly in the slits of our back pockets.

Photography is the art of finding aesthetic order within our unkempt surroundings and squeezing that distilled meaning into a relatively minuscule rectangular canvas. Altering our perspective can bring dynamic order to an unstructured visual cacophony, and allows us to capture a fleeting moment capable of enchanting our optical senses.

The same air that replenishes our lungs and nourishes our senses fills the atmosphere above and beckons the creative artist and inquisitive mind with its soaring, unlimited canvas. Crafting a lasting image in a society of oversaturated visual stimuli can come down to a matter of perspective. Drones are beginning to provide a wide palette of startling, new perspectives and have unveiled an unimaginably expansive optic repertoire for all of humanity to experience. Unmanned Aerial Vehicle technology allows artists to tell stories of another kind—visual narratives rich with the breathtaking angles our minds never realized existed. Drones are a magical technological force because they dominate that distinct airspace beyond the reach of the selfie stick and just below the landing skids of a helicopter.

This book brings the fascinating and ever-changing world of drones to your eager fingertips. The following chapters will guide you from choosing a drone and taking flight, to capturing stunning photographs and creating the meaningful stories they engender. Prepare to embark on an exciting journey of visual storytelling from the skies above.

Photography is once again at its dawn —as drone photography rises above the clouds, a new day will emerge for both technology and artistry.

—Chase Guttman
chaseguttman.com
@chaseguttman

GETTING STARTED

WHAT IS A DRONE?

A drone is a type of unmanned aircraft either controlled remotely by a pilot on the ground, or by a series of onboard electronics, or by both. Drones have their roots in the military, whereby governments could perform aerial combat operations without risking the safety of their pilots. Today, the word "drone" is also used to describe a different set of technology that's not defined by military exploits. This term has come to represent UAVs, or Unmanned Aerial Vehicles. In the context of this book, I will be using both drone and UAV interchangeably to describe the more innocuous variety of unmanned aircraft that's designed for aerial photography and videography purposes. Camera drones, to be specific, have exploded onto the scene in the last handful of years, allowing the everyday consumer to get professional-grade aerial imagery that was once only possible with a sizeable helicopter budget. In an incredibly short span of time, these devices have advanced considerably paving the way for a wide variety of applications and uses.

For example, farmers can now use camera drones to survey crops that stretch across a multi-acre field, property owners or insurance companies can inspect a vast array of infrastructure for damage, police or fire departments can use UAVs for search and rescue operations or to inform their emergency responses, and cartographers can send aircraft into the sky to map surrounding areas. Companies like Amazon are even exploring how they can use drones to deliver products into your backyard in under 30 minutes.

As a photographer, my excitement with drones is driven by aesthetic and artistic urges. With UAV technology, you can elevate your imagery to literal and figurative heights. This book zeroes in on the photographic side of drone tech, teaching you the best practices as you ease into this emerging medium.

THE ANATOMY OF A DRONE

Let's break down the anatomy of a standard camera drone. Depending on whether the drone is a quadcopter, hexcopter, or octocopter, the UAV will either have four, six, or eight arms, respectively. These arms extend outward from the drone body and have motors positioned at the end of them. The motors spin and provide lift to the aircraft when propellers

are attached. At the center of the UAV's frame exists sophisticated electronic systems. These electronics communicate with the remote control used by the pilot on the ground and can also assist the operator in keeping the flight smooth. Below that frame, a camera gimbal sits. A gimbal is a pivoting mechanism that allows the drone operator to move the camera around and keeps the lens still and stable while the UAV is in motion. Then there's a battery, which supplies power to the entire aircraft—out to the motors and down to the gimbal. Lastly, there's the aircraft's legs or landing gears, which allow the drone to safely touchdown without exposing any other parts of the UAV to damage.

The vast majority of camera drones are quadcopters—or drones reliant on four arms and four propellers for lift. Quadcopters are the standard drone model and they have long defined the market because they're cheaply constructed and easily sold. However, quadcopters lack certain redundancies. Hexcopters and octocopters, although rare to find in commercial ready-to-fly systems, have more motors, and thus have greater lift and greater redundancy in case of possible motor failure. Because of these extra motors, hexcopter and octocopters are able to safely land even in the unlikely event of motor failure. Naturally, these larger, redundant systems are typically less transportable and come with a heftier price tag as well. In general, larger copters also take greater piloting and maintenance know-how. Drones have sparked artists to create huge inroads with unique explorations into verticality, offering a heightened vision for the everyday consumer. While the camera drone market has truly taken off in the past few years, the technology itself is still in its infancy. Like any piece of consumer technology, UAVs will certainly be refined over time —increasingly characterized by more intelligent features and autonomous functionality. Naturally, drone models have become more and more sophisticated as marketplace competition has intensified over this exploding tech sector. Currently, there are some fundamental obstacles that limit the strength of contemporary UAV technology. First and foremost, operating a camera remotely has its own set of complications. A live view screen that enables an artist on the ground to see in real time what the camera sees is essential. Without a live video output, aerial imagery and videography becomes a matter of guesswork, severely limiting the medium's artistic function. Furthermore, drone operators need to have remote control over the camera in order to time the shutter's release. Correct timing is not only a pillar of effective imagery, but with regards to drone photography, timing means you don't have to fill your memory cards with undesired photographs that are shot in an interval shutter release mode.

Beyond the need for your camera drone to offer a live view screen with remote shutter release capabilities, there are certain criteria you should use to evaluate all UAV products. Of course, price point and ease of use are paramount to any purchasing decision you might make, but let's delve into other factors.

CHOOSING A DRONE

Camera quality is one vital criterion, as that dictates the visual attributes of your final product. To assess camera quality is to assess camera models, and to assess camera models is to assess a drone's payload. Payload is the amount of weight a drone can carry through the air. Smaller payloads mean greater maneuverability and battery life. The simple fact is that most commercial camera drone models utilize small, lightweight camera systems with small, lower-resolution sensors to reduce the aircraft's payload. One reason why GoPros are popular in the drone realm is because they can output high-quality media from an incredibly small camera model. However, many photographers require higher quality camera models to get professional results.

Towards that purpose, my recommendation is to seek out drone products based on the camera's sensor size instead of megapixel count. This is a technical concept, but essentially sensor size is of greater importance to the quality of a digitally outputted image than the number of pixels the camera is able to capture. Furthermore, to fully utilize the digital capacity of your camera, look for a drone that can process raw, uncompressed files. Additionally, seek out camera lenses with low-light ability (identify models with large apertures) and limited distortion. Distortion or the abnormal curvature of a scene, can make the edges of your frame appear wide-open and loose. As a matter of personal preference, I try to avoid distorted camera drones and when my images have visible distortion, I try to correct that curvature with post-processing software like Adobe Lightroom or Photoshop. On the other hand, distortion can enhance an image if you're endeavoring to accentuate an object's size within the larger context of the landscape.

Battery life is another consideration as flight time can be a seriously limiting factor. The vast majority of camera drone models have flight times that fall in the 10 to 30 minute range. While most models allow you to purchase additional batteries to swap out as needed, this process still requires you to land your UAV before you can get the drone back into the air with a fresh set of batteries. Note that a drone product's posted flight time isn't entirely usable. These time ranges are the maximum amount of time for which your UAV can remain suspended, but most manufacturers will warn you to land your drone before your aircraft's battery

reaches a critical low point. Battery life is of practical relevance because getting incredible drone photography requires even greater discernment, purposefulness, and efficiency when you have less time in the air. When your usable flight time is just a handful of minutes, you can only explore a small slice of your surrounding environment. As a result, you need to have a basic vision in place before you can start your motors. If your ultimate goal is to create stunning aerial imagery, you should use your airborne time to distill rather than discover your vision. Of course, there are serendipitous stories that you can stumble across in the air, but your storytelling ability is in many ways impacted by the limits of your UAV's battery.

THE CAMERA DRONE MARKET

Choosing a commercial drone model that works for you comes down to your needs. For the reasons I previously mentioned, I will only be evaluating commercial, ready-to-fly camera drones that have a live view screen and allow for remote shutter release. Nonetheless, there are plenty of options to construct your own drone for more advanced technical needs. Online communities such as DIY Drones are great for those hoping to embark on their own UAV build.

The drone photography market currently has a few major players that compete with each other for market share. DJI, a Chinese powerhouse, essentially created the consumer camera drone market with the launch of the Phantom Original back in 2013. DJI moves the most drone product of any manufacturer in the industry and for good reason. Every DJI product that I've ever had the chance to test I've found both intuitive and approachable. You don't need to be an expert drone pilot to competently operate their merchandise. GoPro has become a key part of the camera drone market as well, first as a popular attachment camera, and now debuting its own UAV model, the Karma, in 2016. Then there's 3DR, which in 2015 debuted the Solo, a camera drone with deep GoPro integration. Parrot offers a few integrated camera drone models as well with its Bebop series. Lastly, there's Yuneec, another Chinese company whose products have impressive hardware specs.

Now that you know the industry's major players, let's explore which drone product or products might work best for you. No matter what UAV model you ultimately choose to put into the sky, you need to feel comfortable with it both as a pilot and as an artist. Sometimes, the mechanics of an aerial system can become an afterthought for photographers such as myself. Our primary concern is the end result and whether our aerial system can reliably deliver results. In my opinion, DJI currently manufacturers the best camera drones on the market and it offers

multiple product lines which fulfill drastically different needs. DJI's drones are the gold standard—they're feature-rich and do a fantastic job with low-light and long exposure photography. The only downside to purchasing a DJI product is customer service. DJI has been growing at a remarkable speed and it has struggled to maintain high-level customer service throughout its expansion.

On the lower end of the price spectrum, there's DJI's Phantom series. DJI's latest iteration is the Phantom 4, which is perhaps the greatest bang for your buck drone on the market. It's the prosumer option for those wanting high-end features at a modest price. The UAV boasts a 20mm f/2.8 lens with 12 megapixel (or MP) Adobe DNG RAW files for photographers and 4k at 30fps for videographers. The Phantom 4's spectacular 28-minute battery life and extended range is also impressive, but the product's greatest feature is its new obstacle avoidance technology. With two forward-facing sensors, the Phantom 4 can prevent crashes by maneuvering around visible obstructions. This is one of the first commercial drone models to offer this new technology, and I expect to see obstacle avoidance become a standard feature on drone models fairly soon. From my personal tests with the product, the Phantom fares pretty well with sizeable obstacles. My concern is the lack of sensors on the other sides of the Phantom.

As the sense and avoid system only works with forward-facing obstacles, the drone will not detect objects on the left, right, or rear sides of the aircraft when you're flying. Obviously, obstacle avoidance is no substitute for true piloting skill, but it's an awesome safety feature to offer customers. Lastly, the Phantom has multiple intelligent flight modes, which can assist videographers with technically difficult moves. At $1,399, the Phantom 4 is the right drone for most anyone hoping to embark into the world of drone photography. The Phantom 4 is likely a good fit for you unless you require a higher quality camera, want focal length variability, or need the flexibility of moving your camera completely independent of the drone.

Since the release of the Phantom 4, DJI has released an even smaller drone model with comparable versatility to its pricier companion. The Mavic Pro bears the same quality camera as the Phantom 4, but with the added ability to collapse the arms and bring the bird down to a smaller and even more transportable size. A drone that can fit in your hand opens the door for a whole range of new and additional uses. The Mavic Pro also sports a 28mm f/2.2 lens, obstacle avoidance technology and a 27-minute maximum flight time all for $999. The Mavic Pro looks poised to dethrone the Phantom 4 as one of the greatest values on the drone market, however I cannot

recommend the product until I've tested it out for myself, and at time of writing, the Mavic Pro hasn't even shipped to its first customers.

DJI's Inspire series is a tier above the Phantom series across the board—be it camera quality, size, or price tag. The Inspire 1 RAW is an awesome option for serious aerial photographers and especially for videographers. At $5,999, what can an Inspire do that a Phantom cannot? First, the model's integrated camera can be freely moved in any direction no matter where the drone is pointing. Inspires can work with two controllers—one designated for a pilot and a separate controller just for a camera operator. This additional precision is game changing for videographers as it opens up a world of possibilities, but it's less critical for still photographers. If you wish to use only one controller, you can still aim the camera in any direction using the DJI Go App. Inspires also have retractable landing gears that lift above the body of the drone in flight. This feature goes hand-in-hand with the ability to move the camera in any direction. Without retractable landing gears, the legs of the drone would block the camera's view as the gimbal swivels around. In addition, the camera sits so low below the aircraft, that you will never get spinning propellers within your frame (as is possible with Phantom models). The Inspire 1 RAW even boasts the ability to interchange lenses. As the selection of compatible lenses grows, I have become increasingly impressed with this aspect of the Inspire. Although the Inspire 1 RAW ships with a 15mm f/1.7 lens, the ability to extend your focal length range to up to 45mm is a huge benefit. Wide-angle lenses are very limiting in the artistic stories that you are able to tell and the ability to throw on a different focal length lens is an exciting prospect for a ready-to-fly drone system. Ultimately, the biggest selling point for the Inspire is camera quality. With a Micro Four Thirds sensor, especially in terms of sensor size, the Inspire 1 RAW blows the Phantom 4 out of the water. The drone shoots 16MP stills as well. This results in practically DSLR camera quality imagery from the sky. The obvious disadvantages of the Inspire are decreased battery life (the 15-minute advertised battery life is on the lower end of the drone flight time spectrum), lessened portability due to size, and a remarkably higher price tag.

There does exist a step beyond the Inspire for those hoping to get full sized camera bodies into the air. Given the recent release of the Inspire 1 RAW, in my opinion, this is only practical for videographers that are making Hollywood grade productions, but if you're interested in flying professional payloads, both DJI and Freefly Systems offer industrial grade drone solutions that you can explore.

There are a few substantial alternatives to DJI that you should consider as well. Yuneec is one brand to watch in the drone space. Its product, the Typhoon H, has very notable specs and features. At $1299, the Typhoon offers up a 14mm f/2.8 lens and 12MP images while utilizing the same size sensor as the Phantom 4. The Typhoon has comparable sense and avoid sensors to the Phantom 4 and has a 25-minute flight time. The camera can even do some things its competitors cannot—like move freely and independently of the drone's movement. Even though the aircraft is small, it's a hexcopter with six motors and propellers (in terms of safety, that means the drone should be able to land even in the unlikely event of motor failure) and retractable legs. These are elements not found in DJI's flagship model. Given the company's modest size, Yuneec also has a decent customer service track record. The key issue with the Typhoon is its inferior long exposure ability (the Typhoon can only manage 1/30th of a second, but the Phantom 4 allows for eight-second exposures) and range. Depending on the speed of your subject, 1/30th of a second may not be a long enough exposure to adequately introduce a sense of motion into your frame. DJI products consistently have the best range, but the Typhoon's one-mile maximum range shouldn't matter if you're maintaining line of sight with your aircraft as is legally required in the United States. Yuneec has a superb

alternative to the Phantom 4 on its hands with the Typhoon H. Although I have not yet gotten my hands on a Typhoon (so I can't speak to its fluidity or ease of use), based on specs alone this UAV is worth a try.

The GoPro Karma is a wonderful option for videographers looking to branch out into the drone space. Working with a GoPro camera you may already have (the Hero 4 or 5), the Karma offers the ability to collapse its arms and legs to an incredibly manageable size making it one of the most compact and nimble camera drones on the market. The camera, which of course is a GoPro product, can shoot 12 MP RAW stills and 4k video at 30fps. The drone features a detachable gimbal, something that can be removed from the bird and placed on the Karma Grip, a device that ships with the UAV and allows videographers to get incredibly stable handheld footage while on the ground. With a 20-minute flight time, the Karma's ergonomic controller utilizes a built-in screen, eliminating the need for a smart phone. However, GoPro has a mobile companion app where another person can control the camera and choreograph shots on their phone, while the pilot continues to guide the craft with the main controller. Meanwhile, companies such as DJI, make you spend hundreds of dollars on an additional controller for dual person operations. At $799 (without the GoPro camera) and given its size

and flexibility, The GoPro Karma is the ideal drone for budding videographers or anyone who already owns a GoPro Hero 4 or 5.

The 3DR Solo, which is essentially a "smart drone" that works with your GoPro, is another option. The Solo's value is in its ability to do difficult cinematographic maneuvers for you while functioning with a camera you may already own. At $999 (minus the GoPro camera), the Solo is an impressive, compact drone product. With GoPro now retailing its own drone, the GoPro Karma becomes a much more worthwhile investment, as the company knows how to take better advantage of its own camera product.

Parrot's Bebop series is another alternative. At $549, the Parrot Bebop 2 uses the same size sensor as the Phantom 4, but offers higher megapixel images (14MP) shot in RAW format as well. This compact model also offers a 25-minute flight time to boot. The Bebop is operable with your mobile device, however you can purchase a remote controller separately. The Skycontroller, Parrot's sleek controller, which mimics the look and feel of an airplane's yoke, would bring the total cost of the drone up to $799. In terms of video functions (1080p and 30fps) and especially flight range, the Bebop lags significantly behind its competitors. In fact, the Parrot Bebop 2 is arguably more of a toy drone than a professional camera drone model. However, the Parrot Bebop 2 may be the right UAV for you if you're looking for an inexpensive still camera drone stripped down to its bare necessities.

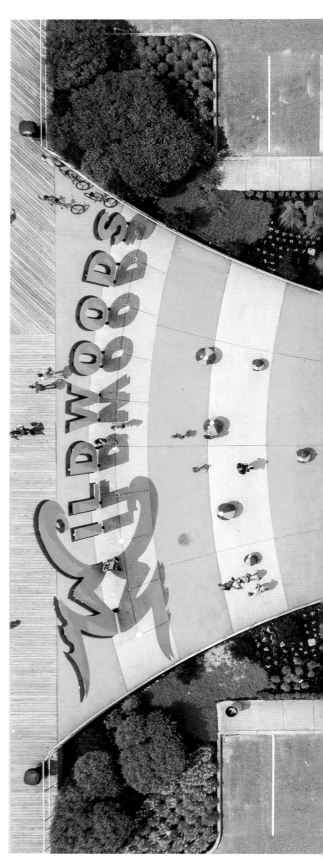

A lollipop-style roundabout, concrete beach balls, and a Doo-Wop style sign brushes the edge of a beach boardwalk along the South Jersey coast.

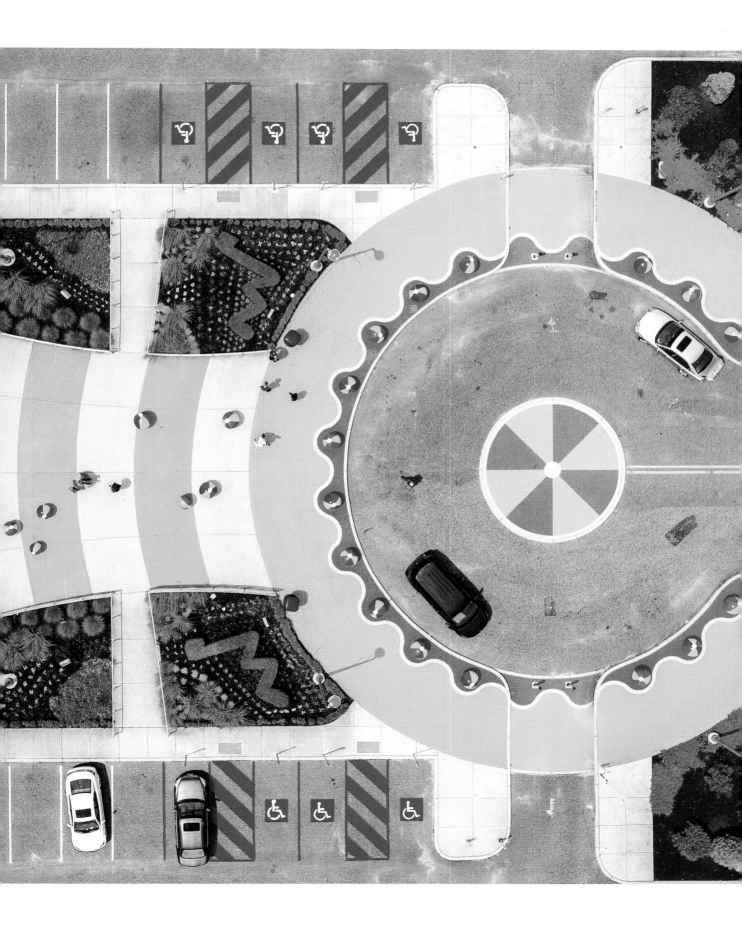

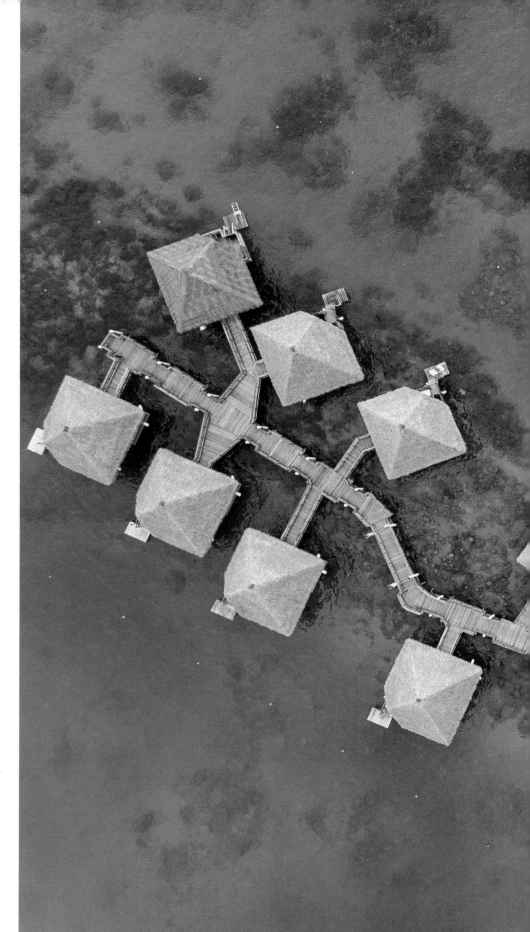

Rich in Polynesian fantasy,
over-water bungalows are
steeped in vibrantly tinted
Tahitian seas.

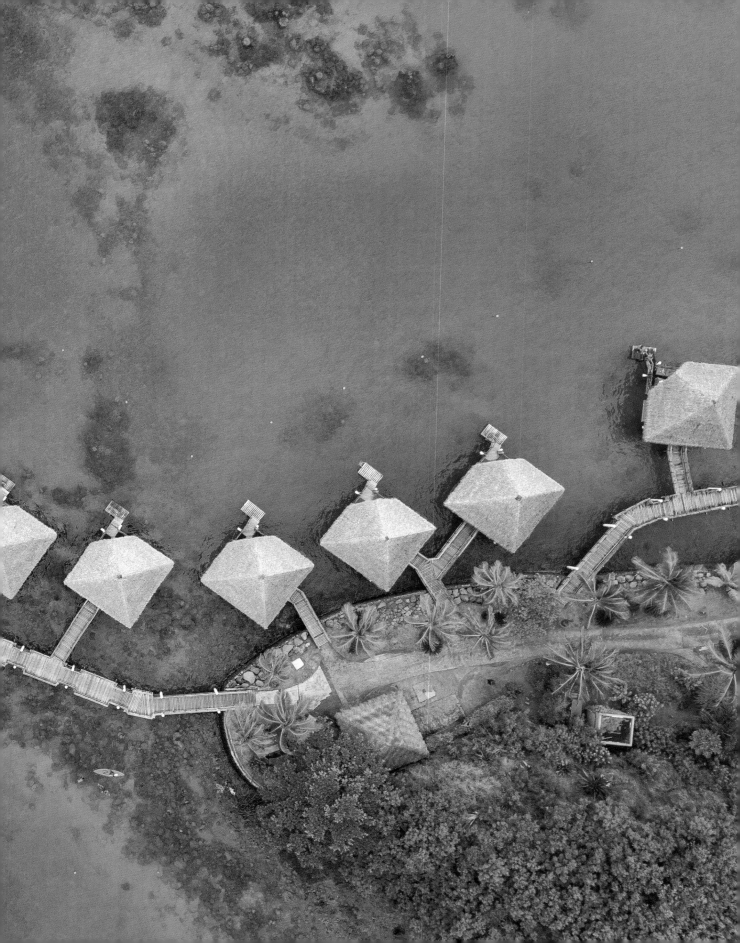

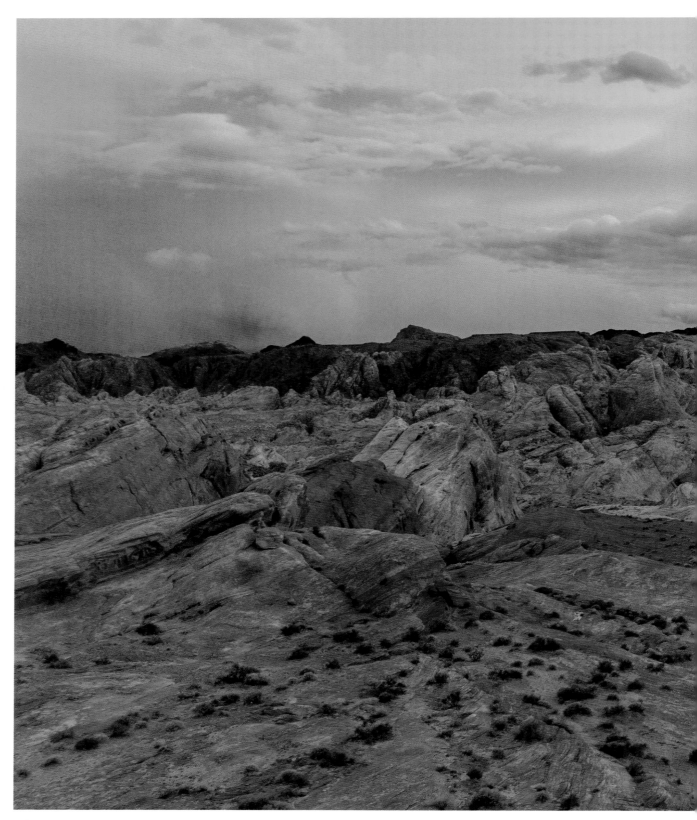

Vibrant red and pink hues stimulate the visual senses as the sun sets over the aptly named Valley of Fire in southern Nevada.

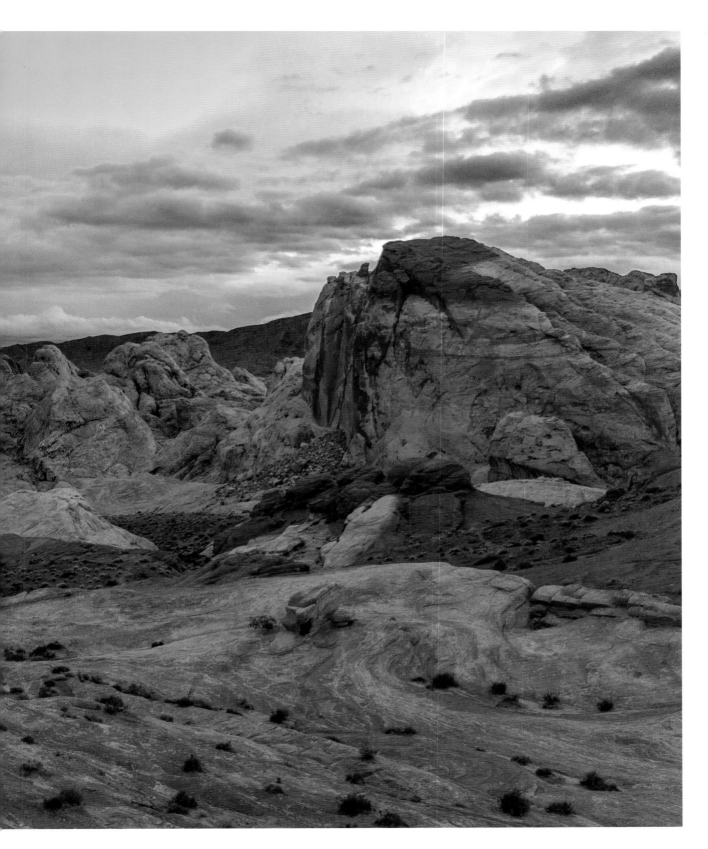

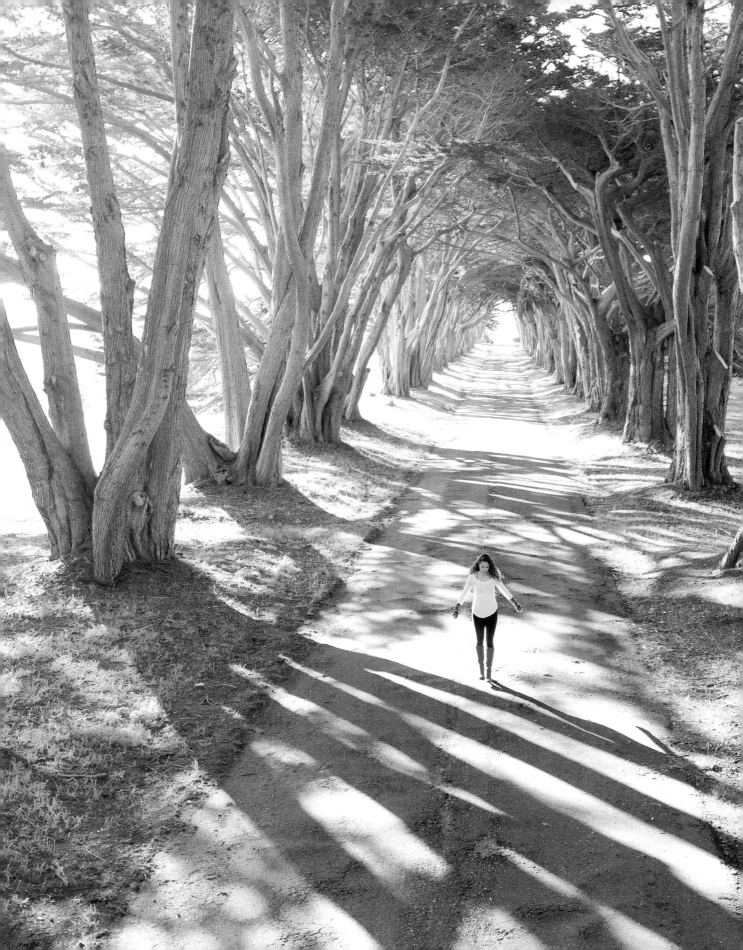

The morning sun casts ominous shadows among a cypress tree tunnel near Point Reyes in California.

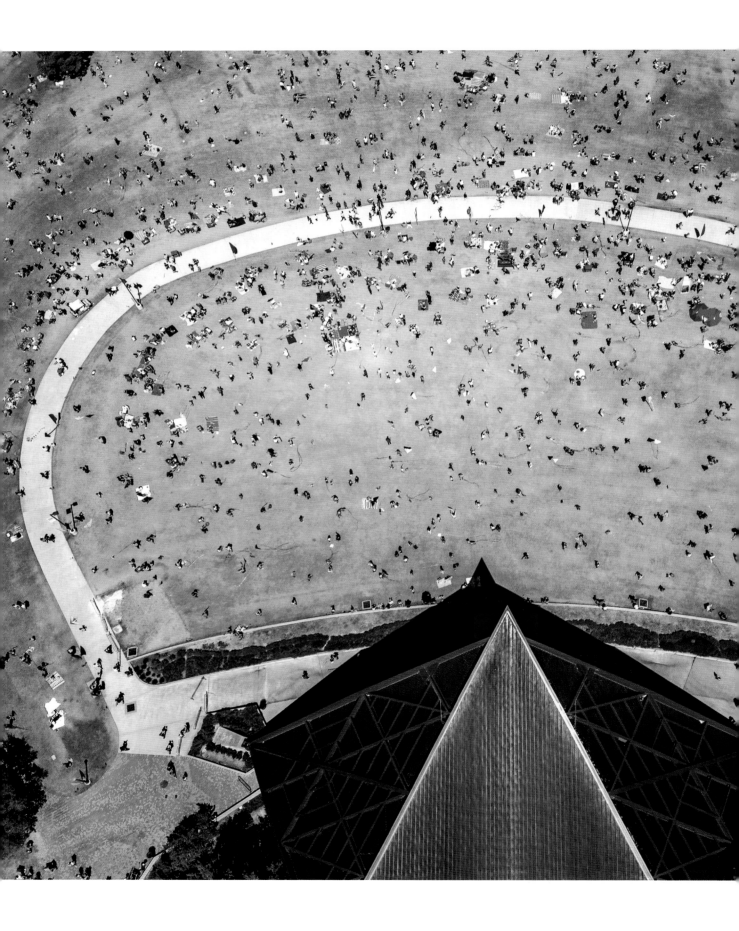

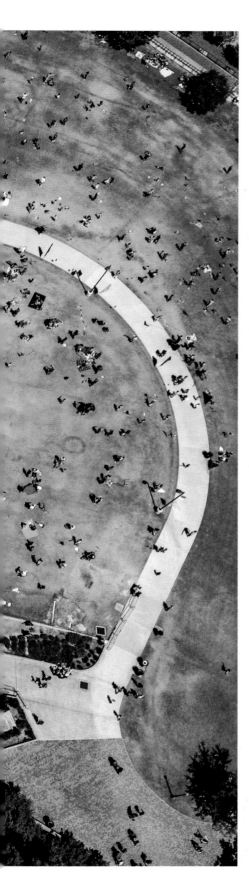

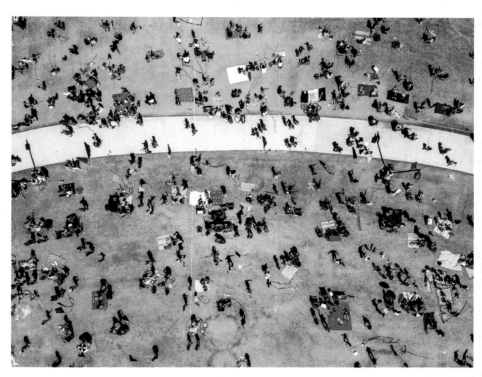

Kite tails dance through the breezy Texas sky over the heads of picnickers enjoying a sun-soaked weekend morning in Houston.

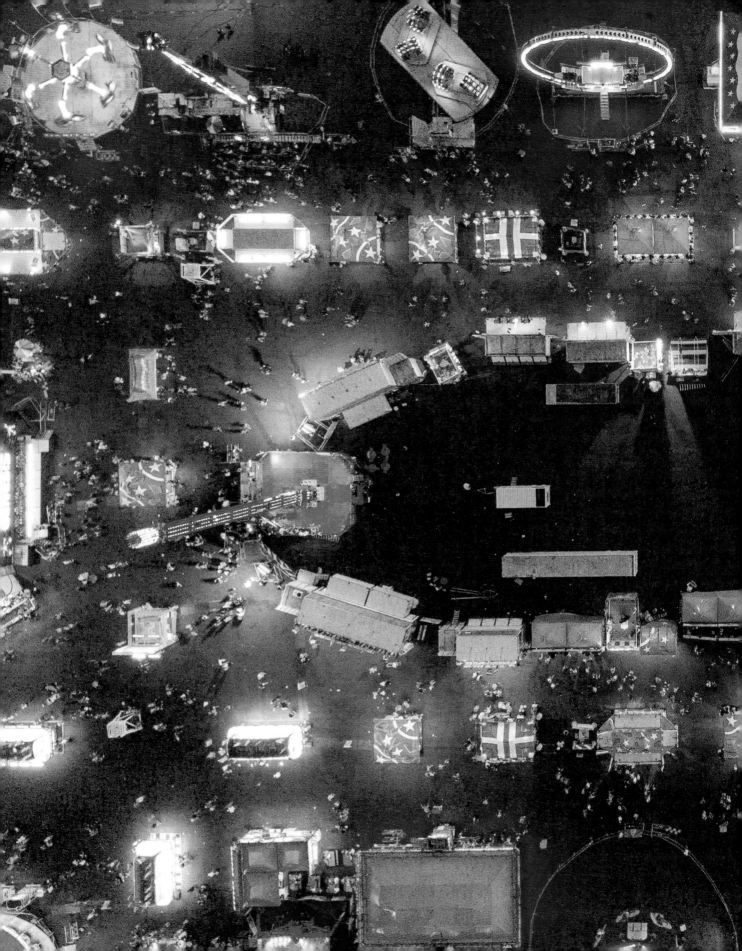

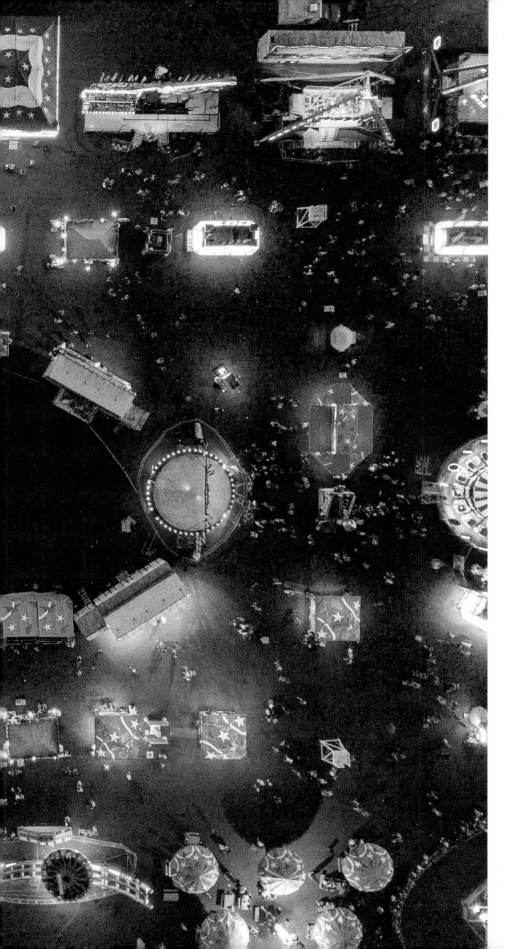

Pedestrians saunter past twirling rides, as The Great New York State Fair becomes aglow in its evening hubbub.

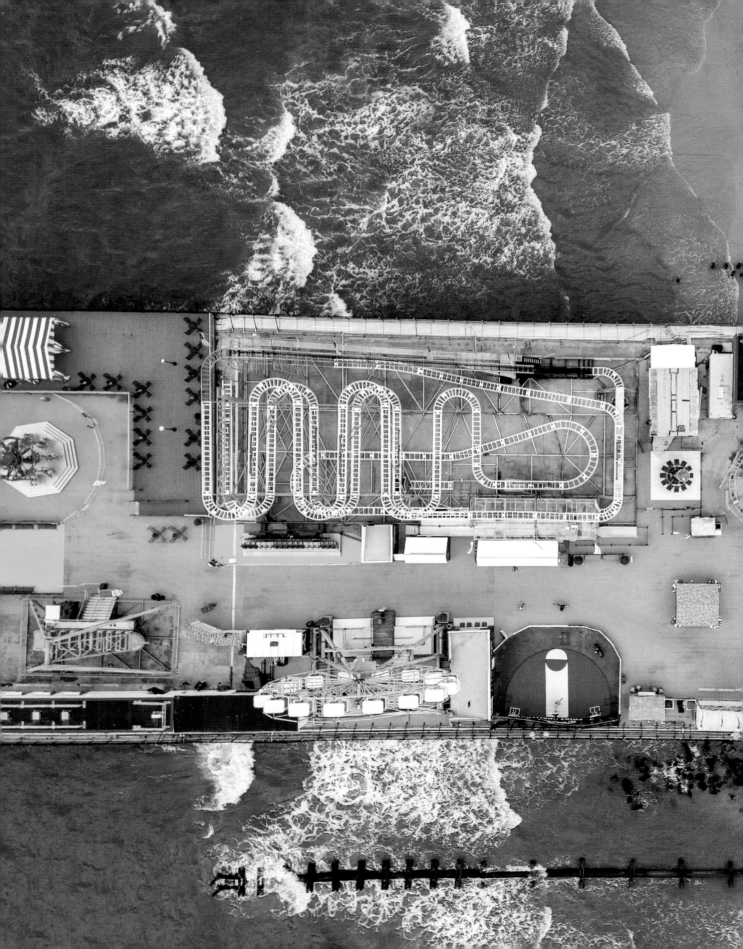

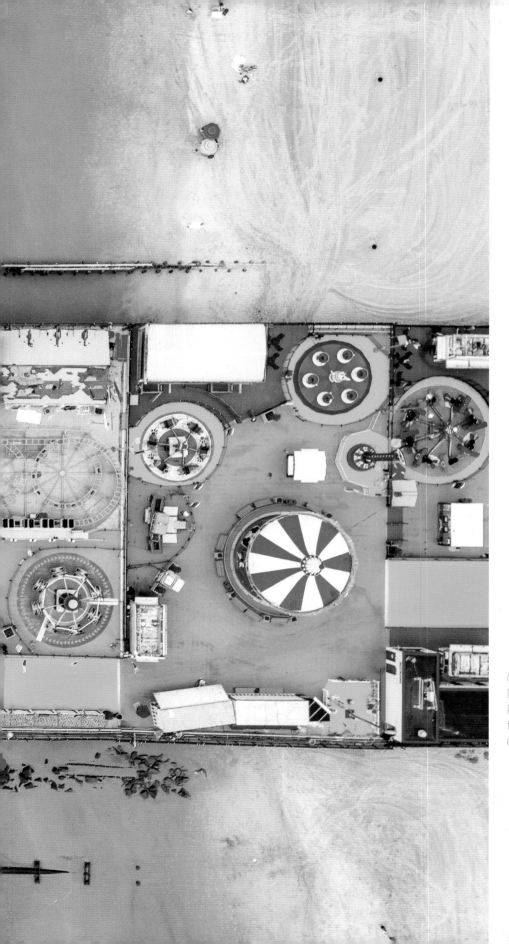

Originally the "Showplace of the Nation," the 1,000-foot-long Steel Pier in Atlantic City was once the crown jewel of northeastern entertainment venues.

Morning haze blankets
the rolling cliffside hills
of Northern California.

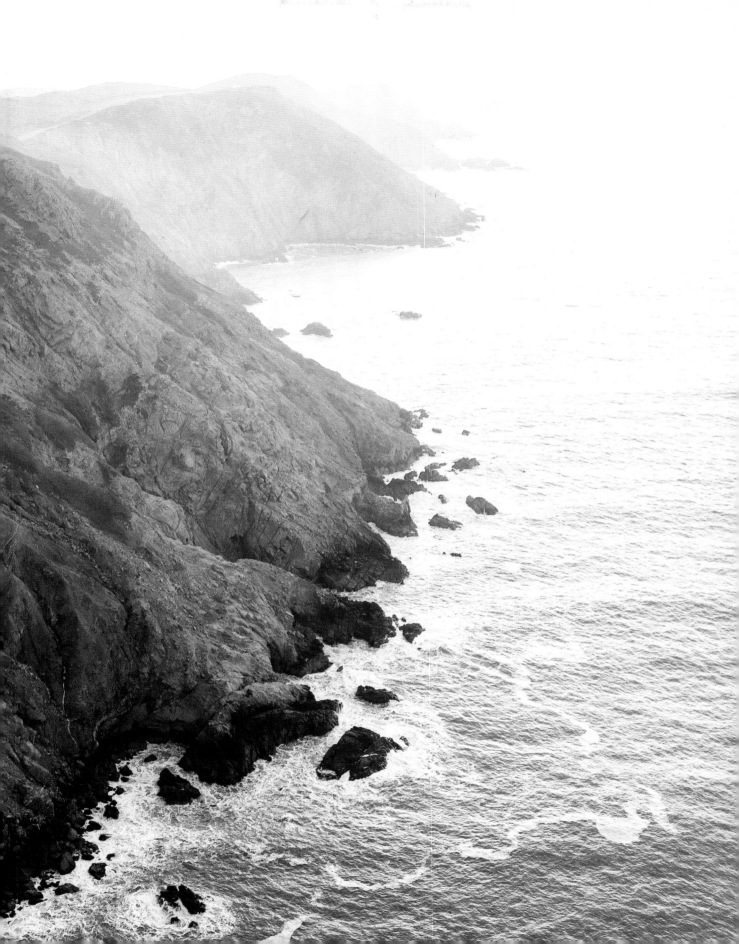

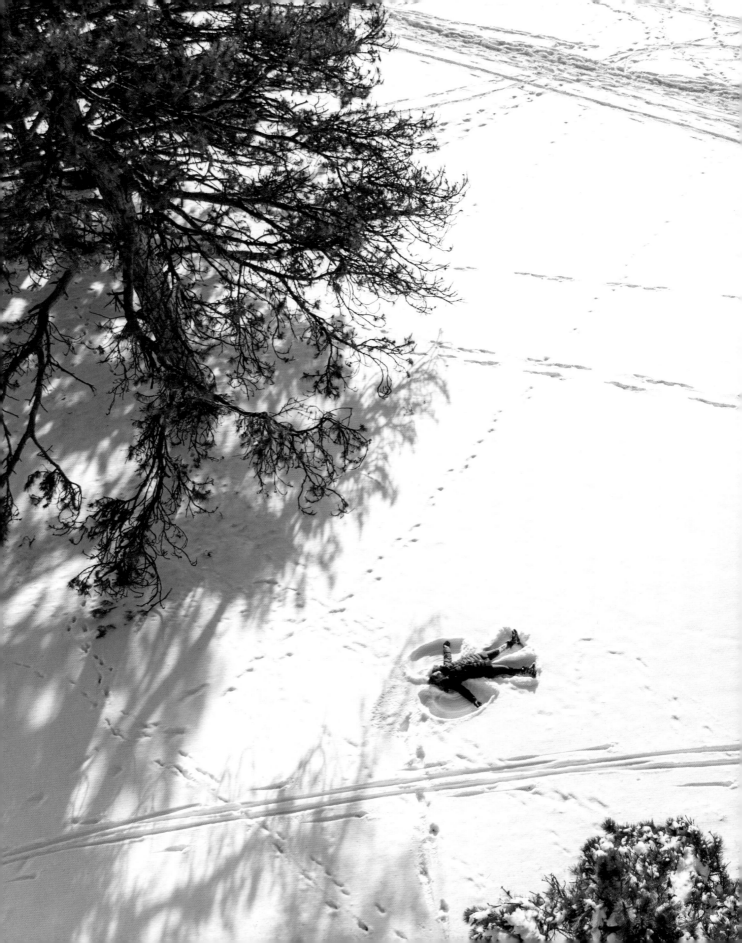

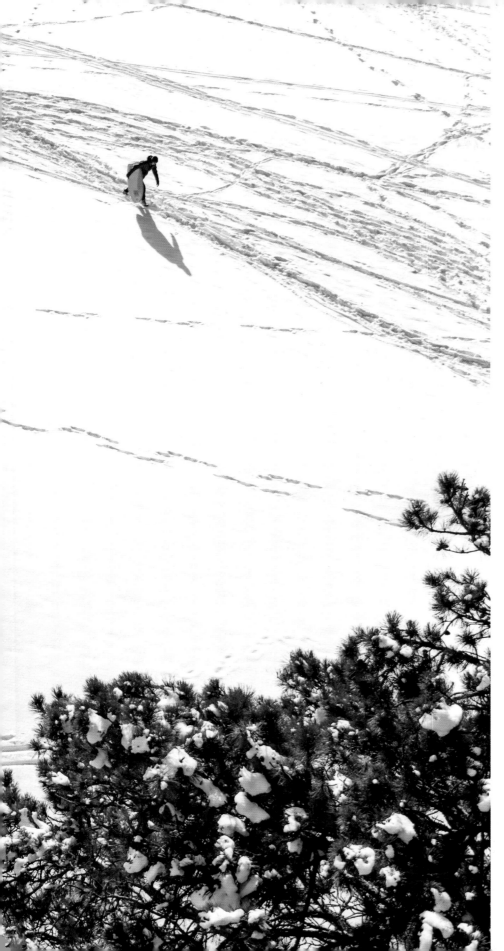

A frost-laden expanse is enjoyed by snow angel makers, tobogganers, and the playful at heart. .

29

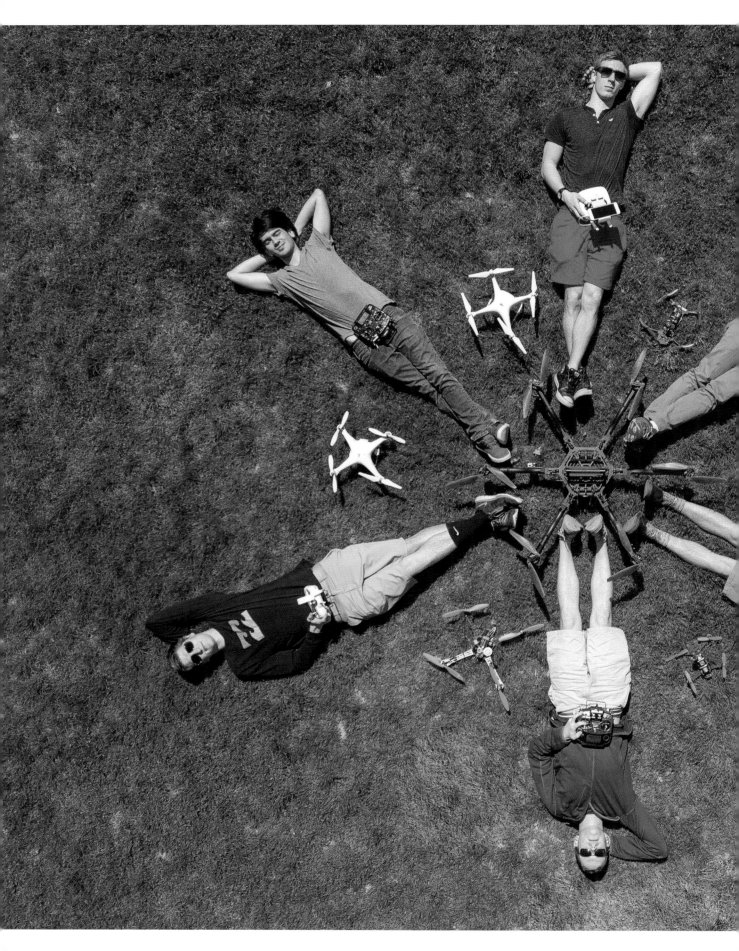

The Freefly Alta 6, the ImmersionRC
Vortex 250 Pro, the DJI Flamewheel
f450 and the DJI Phantom series
help to form a human snowflake
in a grassy spring day pasture.

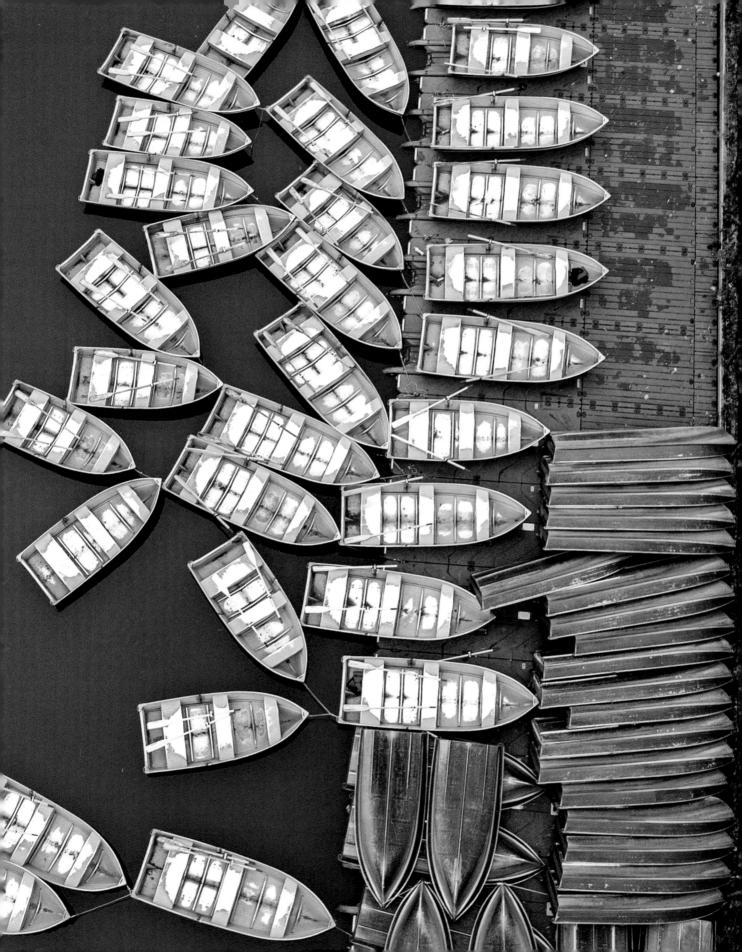

UP, UP, AND AWAY

FLIGHT CONTROLS

Let's talk about how to fly. Your basic controller will have two sticks (a left lever and a right lever), with the direction that you move each stick dramatically affecting your drone's flight path.

Starting with the left stick, a left-right motion on the left lever influences the aircraft's yaw and an up-down motion on this lever impacts the drone's throttle. Yaw is the direction in which your drone is facing, with a left motion rotating the UAV counterclockwise and a right motion rotating the UAV clockwise. Yaw is a critical control for amateur drone operators to understand as it's the least intuitive of the four controls and a lack of yaw adjustment is a common cause of UAV crashes and collisions. As mentioned, yaw controls which direction your drone is facing, and for beginners it's essential that you constantly adjust the drone's yaw so the front of the UAV is facing away from you and the rear of the aircraft is facing towards you (known as nose out). If you fail to align the drone with yourself or, for example, you have the front of the drone facing towards you, you will be effectively flying the drone backwards and all of your controls will be inversed on the controller. The vast majority of commercial drone models have colored indicator lights that help to orient you and cue the drone operator as to which is the front side and which is the backside of the aircraft. On your first flight, you should take off with the drone properly oriented nose out, but be aware that your UAV will often drift in the course of a flight, requiring strategic yaw adjustments. As you grow more advanced, yaw can be utilized for precise maneuvers allowing you to aim the drone in a specific direction. Note that some models offer heading assist or IOC (Intelligent Orientation Control), where you can control your drone as if it was nose out, no matter the actual direction the aircraft is pointing. Throttle effectively impacts the height of your drone by dictating the overall speed of the UAV's propellers. Again, an up-down motion on the left stick impacts the drone's throttle. The throttle is a fairly intuitive control, moving the stick up accelerates the drone skyward and moving the stick down makes the aircraft descend.

On to the right lever—you control the UAV's roll with a left-right movement and the drone's pitch with an up-down motion. In short, moving this lever to the left makes the drone travel in that direction and moving the stick to the right forces the drone to the right. Similarly, an up motion results in the aircraft traveling forward and a down motion causes the UAV to venture backwards. Roll and pitch works by tilting the drone in the direction you want it to go, thus slowing down the two motors facing that direction and accelerating the motors on the opposite side. Lastly, assuming you're in GPS mode, by releasing both of the levers on your controller and allowing them to return to their default positions, your UAV will attempt to hover still in mid-air (empowered by a mixture of GPS and ultrasonic technology as well as accelerometers and sensors).

Now that you have a basic grasp of the four main controls, it's time to test out your skills. Learning to fly is a joy—particularly when you're not putting a thousand-dollar piece of technology at risk. In the very beginning of your piloting career, crashes are inevitable. That is why I would strongly recommend that you purchase a trainer drone—an inexpensive toy-like drone model where you can refine your flying skills before investing in a more serious piece of hardware. Compact trainer drones, which can be purchased online for as little as $20, allow you to

push yourself as a drone pilot. They're typically durable and safe, and as these lower-end models lack all the sophisticated hardware that can be found on more expensive products, most trainer drones will be decidedly more difficult to fly. Without GPS positioning, or other auto-correcting technology, you'll have to be a vigilant pilot, ready to react and correct to ever changing conditions and movement. As a result, if you master flight with a trainer drone, you will be able to navigate the skies with relative ease when you finally upgrade to a more feature-rich drone. In addition, you'll be better prepared to fly your drone when you can't obtain GPS signal. GPS technology is critical to making drones accessible to amateurs, but when you're flying indoors or you're surrounded by objects such as skyscrapers or mountains that obstruct your ability to latch on to a satellite signal, you may have to pilot without this assisting feature. What I did when I was first learning how to fly was give myself different navigational challenges to perfect with my trainer drone. I would challenge myself to safely maneuver my UAV in and around a series of obstacles until I became proficient in the handling of my aircraft. I would start inside, weaving my drone through hallways and whizzing over couches. Satisfied with my indoor flying abilities, I would then attempt figure eights and circles outside to further test my expertise. Inevitably my cheap drone would occasionally

end up tangled in a tree, but failure is an important part of the process. In many senses, I got greater satisfaction out of accomplishing a maneuver with an inexpensive, GPS-free drone model than with an advanced UAV system that constantly makes piloting corrections for me.

Piloting skills are fairly crucial to creating phenomenal drone content. First of all, with a skilled pilot at the helm, you can greatly expand the visual range of your imagery. Battery life or time is often your greatest limitation when working in the field, and to become fluent in flying and navigation is to get the most out of your battery's power and your time. More importantly, with a mastery of flight, you can safely navigate the heavens as you learn to prepare for surprise airborne conditions. If you already purchased a UAV, you can still practice the art of flight without risking the safety of your drone model or others. For instance, DJI and 3DR offer flight simulators that work with your actual controller to give you a good feel for the handling of your drone. In this flight simulator, you can test out each flight mode in a variety of wind conditions. Yuneec also offers free flight simulator software that you can use with your computer. Obviously, experience is the name of the game here. Flying is its own unique skill and it's one that can surely help enhance your aerial storytelling endeavors.

GETTING AIRBORNE

Every time you opt to fly, there are a variety of motions that you should go through to ensure the safety of yourself, your drone, and everyone around you. Over time, this checklist will become second nature to you, but for your first few flights you should be hyper vigilant in ensuring you dot your I's and cross your T's.

In later chapters, I will discuss my process for finding visually interesting locations to fly over. However, especially for your first few flights, your takeoff location needs to have more than artistic merits —it needs to account for overall safety. For starters, you want a flat, wide-open area clear of obstructions, obstacles, and people. You should give yourself a wide enough area to navigate through and make mistakes without significant consequences. In addition, as per FAA regulations (see the last chapter, In the Know), you want to check that you have registered your drone and distanced yourself from airports or other sensitive infrastructure.

Now let's talk about your craft. Is everything properly assembled and tightened? Are your propellers arranged and locked into the correct place? Is your camera, if it's detachable, safely affixed to the craft? Is your memory card in its designated slot? Does your memory card have empty space for you to shoot?

Are your batteries in place and fully charged? Is your drone resting on level ground? It's common to have uneven horizons in your photographs and videos whenever your drone takes off from a crooked surface. Most cameras orient themselves so they're parallel to the surface that they're taking off from and the only solution to correcting these issues is landing your drone and restarting the UAV battery once the aircraft is placed on an even plane. It's also wise to do a quick visual check of your drone before each and every flight with a critical eye towards anything that might be loose or damaged.

After a brief physical inspection, you're ready to start up the power. Turn on your drone and the remote controller and follow instructions to launch any smartphone companion app your UAV might need. Next, calibrate your drone's compass. Typically that means rotating your drone 360 degrees both horizontally and vertically, but I personally find that it's easiest to hug the drone and spin around with it in a complete circle once with the nose pointing parallel to the floor, and again with the nose pointing down to the floor. This should be a part of the drone preparation process anytime you bring your drone to a new location. Also, be aware that metallic surfaces can interfere with compass calibration. Now await GPS lock. Remember how GPS advancements made UAV's accessible for amateur drone operators? I suggest that you fully utilize the power of your drone's internal GPS-based processing systems for your earliest flights, although you'll be ready to fly GPS-free soon enough. Now, scrutinize your mobile app, controller, or drone indicator lights for any warnings. Issues typically range from low battery and low temperature warnings to missing GPS signal and improper calibration. Once you're free and in the clear, make one last check of your surroundings for any moving obstructions such as people and verbally warn any passing bystanders that you're about to takeoff. Initialize liftoff by arming your drone. The process of arming your drone varies from model to model. With DJI drones, for example, arming involves taking the two sticks of the controller with each of your thumbs and, in one motion, pulling them both down and away from each other at the same time. Regardless of how you arm, the UAV's propellers should begin to spin. Gently pull up on the throttle (motion up on the left stick) to separate the drone from the ground. Note that in very close proximity to the ground, the drone's propellers create its own wind force that the drone cannot stabilize itself in. Another takeoff option, dependent on the type of drone you own, is to press the takeoff button. Although not recommended (you're trying to learn how to do things manually here!), when you press the takeoff button the drone will automatically ascend to

a modest height and hover until you're ready to take the reins.

Okay, you're now at the helm of a hovering drone. Assuming you're utilizing your aircraft's GPS functionality and that you have cleared the ground by a few feet, your drone should be holding still in mid-air. Get a feel for the sensitivity of your controls (which can typically be adjusted with any companion mobile app) and the aircraft's reactivity to your commands. Smoothly and slowly experiment with flying in each direction using the right stick. Anytime you get nervous, you can remove your fingers from the sticks of the controller and your GPS-empowered drone will halt its motion and hover in place. Similarly, UAV model's like the 3DR Solo, and more recently the Phantom 4, have put pause buttons on their controllers, which act as emergency brakes for any drone in mid-flight. Once again, be mindful of the drone's orientation in comparison to you and make necessary yaw adjustments (on the left stick, motion left to rotate the drone counterclockwise and right to rotate the UAV clockwise). Nonetheless, don't be afraid to look around your environment, either by rotating the drone through yaw, or swiveling the camera's gimbal through an app or a second controller. Staying within your comfort zone, safely explore the boundaries of your environment before bringing the drone back towards you. To land, have your drone

hover at a slight altitude and once the coast is clear, cautiously lower the throttle until the UAV's legs meet the ground. Stop the propellers from spinning by going through the same motions that you used to arm your craft. Alternatively, if your drone had a takeoff button, it will also have a landing button that you can let do the grunt work for you.

One critical safety mechanism to be aware of is the Return to Home feature, standard on most high-end models. As soon as your drone latches on to satellite signal, the aircraft's "home point" is established. If something happens to your controller, or you lose signal with your aircraft, the drone will automatically fly itself back to its point of takeoff, where it can land itself, or be manually controlled by an operator who has regained signal. Obviously, do not use the Return to Home feature if you're taking off from, say, a moving boat, as your drone's "home" may end up being the water. Features like Return to Home are marvelous safety redundancies that are there when you need it, however, it's always wiser to operate the aircraft yourself whenever possible.

FLYING SMART

With enough experience, the motions of flying will become natural—a part of your muscle memory. But before you embark on an airborne adventure, there are a few things that you should keep

in mind for consistently safe flights. For novice operators, GPS mode is a must, as it keeps your initial flights smooth and fluid when it may otherwise be jerky and choppy. In addition, always keep your machine within your line of sight. Not only is this an FAA guideline, but it's also a safety consideration. Drones have phenomenal range, but most lost signal issues come from flying a drone beyond an obstacle (controllers have a harder time communicating with the drone if there are obstructions in the way) and out of view. Interference, or having other radio signals interrupt the controller-aircraft connection is also possible, particularly in urban areas. Keeping your UAV in sight will not only help maintain controller-aircraft connection, but it will also help avoid crashes. Depending on the direction in which your camera is pointed, you can easily be blindsided by objects in flight. Obstacles can even sneak up on you when your gimbal is pointed the right way, as objects on your live view screen are closer than they may appear. Having a set of actual eyeballs evaluate the space that you have to maneuver in is tremendously beneficial. Orientation can similarly be confusing without a set of eyes trained on the aircraft. As mentioned, indicator lights are there to help you properly adjust the UAV's yaw. Nonetheless, be mindful that the farther you are away from your drone, the worst your perception of depth and distance becomes. For particularly

difficult maneuvers, the closer you are to the aircraft the better. If, for some reason, you ever lose track of your drone in the sky, you can swing the camera around until you find familiar surroundings, use the app's map feature to point you in the right direction, or utilize the Return to Home function as a last resort. Furthermore, endeavor to limit distractions as you fly. When you're airborne, your piloting mind should be attentive, and your artistic mind firing on all cylinders. One small thing that has made a world of difference for me is turning notifications off on my mobile device before I take off. This way, incoming messages and calls won't interfere with my short airborne stint. Weather and wind also have a tremendous effect on flight. There's a certain dramatic gloominess created by precipitous weather, but it's a type of beauty you must be cautious in attempting to capture. Your drone is an inherently electronic system, making moisture incompatible with the device's operation. While many drones can fly in light rain or snow, by exposing your UAV to water, you're risking the health and longevity of your aerial vehicle. Weather systems also lower visibility—both the camera's visibility and your capacity to track the drone in the sky. Wind is an even more common obstacle for pilots. On a gorgeous day, wind can ground the most prudent and wise drone operators because it causes undesired drift and lessens the margin of error for maneuvers. Flying through

strong gusts means being super reactive and steering very clear of obstacles. No matter what, it's imperative that you always feel in control of your craft. The second you're no longer confident in your ability to guide the drone, it's time for you to bring the device down. Excessive drift or low drone stability is a clearcut sign now might not be the best time to fly. Remember, the higher in altitude that you climb, the more the wind can intensify. Along the coast or in between tall buildings (where a wind tunnel effect is possible), powerful breezes are especially common. Either way, be sure to master flight in normal conditions before you dare to test Mother Nature. Lastly, keep a constant eye out for warnings. Pump your device's volume up high so you can hear issues as they may pop up. Certain drone companion apps will provide verbal prompts if, for instance, you reach maximum flight altitude or your battery is running low. Most especially, monitor your drone's battery life because a multitude of factors can affect your vehicle's flight time. Your UAV's companion app should give you a number of ways of understanding your aircraft's battery life (flight time remaining or battery percentage for example), warn you as your battery dwindles (you can adjust the battery percentage that you're warned at), and utilize safety features such as Return to Home when you're pushing the limits of your craft too far.

FLIGHT MODES

As I alluded to, your aircraft has a few different flight modes that serve varying functions. There are two modes that are standard on commercial UAVs, but they're often given different names. Please consult your manual about what these modes are called on your product. First, there's a GPS mode. This is a lifesaving flight mode for beginner pilots as it keeps the drone incredibly stable and still in the air save any extreme weather or wind condition. Next, there's ATTI (or Attitude) mode, in which your aircraft doesn't utilize its GPS functionality. In ATTI mode, the drone attempts to maintain its altitude, but will not try to maintain its position. As a result, the UAV will drift wherever the wind is taking it, and you must be proactive as a pilot to stay in control and keep the aircraft away from obstacles. In addition, releasing your controller's sticks will not stop the UAV from moving as it does in GPS mode. Instead, the drone will continue in the same direction until you counteract its movement by moving your controller's stick in the opposite direction. Obviously, flying in ATTI mode requires greater piloting abilities, but this is a practical skill to learn for when you're in an area where your drone is unable to latch on to GPS signal. You may even have other flight modes depending on your drone model. There's manual mode, where the drone's movement is entirely at your fingertips. The UAV will not correct itself or maintain itself in

any way, shape, or form and you must constantly throttle to keep your height, while continuing to correct for drift (as you must in ATTI mode). Sport mode is essentially an iteration of ATTI mode that enables you to travel at faster speeds. Heading assist, or IOC (Intelligent Orientation Control), allows you to control the drone the same way, no matter its heading direction. In other words, the aircraft will move in relation to you, regardless of the direction the drone is pointing—it will come towards you when the right stick is moved back, and go away from you when it's moved forward. There are even a series of Intelligent Flight Modes where you can tell the drone to follow something, encircle and track a point of interest, or fly to a chosen waypoint autonomously.

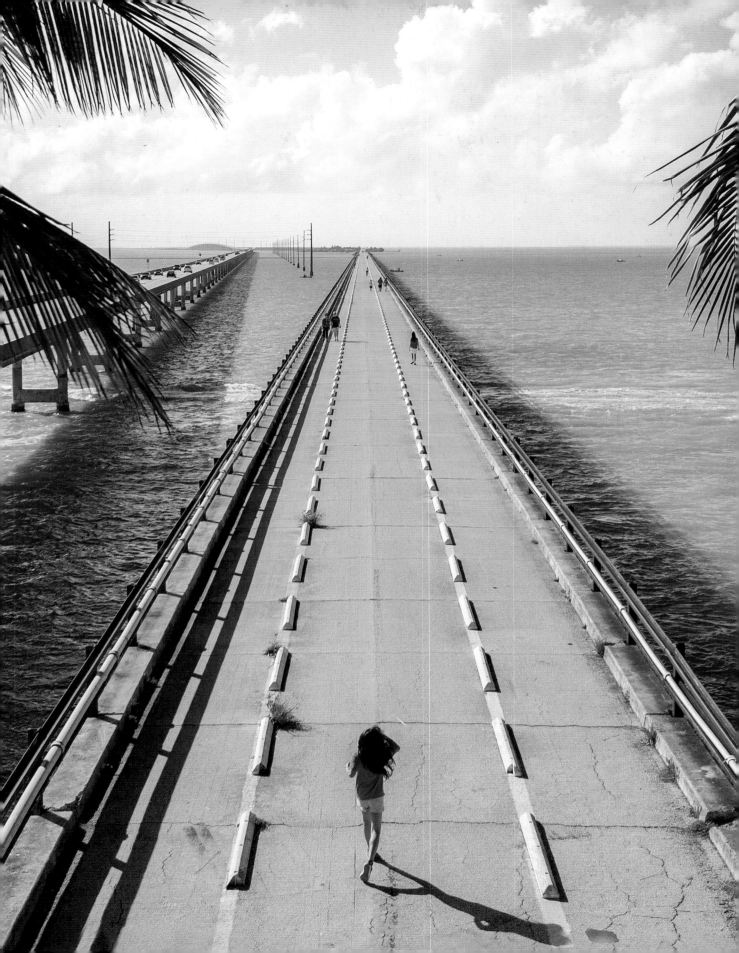

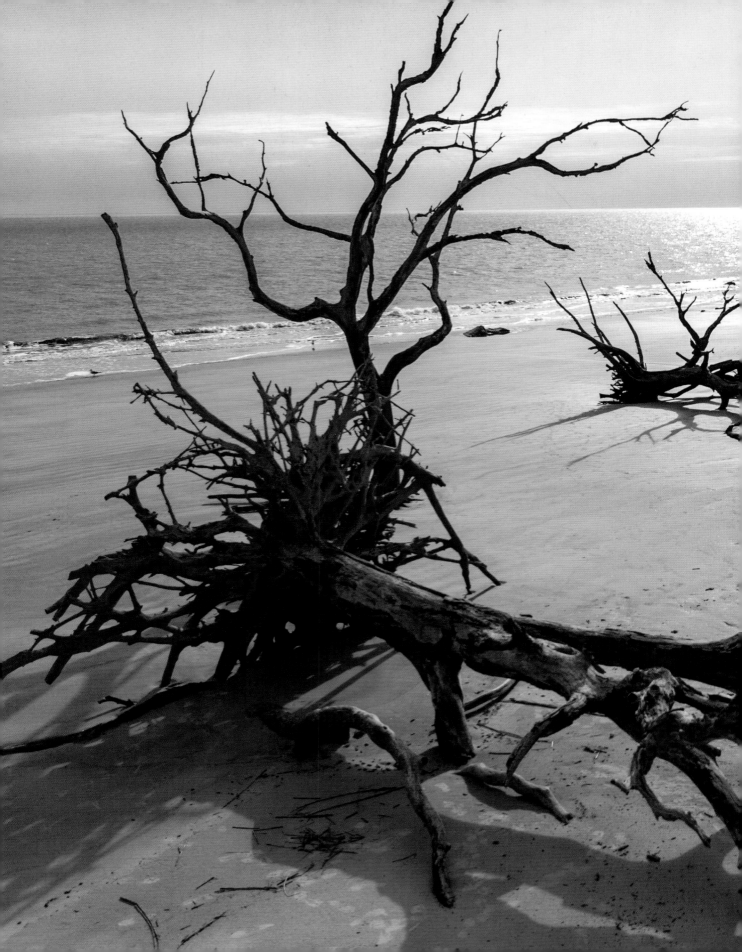

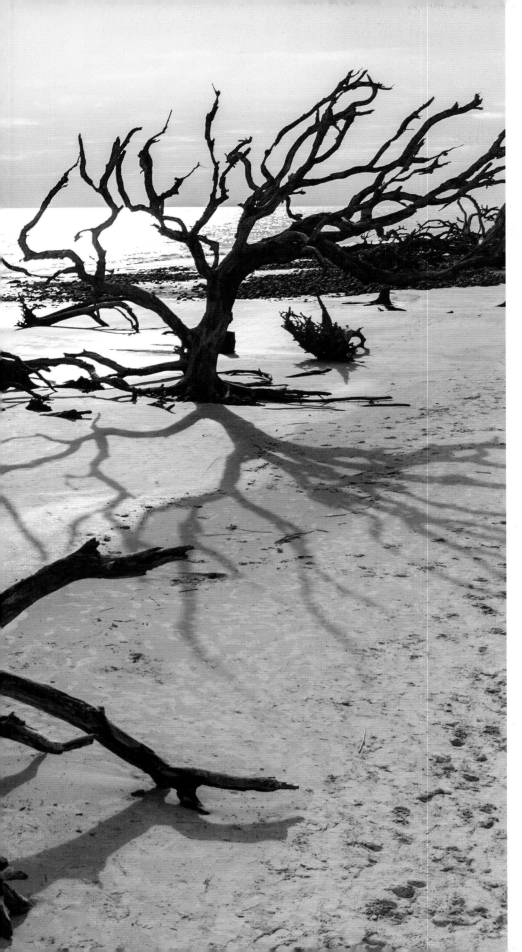

Massive pieces of driftwood remain from a flooded forest on the shores of Jekyll Island, a Georgia community once home to the nation's wealthiest families.

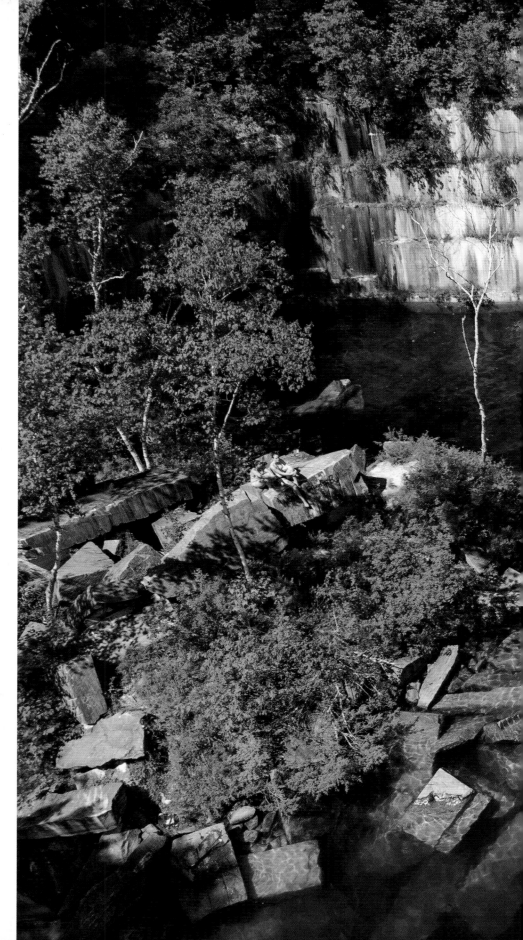

The rocky remnants of a
marble quarry abandoned in
the aftermath of World War I
create an aquatic playground
for swimming locals near
Dorset, Vermont.

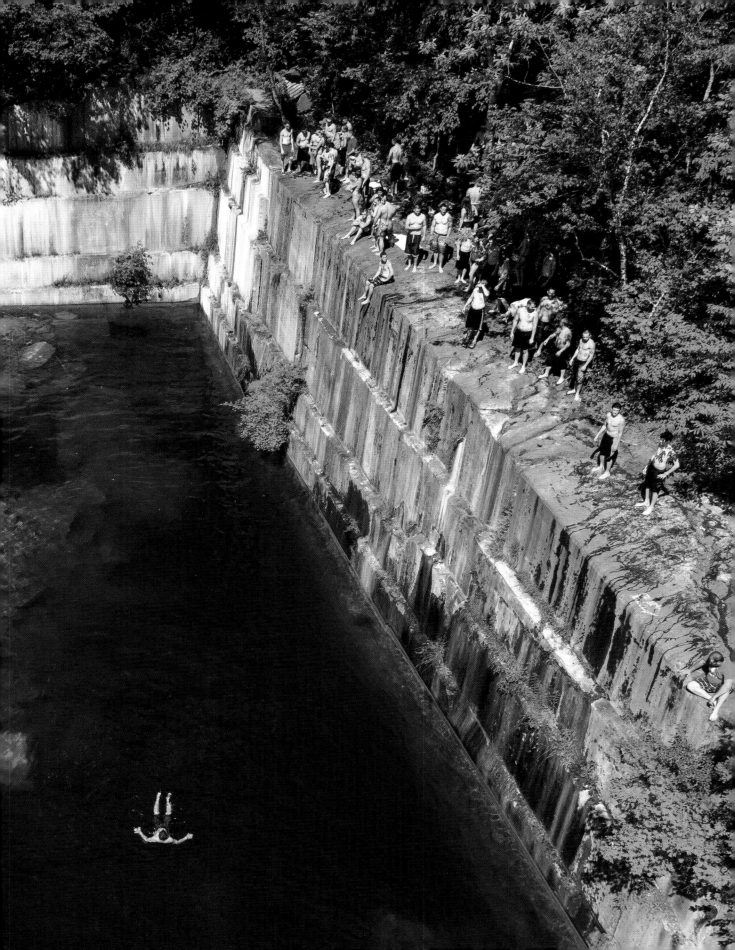

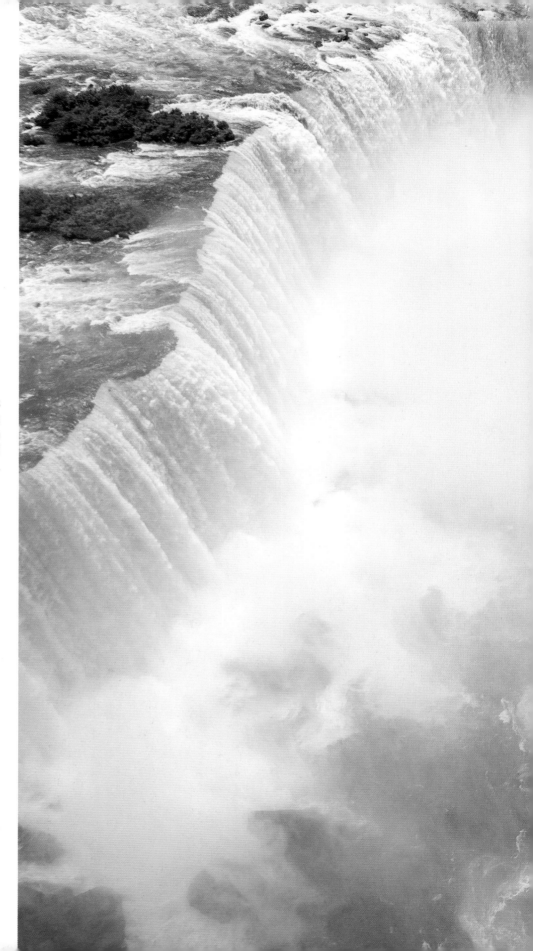

Maid of the Mist journeys through the thundering veil of Horseshoe Falls, a 2,600-foot long waterfall spanning two nations.

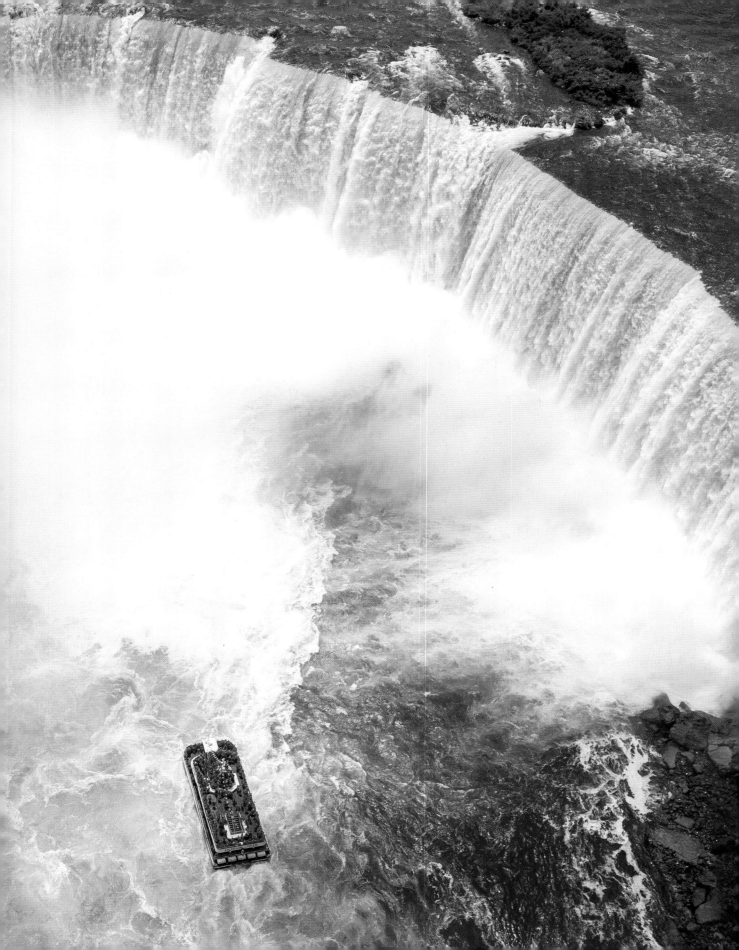

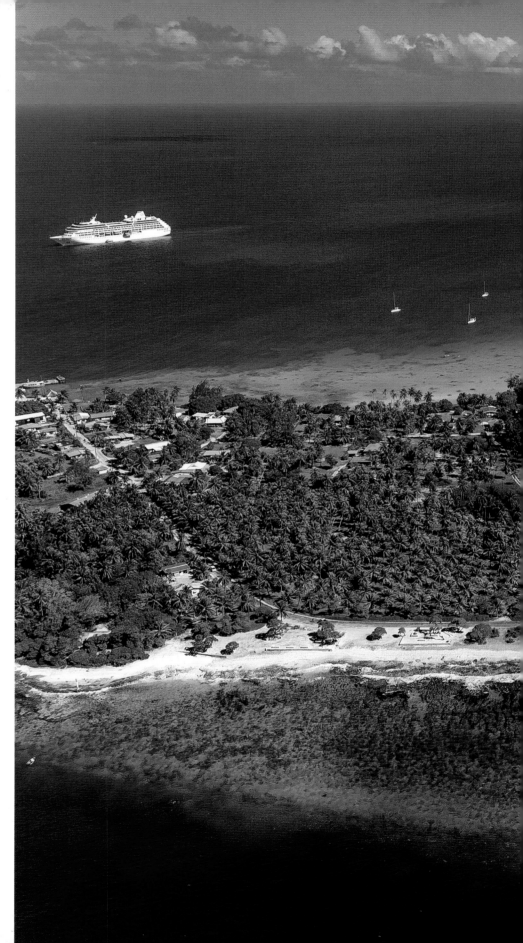

An Oceania cruise ship and the azure hues of a French Polynesian coral reef are surrounded by Rangiroa, the world's second largest atoll.

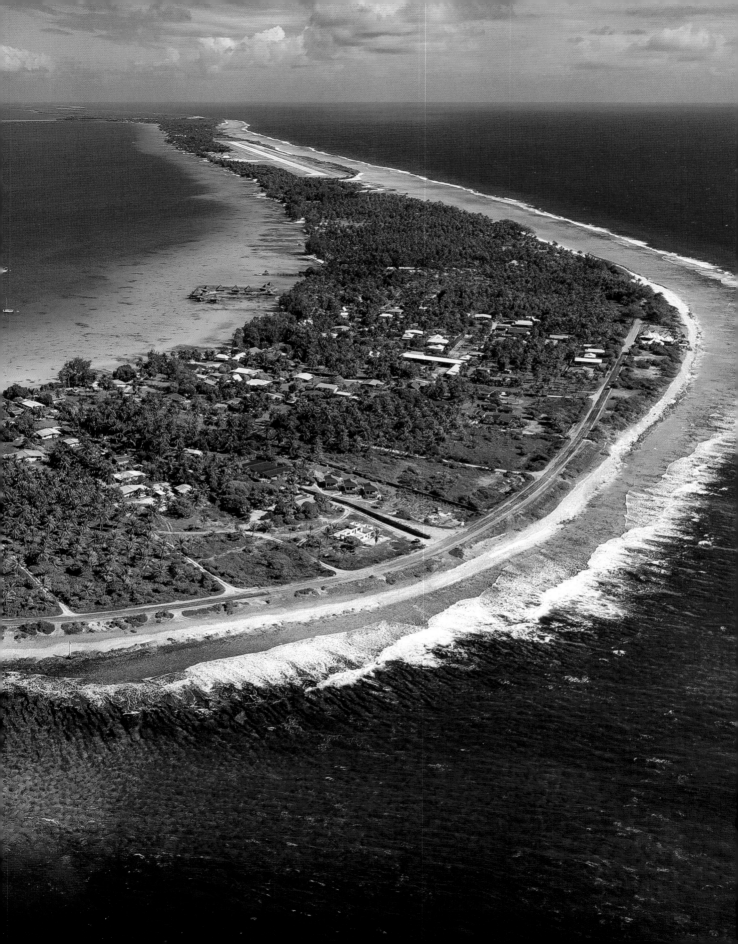

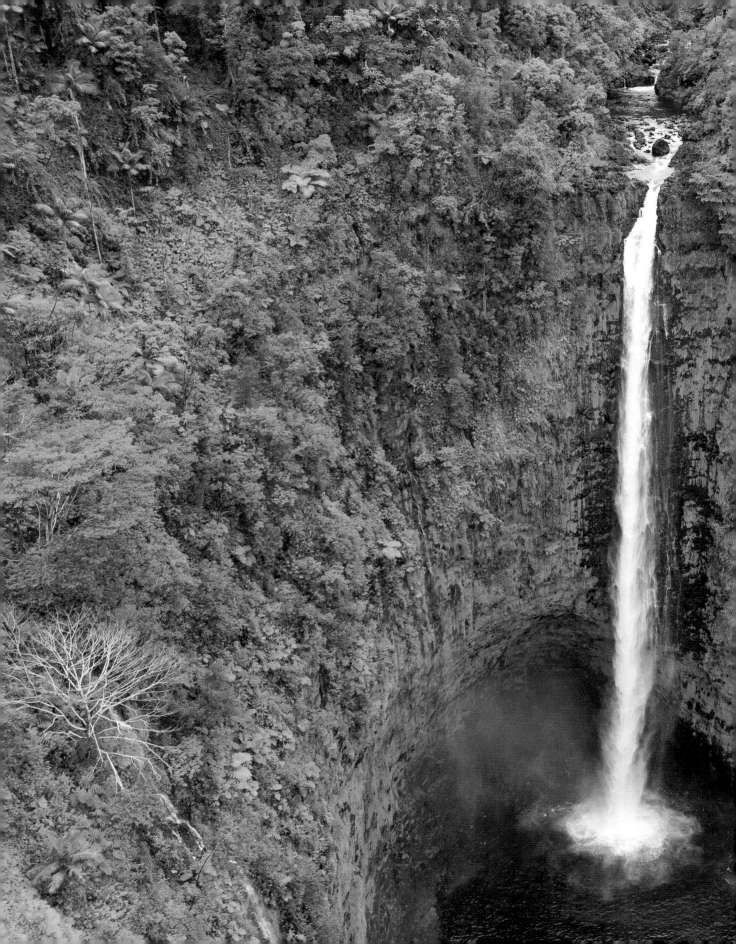

The largest in a string of volcanic Polynesian islands, Hawaii is home to lush gorges and impressive 422-foot high cascades.

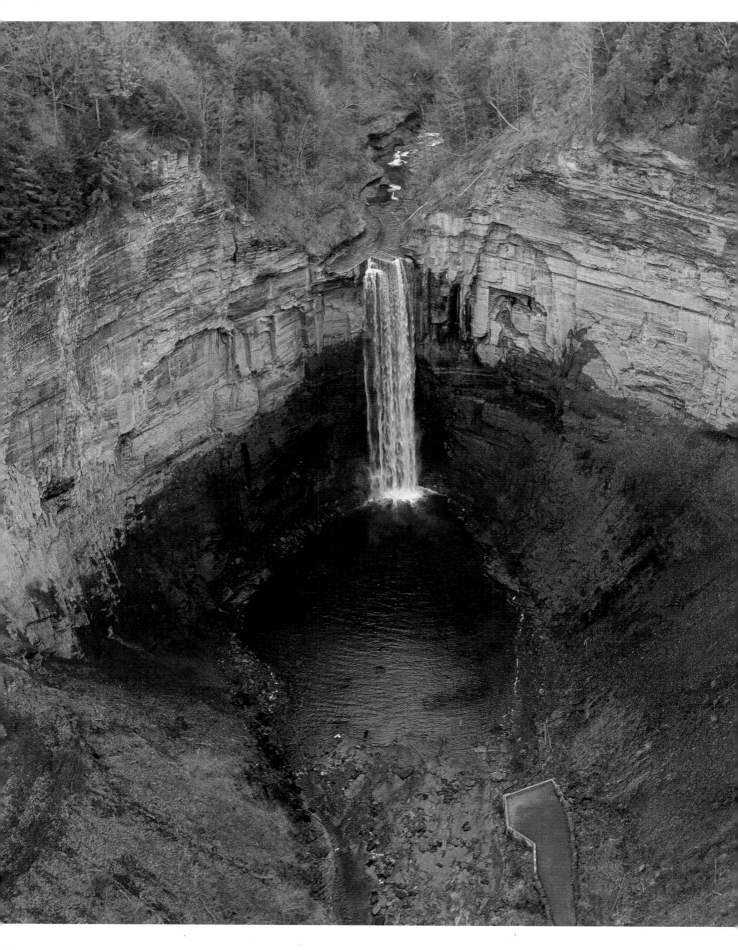

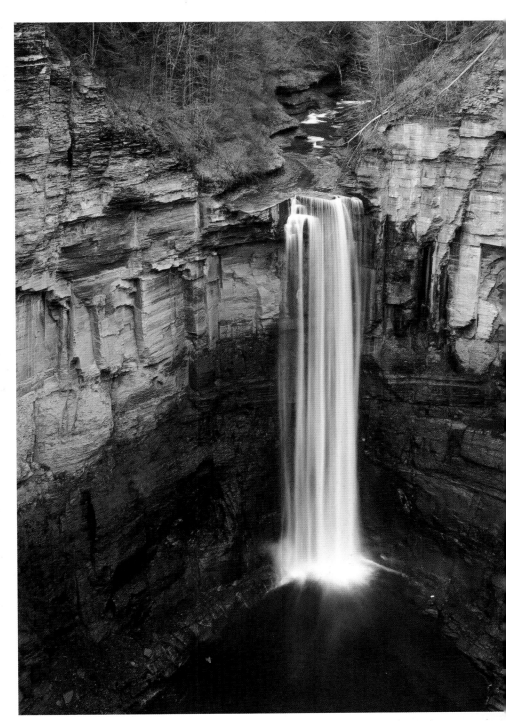

In New York's Finger Lakes region, Taughannock's powerful, 200-foot tall cascade is miniaturized by a wide, autumnally tinged ravine.

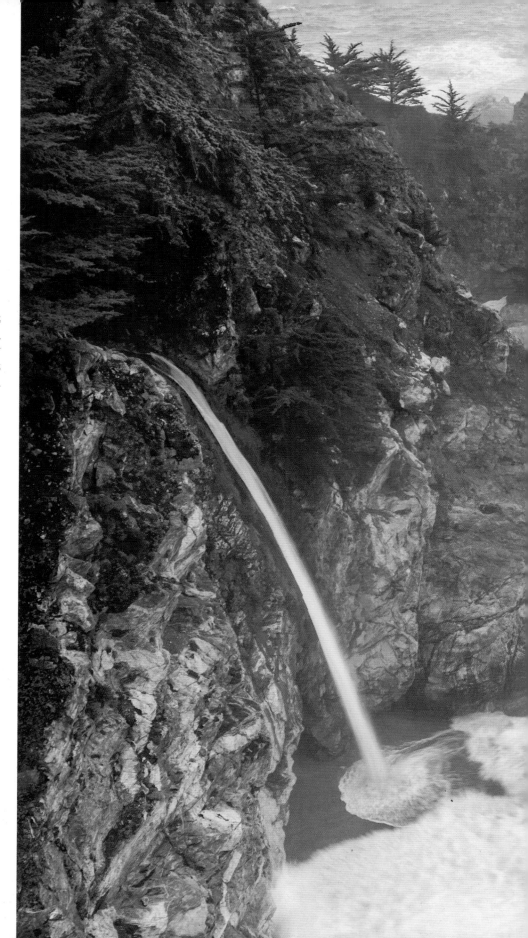

Dwarfed by the vastness of a stormy Pacific Ocean, McWay Falls at Julia Pfeiffer Burns State Park trickles over a rocky ledge.

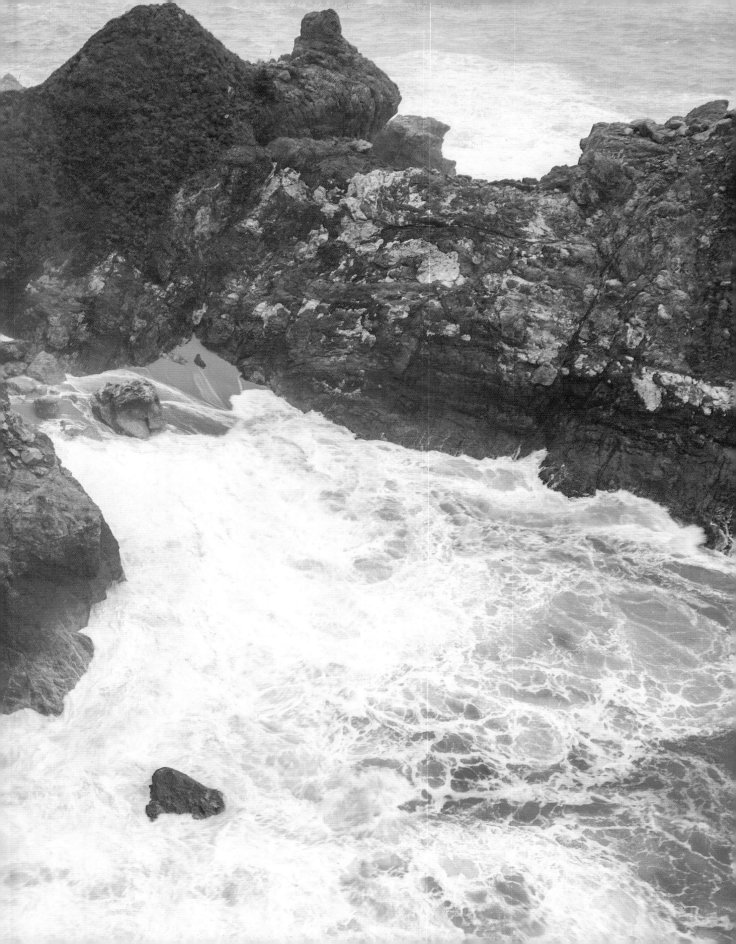

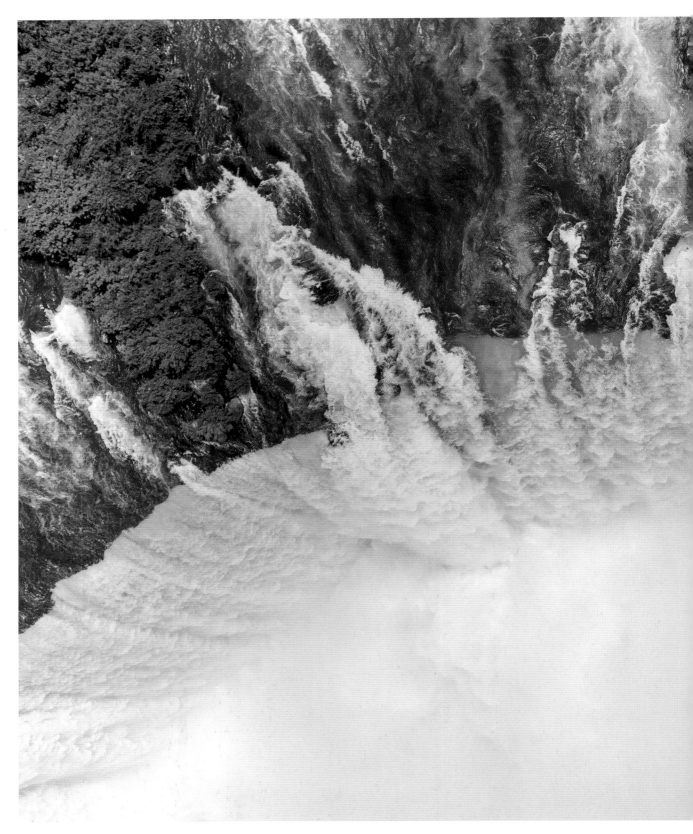

A soft cloud of mist rises from the Niagara River's cascading torrent.

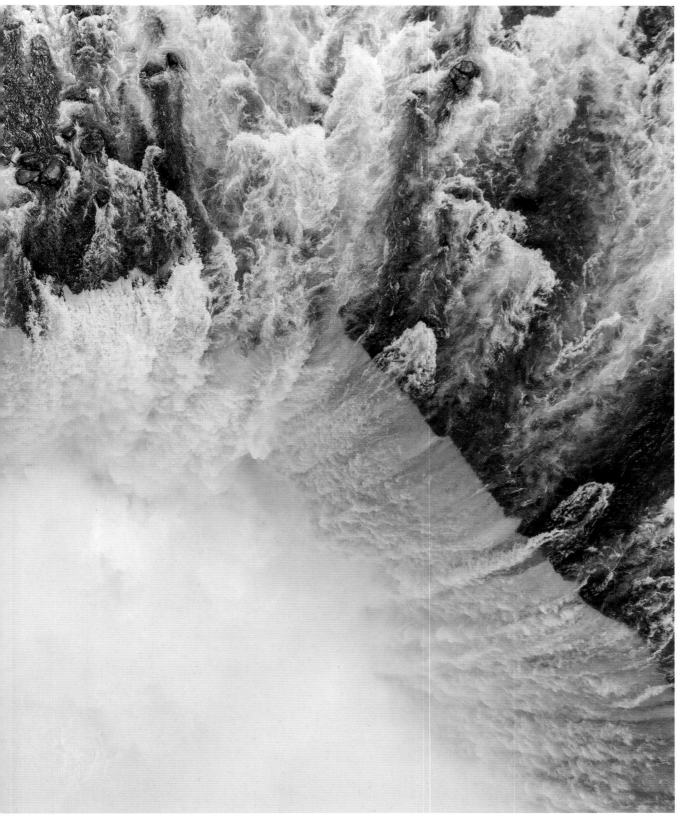

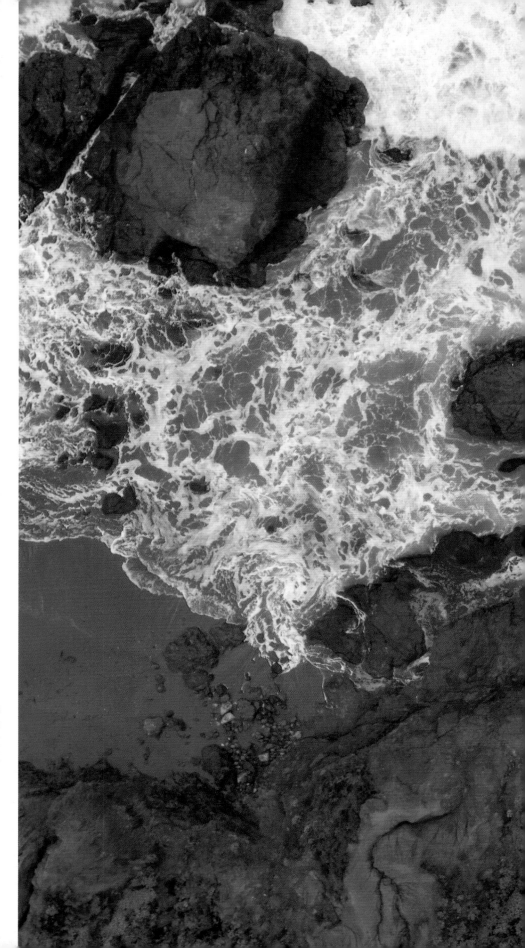

Crashing Pacific waves
invade the rocky crevices
of the California coast
near Big Sur.

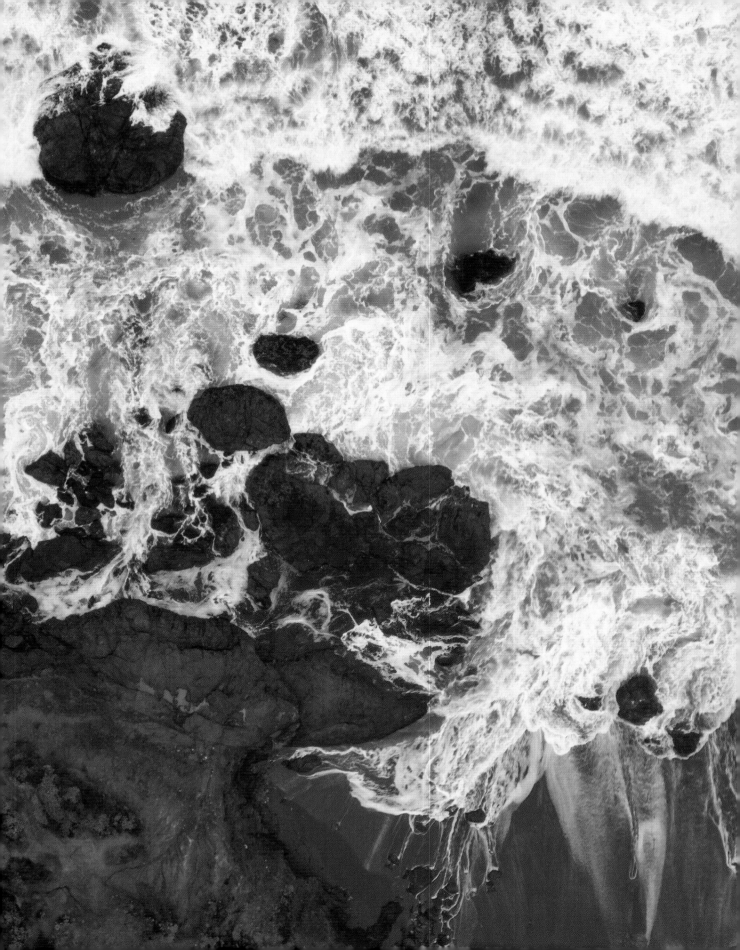

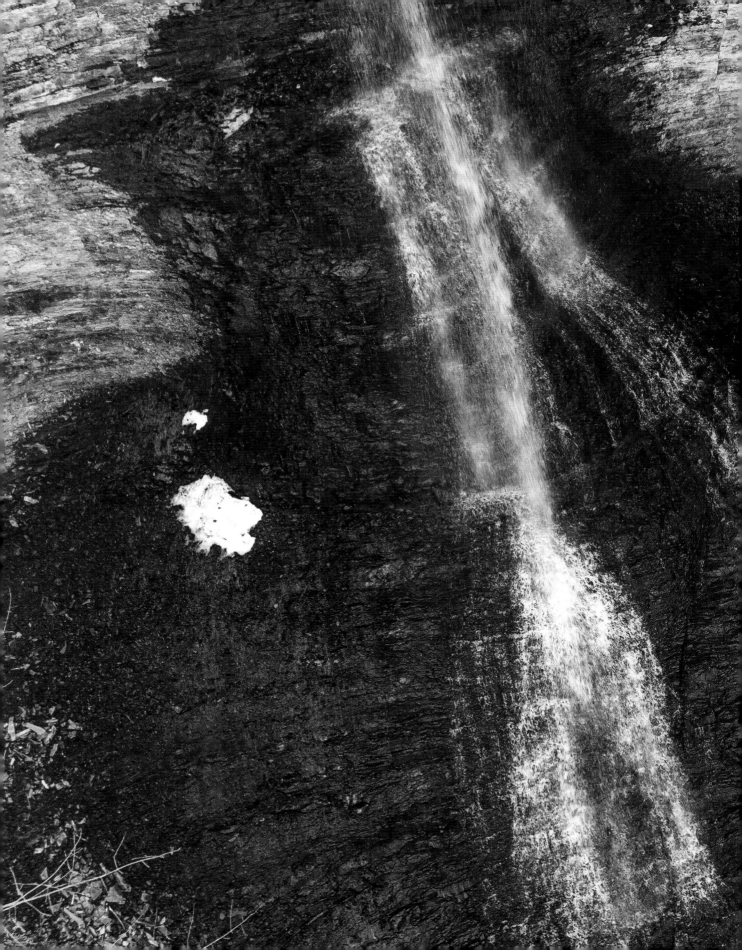

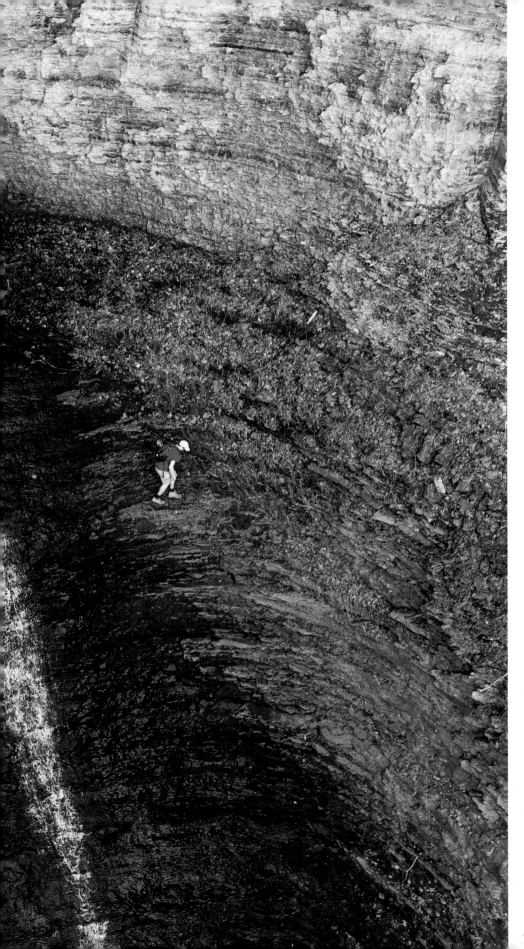

Circumventing the slick rock face, a hiker makes his steep descent in the shadow of a towering cataract.

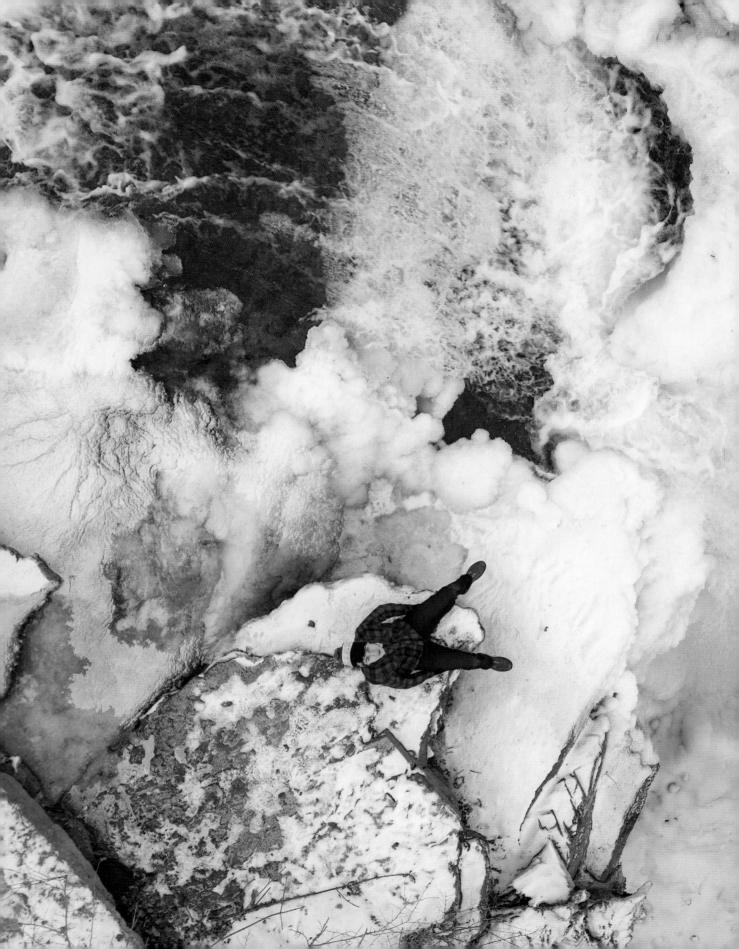

Limbs dangle atop an icy
precipice that protrudes
over a roaring cascade.

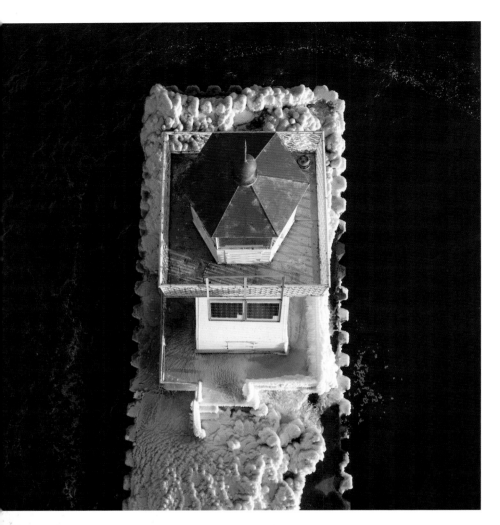

As the sun disappears behind Lake Ontario, the evening's last touch of light dances around the frigid rim of Sodus Point Lighthouse.

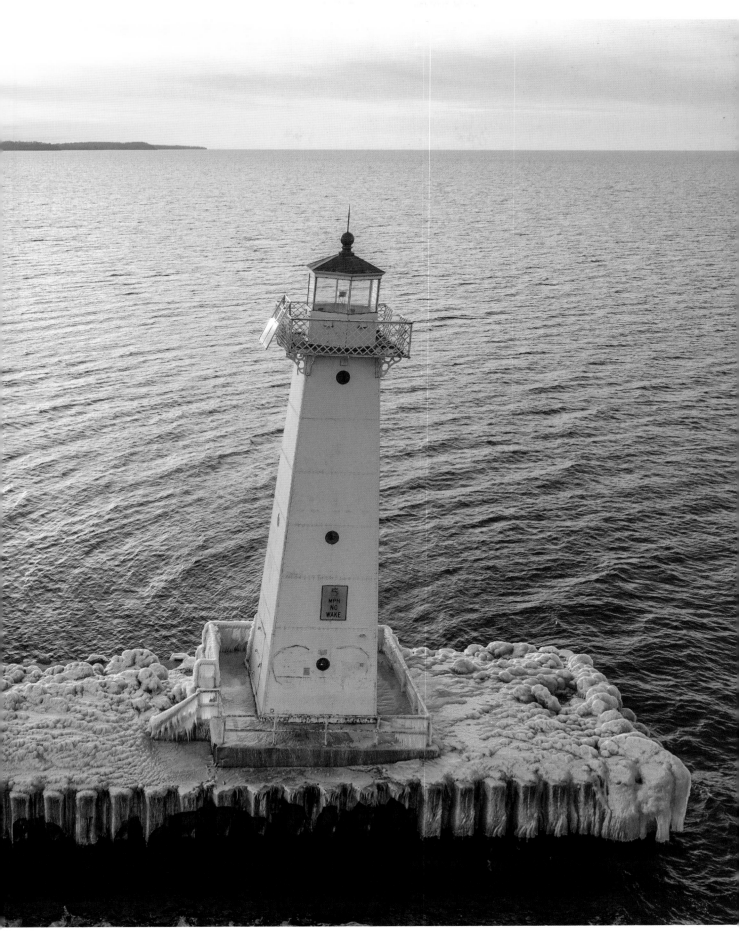

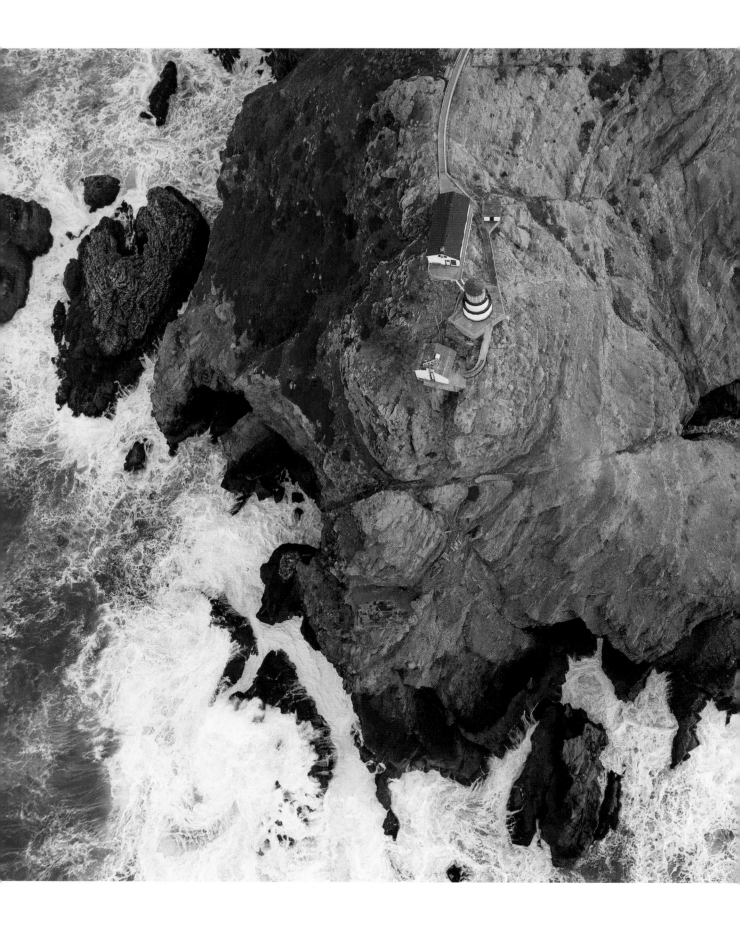

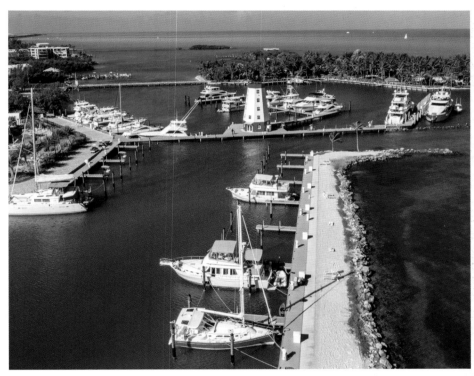

(above) Narrow spits protect docked ships waiting to embark on turquoise-colored seas from the Keys' Faro Blanco Lighthouse.

(left) Perched high above a jagged cliff, a lighthouse seems to dangle over the Pacific Ocean.

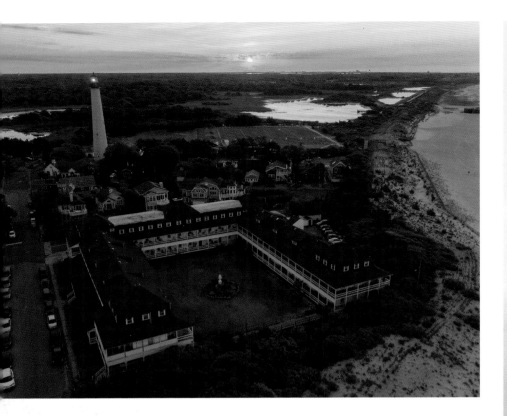

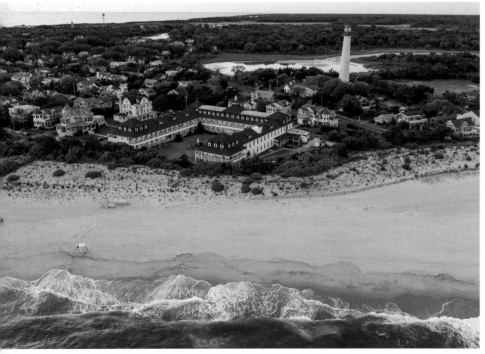

Erected at the southernmost tip of New Jersey, the Cape May Lighthouse replaced its two predecessors that were both swallowed up by the sea.

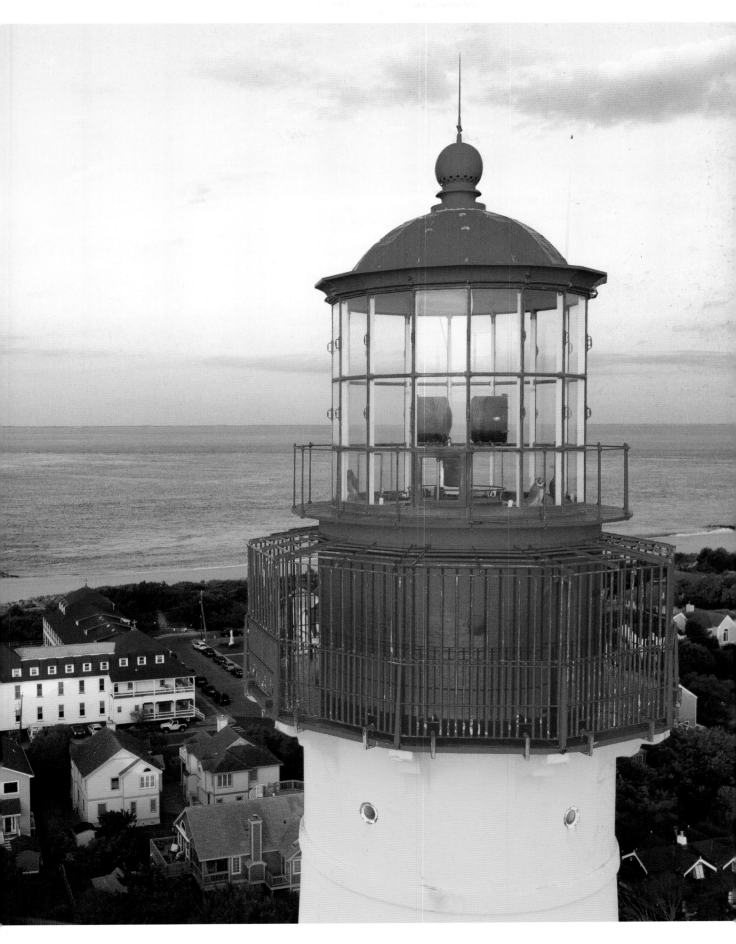

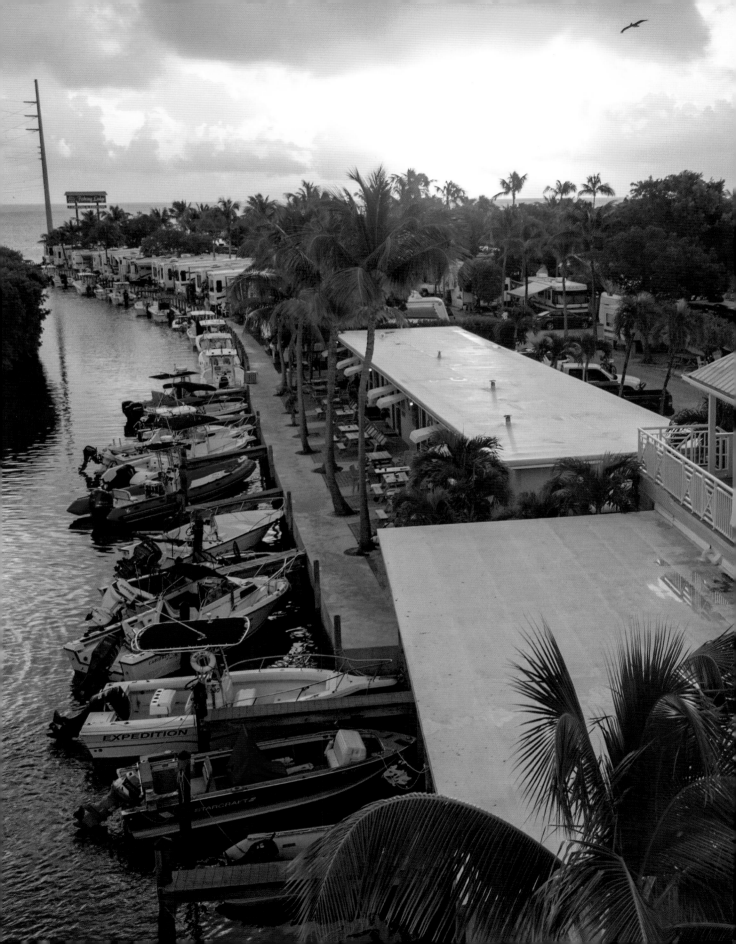

In the Keys, bursts of sunlight awaken the Big Pine Key Fishing Lodge as light begins to spill into its inner harbor.

71

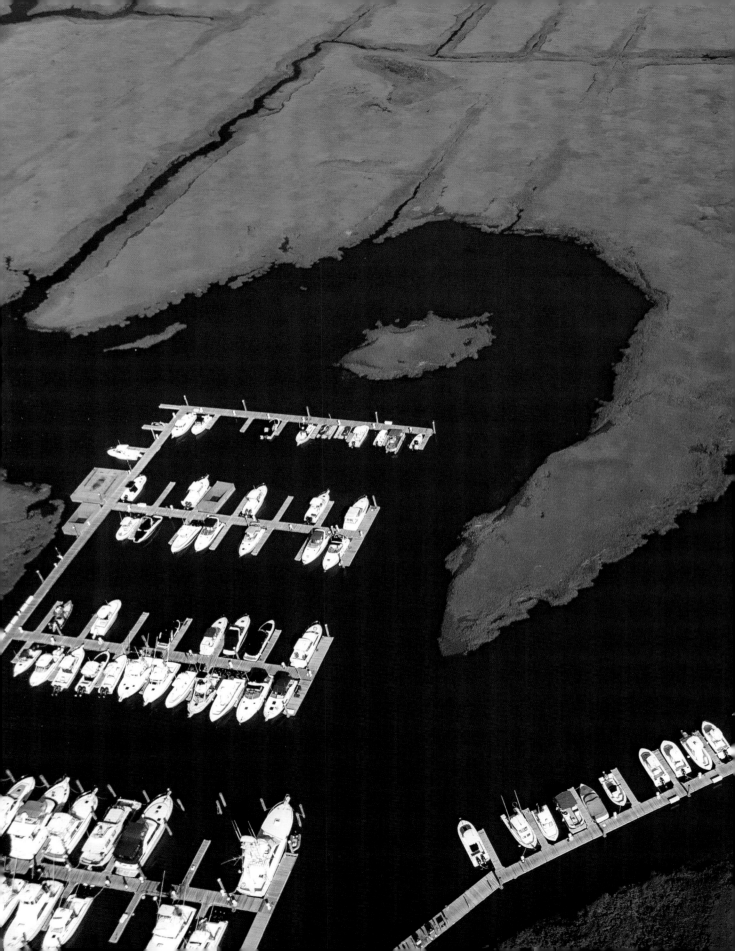

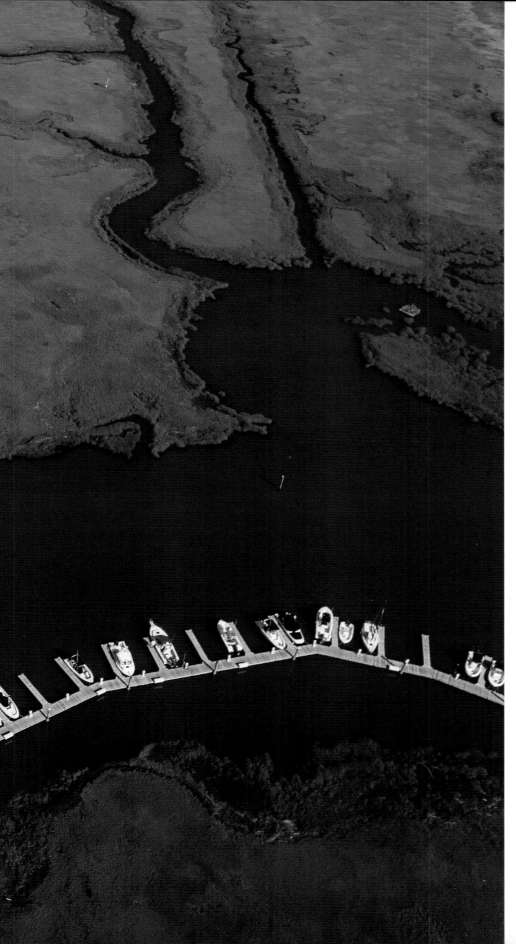

A parking lot of fishing vessels stretches into the meandering marshes of New Jersey's Delaware Bay.

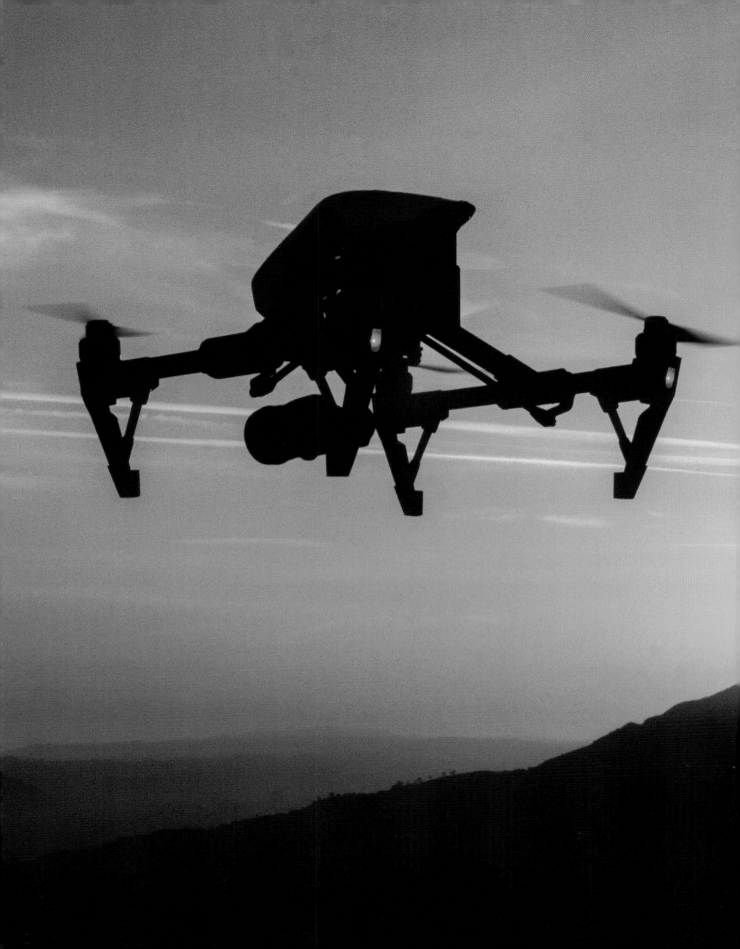

LIGHTING AND EXPOSURE IN DRONE PHOTOGRAPHY

EXPOSURE TRIANGLE

There's something lyrical about a successful photograph. A stunning image can make your eyes dance around the frame. Every little detail works together to reveal something meaningful or pleasing.

Light is the foundation of an image. In nature, light sustains magnificent plants and vegetation. In photography, cameras take in light to produce the visual matter that our eyes consume daily. Understanding the subtleties of light and the technical means by which light can be controlled is an essential aspect of the photographic craft both in the air and on the ground.

Modern digital cameras use sensors to take in the light that create still images.

Three important settings work together in your camera to create what's known as your exposure—or the amount of light that your sensor receives. Shutter speed, aperture, and ISO culminate in the "Exposure Triangle" and each setting works to control how light interacts with your sensor and illuminates your resulting frame.

To understand the "Exposure Triangle" you must understand how a DSLR camera functions. When you fire off an image, a shutter curtain opens up for a specific amount of time to expose your sensor to outside light. This is what you control with shutter speed—the length of time that the curtain is up and that the sensor receives light. Aperture, on the other hand, is the size of the opening that allows light onto the sensor. Lastly, ISO dictates the sensor's sensitivity to the light it's being exposed to rather than the amount of light it receives. Let's explore each of these settings more in depth.

Shutter speed is how long your camera's sensor is exposed to light. In most cameras, that typically ranges from 1/4000 of a second to thirty seconds. Longer shutter speeds mean more light and a more exaggerated sense of motion. By contrast, quicker shutter speeds can freeze split-second moments, but will result in less light in the resulting image. Shutter speed is an essential consideration when deciding how to best capture action. If you think about a waterfall for instance, a long, five-second exposure would

capture the water looking smooth and milky as the sensor is capturing motion over a significant period of time. On the other hand, if you're trying to freeze the individual water droplets in your frame, a quick 1/1000 of a second exposure will effectively capture the droplets frozen in mid-air. Most DSLRs and advanced camera drone attachments allow you to fine-tune shutter through two different camera modes. For one, in manual mode (typically denoted by an 'M') you can adjust each of the three settings that form the "Exposure Triangle." In shutter priority mode (typically denoted by an 'S'), you can specify a shutter speed and the camera will automatically adjust the other "Exposure Triangle" settings to create what the camera's electronics believes to be the most competent exposure. Obviously, a drone in motion requires a much faster shutter speed than an UAV that's securely hovering and a drone without a gimbal requires a much quicker exposure than an UAV with one. If your drone has a gimbal capable of reducing vibration and is able to stay stably suspended in the air, you have some artistic choices. First, wind plays an important role in any calculation you make with regards to your drone's shutter speed. Ask yourself: How still is my UAV holding its position in the air? The more stable the drone, the better your camera can capture longer exposures without unwanted blur. If your drone is holding steady in the air, consider whether you

want to capture a split second in time or an elapse of time. It may take a bit of experimentation at first to figure out the feeling you're trying to convey or the aesthetic you're endeavoring to capture, which is why you can always allow the camera to expose for you in automatic mode (typically denoted by 'Auto'). Luckily, more advanced commercial drone models, like DJI's Inspire 1 series, allows you to review images while you're still flying. With these systems, you can adjust your camera's settings to correct your exposures and compositions mid-flight.

On the ground, sharp long exposure photography usually starts and ends with a tripod. Tripods serve to keep your DSLR incredibly stable, so only intentional movement is captured while the shutter remains open. Of course, you cannot work with a tripod while you're airborne. Modern UAVs employ GPS technology to keep their position stable in the air during poor weather and strong winds. However, the slightest movements can become apparent in a long exposure frame. If you're trying to capture sharp long exposure photography from the air, you typically need to operate in the daytime with calm weather and little to no wind. In addition, experiment with a variety of shutter speeds. Depending on the movement you want to capture, $1/30$ to five seconds will do, but try not to stick to a single shutter speed—give yourself a variety of options to work with as different

shutter speeds can convey different moods by capturing varying degrees of motion. Also, take as many photographs as possible. Flip your integrated camera or DSLR to burst or continuous mode to snag numerous images at once. If you take enough frames at the right shutter speed, you'll eventually capture a photograph free of unwanted blur. Lastly, you can fight undesired blur with distance. By hovering away from your image's stationary focal points, you can lessen the appearance of undesired movement.

As mentioned, aperture is the size of the opening that the camera allows light to pass through to reach the sensor. The size of that opening is measured in fractions. Aperture commonly goes from f/2 to f/22, where f/2 is a LARGER opening that lets in more light and f/22 is a SMALLER opening that restricts the volume of light (remember we're dealing in fractions). In addition, aperture affects your image's depth of field, or the portion of the frame that's found to be in sharp focus. This is of particular importance when you're trying to control your background. Through depth of field you can separate your foreground and background whether you're trying to emphasize a nearby focal point or deemphasize a distant one. On most drone configurations, creating an easily evident shallow depth of field is difficult. Firstly, wide angles lenses are used on the vast majority of camera drone models. Wide-angle lenses tend to compress

distance within the frame, which creates the very opposite effect. While proximity flying can help combat this effect, drones are still prone to crashes and hovering near a stationary object isn't really recommended. Instead, if your set-up allows for it, throw on a zoom lens to create the desired effect. Note that only a very small selection of commercial drone systems makes flying with a cropped lens feasible. Also, newer commercial models with larger sensors like the Inspire series by DJI are better able to render shallow depth of field imagery. Lastly, be mindful that it's harder to achieve depth within your photograph when your drone is flying at a very high altitude or its camera is facing straight down. In these two situations, the photograph can often become one-dimensional, particularly if you're shooting with the default wide-angle lens. By pointing the camera up a bit and shooting to the side of your subject, you can layer your images more harmoniously. To achieve the greatest range of sharpness, use a smaller aperture opening (often ranging from f/8 to f/22) and to narrow the plain of sharpness utilize a larger aperture opening (often ranging from f/1.4 to f/4). In aperture priority mode (typically denoted by an 'A'), you can specify an aperture setting and the camera will change the other "Exposure Triangle" settings to create what it believes to be the best exposure. Note that a lot of drones have low fixed apertures, which permits a lot of light to reach

the shutter. Therefore, be mindful that you may need a very quick shutter speed or even a Neutral Density filter to keep your frame from being overexposed.

ISO determines the camera sensor's sensitivity to the light it receives. In other words, the higher the ISO, the brighter the final image will be and vice versa. If you're photographing on a bright day, ISO can be dialed down to the lowest number. However, suppose you're trying to capture a low-light scene. ISO will likely be central to any well-exposed shot taken in a low light setting. While you shouldn't be afraid to crank your camera's ISO as needed, be aware that a high ISO can create image noise or pixilation in your final frame. This issue is especially evident with UAV technology because the vast majority of camera drones still use small sensors that are highly susceptible to these problems. Considering the negative effects of a high ISO, you should typically attempt to adjust the camera's shutter speed and aperture settings first. If you're still unable to create your desired exposure with just those two settings, raise the ISO as needed.

GOLDEN HOUR
The vast majority of amateur photographers make their images mid-day, when the sun bares harsh light on the Earth below it, often culminating in ugly shadows and unevenly lit landscapes. This

is because people are typically out and about near noontime, when outside light seems to lack any semblance of subtlety. Because light is a crucial ingredient to every photograph, chasing and capturing dazzling light is a central pursuit for most professional photographers. This is why golden hour and blue hour are special times of the day for the visually inclined. These time periods often bring forth extraordinary lighting that's preferable to the shadowy horrors of the noonday sun.

Golden hour refers to the soft yellow-tinted light that fills the skies as the sun begins and ends it journey across the horizon. Each day, as the sun rises and sets, the sky has the potential to become almost magical. On clear sky days, capitalizing on this lighting is key as there are some special qualities to golden hour that makes photography particularly alluring. For example, when you're hovering parallel to a city skyline, you can capture a descending sun's twinkling reflection on the glassy façade of tall buildings. If you train your flying camera on the dwarfed elements below, you can tinker with the geometry of the elongated shadows caused by the shapes of figures. When you're in the air, the sun can even become a major element of the exposure. Experiment with positioning your drone to capture the sun peeking out of the clouds or other prominent objects within the frame. In addition, use

this time period to seek out exceptional silhouettes, as objects can become striking shadowy outlines when you're willing to shoot towards the sun. Golden hour is also preferable to afternoon lighting because colors become richer as the sun slowly dwindles. The interplay of lightness and darkness is simply a wonderful sight that you should take advantage of as a drone operator. To capitalize on this time period, research the exact time the sun is expected to set and be ready to be in the air 30-minutes ahead of the light's disappearance. Remember that the sun tends to linger a bit longer when its beauty is viewed from a high altitude.

BLUE HOUR

Before golden hour in the morning and after golden hour in the evenings, there is another special stage in the day's light. This period, called blue hour, is when vibrant blue hues take over the sky. By carefully watching the skies during this time, you can see a whole slew of vivid shades engulf the atmosphere, from the lightest tints to the darkest hues of blue. Contrary to popular belief, the sky doesn't instantly transition from light to dark upon the disappearance of the sun or moon. Rather, the sky evolves from light to blue to dark in the evening and dark to blue to light in the morning. Blue hour is wondrous because it's one of the most reliable times when lighting is exceptional. No matter the day's weather, be it dense clouds, rain, or snowfall, you can expect the heavens to fill with vivid indigo hues for blue hour. As a travel photographer, I use blue hour to ameliorate the effects of a dreary day. When you're on the road or in a place for a short stretch of time, sometimes you just have to make pictures despite the weather. Blue hour gives you the perfect window to create the imagery that you need. It reaches its visual climax when artificial light seems to harmoniously balance and resonate with the cobalt skies above. Moreover, with natural light limited to the dark hues of the sky, it's imperative that you work with bright, artificially lit focal points within your frame. Towns, villages, and cities are fantastic to photograph during this time frame. Lit-up architecture is accentuated by the dark colorful skies overhead and the city streets are typically emptier than usual, adding a haunting sense of drama or quiet to a still frame. Depending on the season, the weather, and your location, blue "hour" ranges in length from a few meager minutes to hours of prolonged sapphire skies. In short, effective blue hour photography really comes down to creating rich tonality in your images, which is why I'll always be on the lookout for incredible lighting in the aftermath of a sunset or at the commencement of the day.

WEATHER

Weather has a tremendous effect on the skies that you have to navigate and

the images that you're capable of framing with your UAV. As intense weather systems move across a landscape, the heavens begin to darken and our airborne camera is well primed to capture the intense contrast between the gloominess of the atmosphere and the elements that color the ground. Weather helps to develop yet another type of extraordinary lighting phenomenon—one that should be cleverly capitalized on without comprising the safety of your aircraft. While most unmanned aerial cameras can deal with moisture from mist, rain, or snow in small doses, remember you're operating a sensitive, highly electrical system. You should always use your best discretion when deciding to take flight in poor weather and remember no single image is worth the risk of a crash.

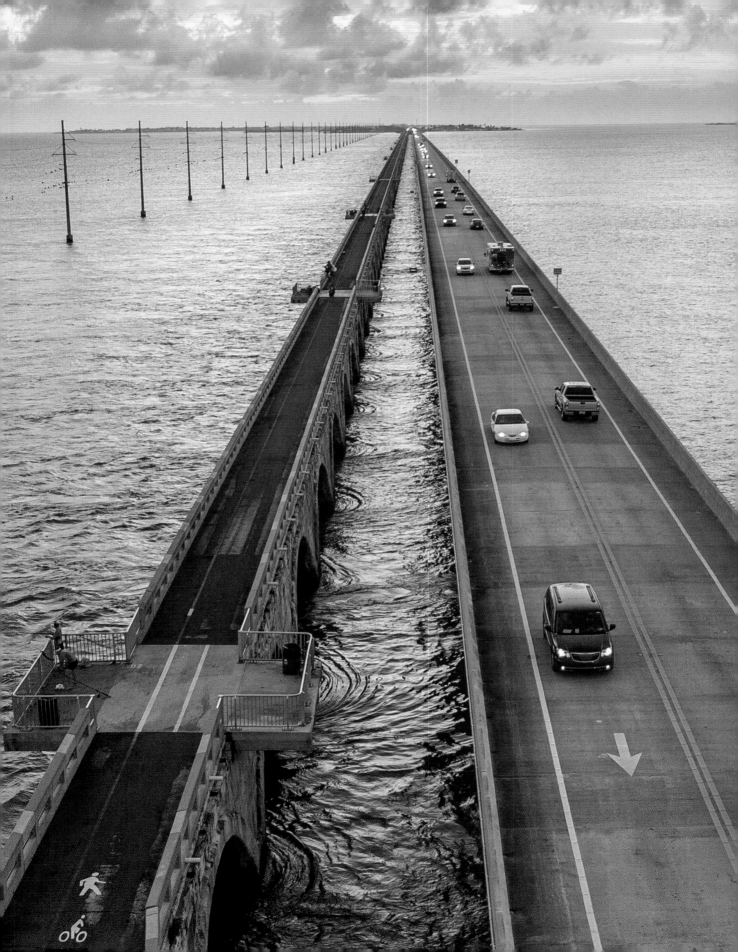

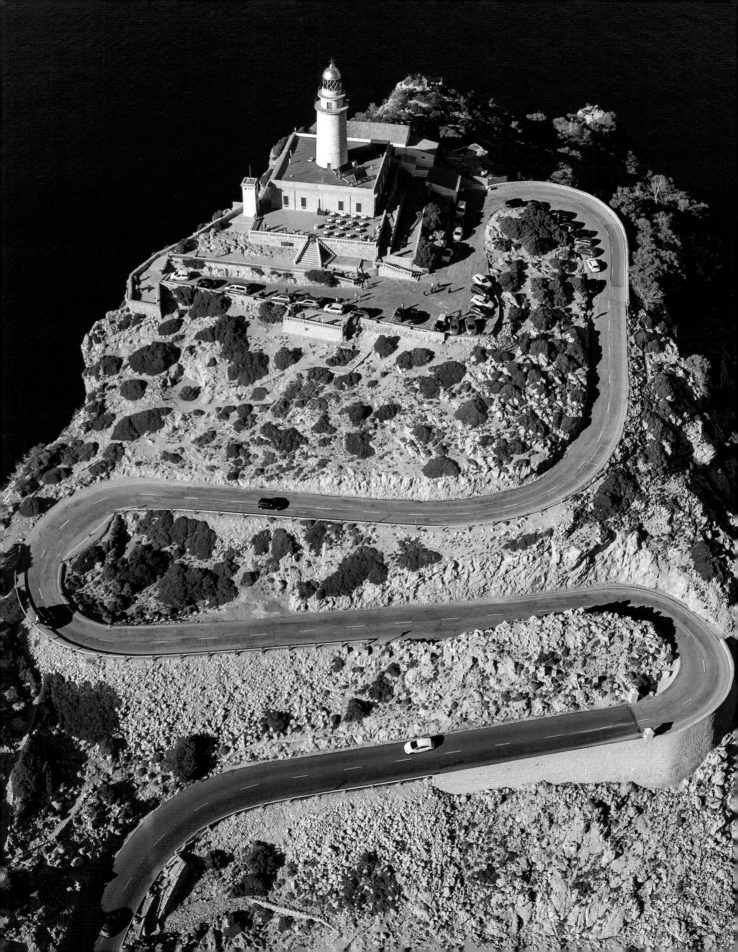

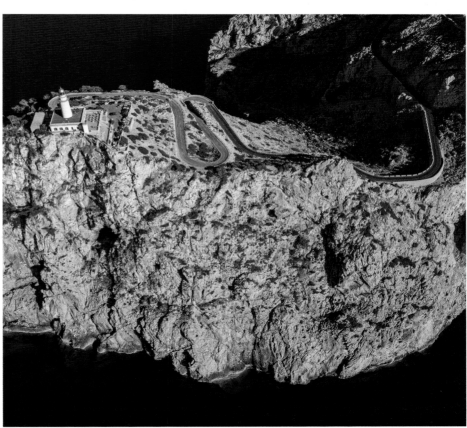

Crowning a Mediterranean cliff, the Formentor Lighthouse stands atop a serpentine ribbon of Mallorcan asphalt.

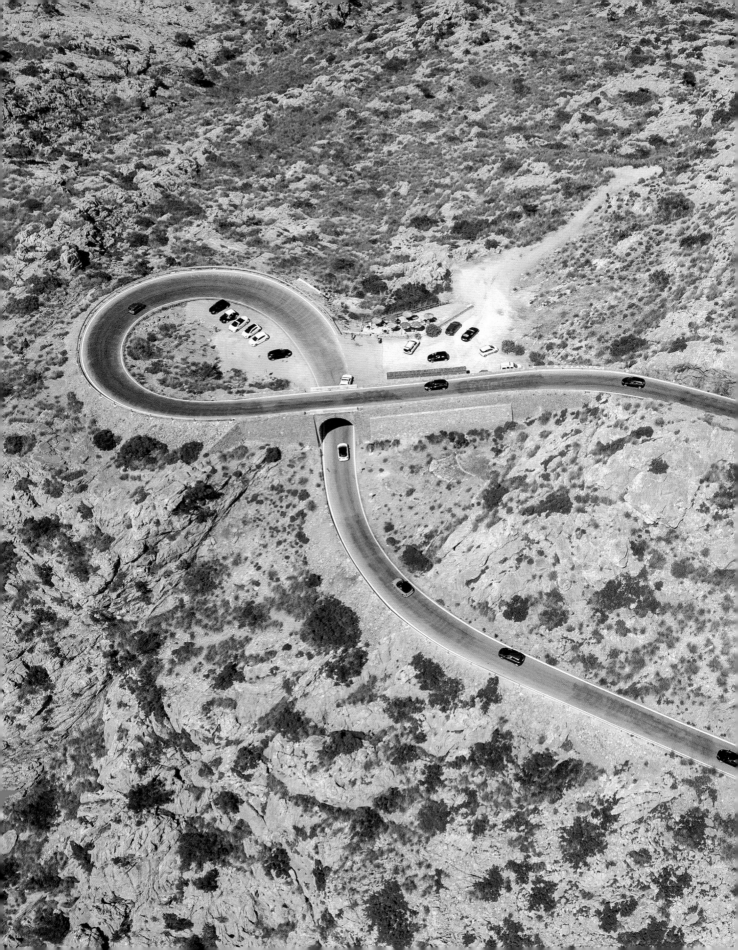

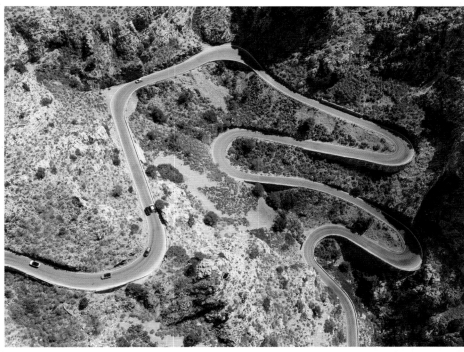

A swirling cluster of twisting pavement guides vechicular traffic through the towering Serra de Tramuntana in Majorca.

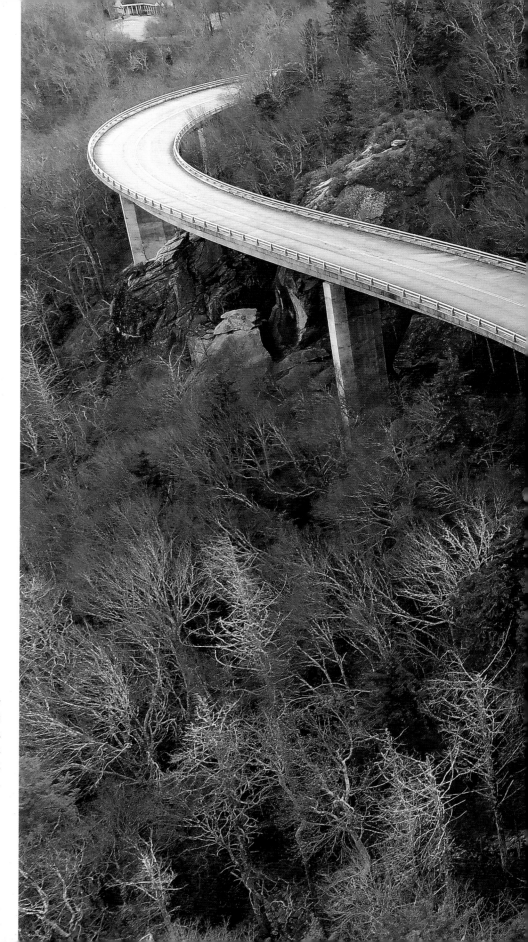

Delivering the family Christmas tree, a red pickup truck traces the curving contours of North Carolina's Grandfather Mountain.

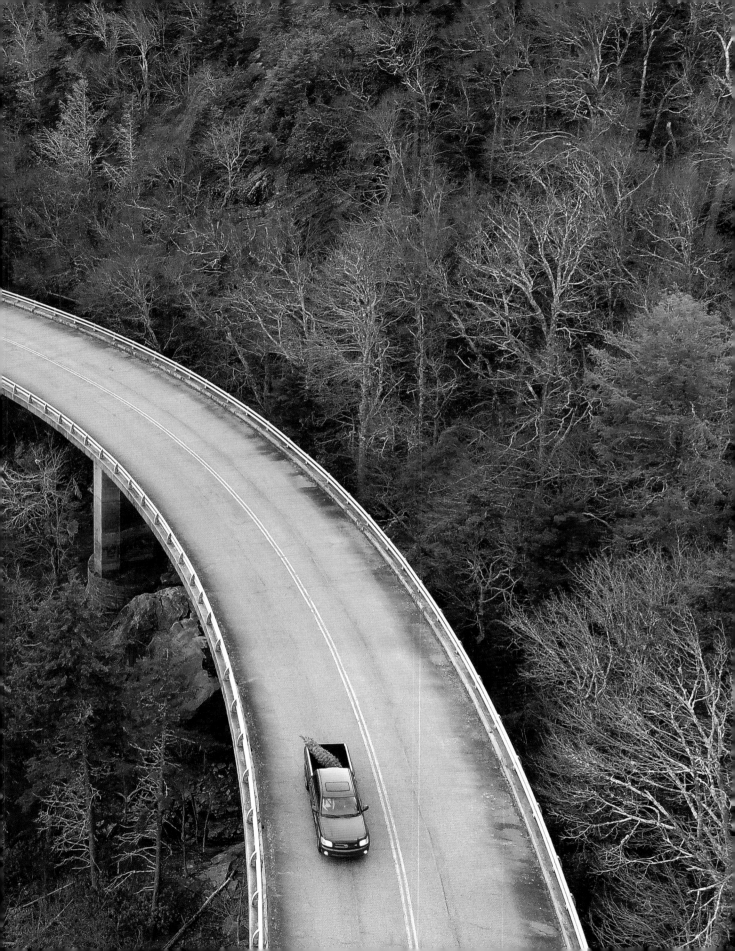

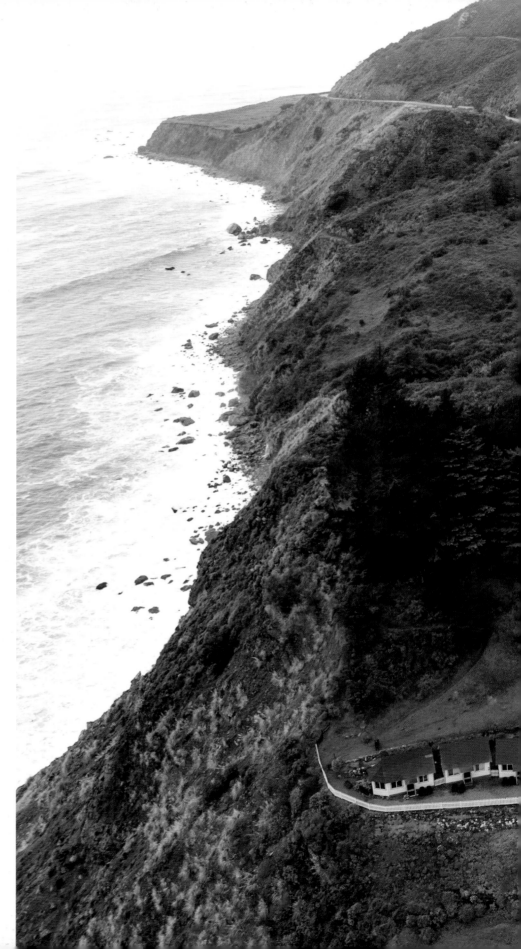

The rambling Pacific Coast Highway stretches past small, cliff-side, ocean-view lodges and lush hills.

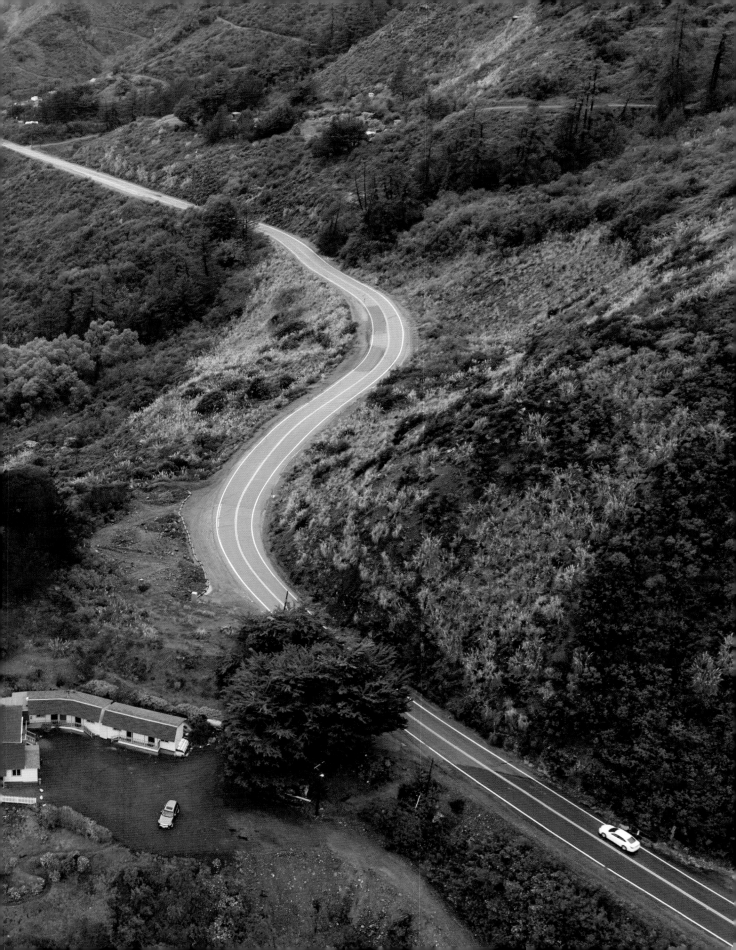

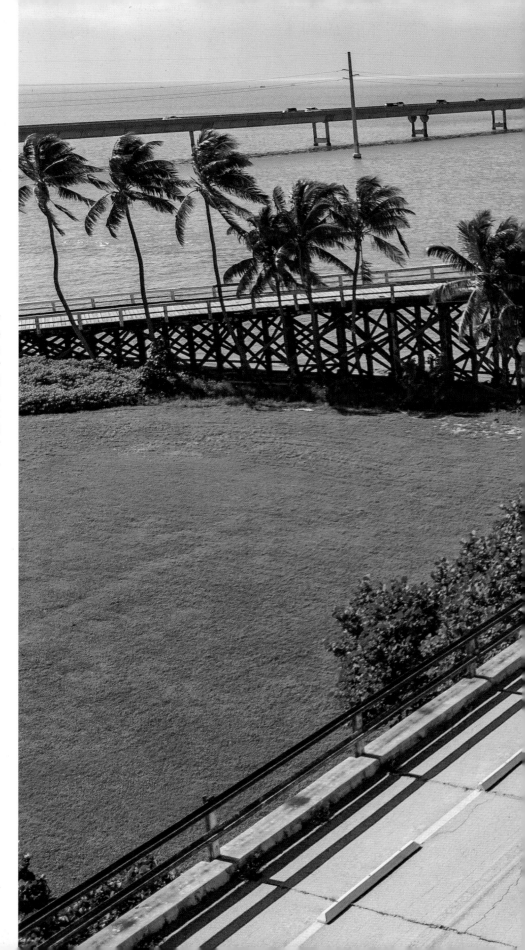

The Overseas Highway makes its seven-mile journey across acqua tinted waters and over Pigeon Key, an island that housed the workers who built this landmark pathway, once coined the Eighth Wonder of the World.

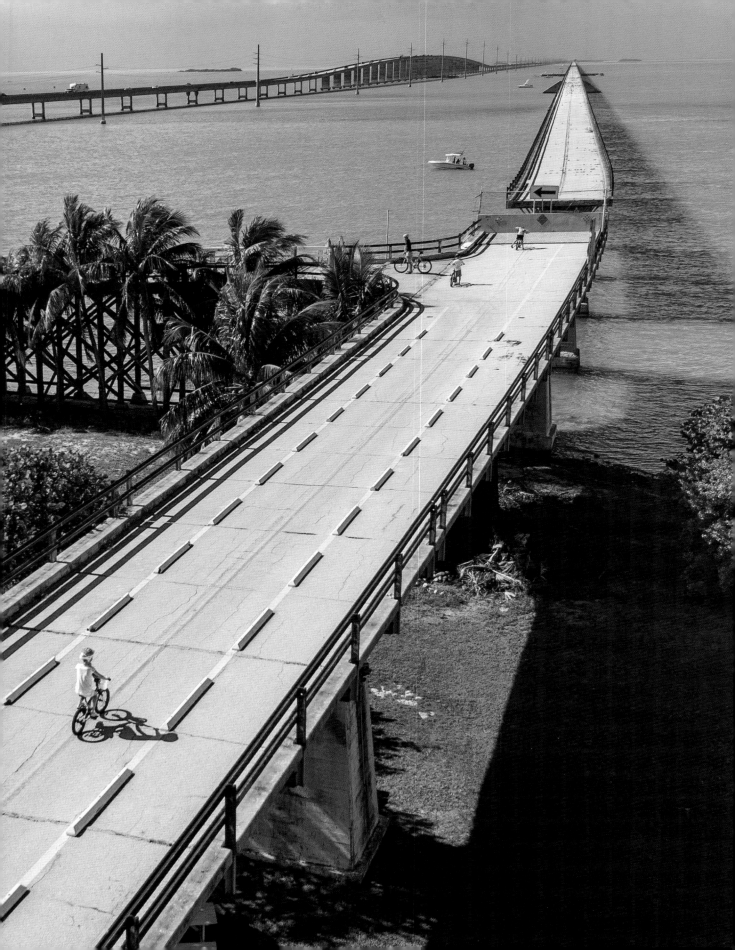

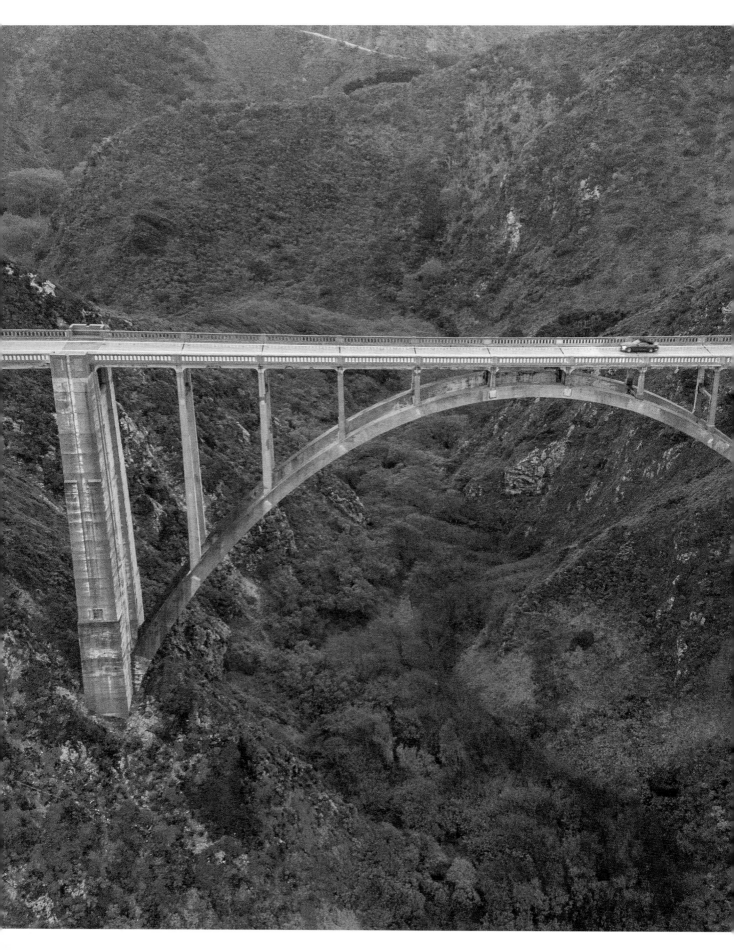

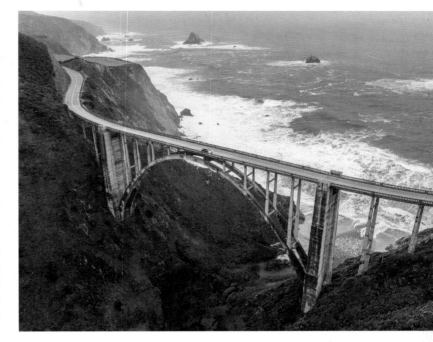

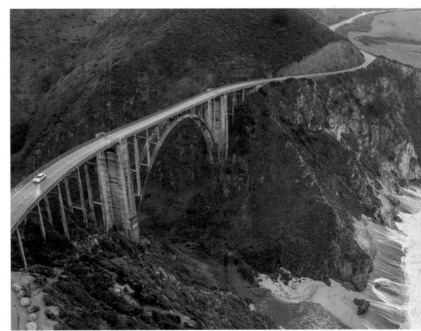

The drama of Bixby Creek's famous deck arch bridge has inspired countless car commercials.

An antique checkered taxi cab passes a popular amphitheater vacated by a sudden afternoon drizzle in New York's Leatherstocking District.

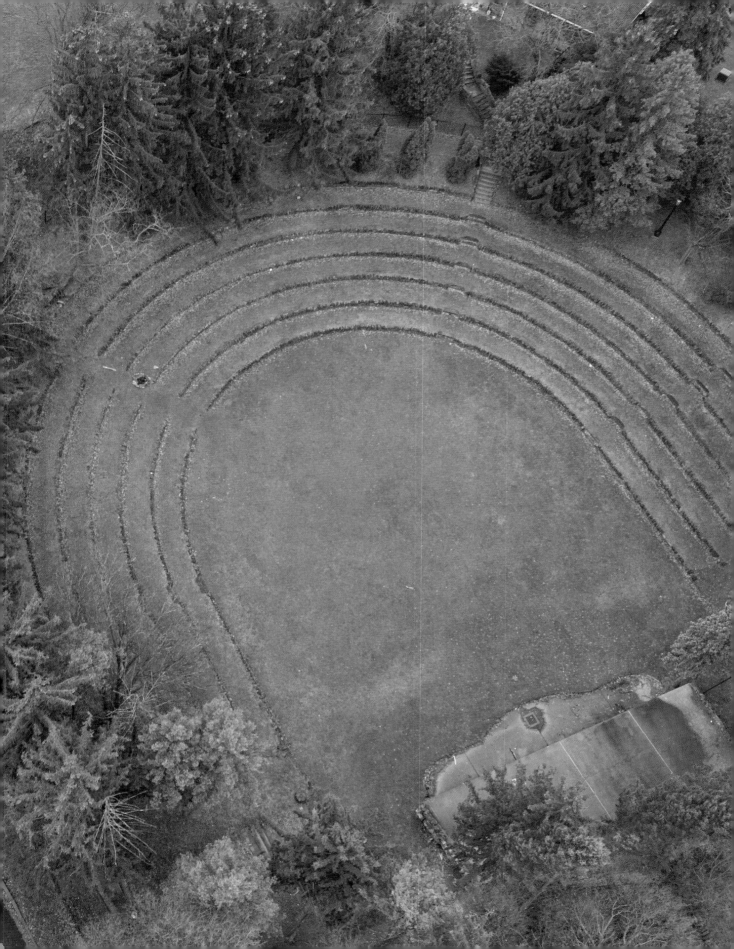

Crooked country roads run
parallel to rapids churning
in the river valley below in
Upstate New York.

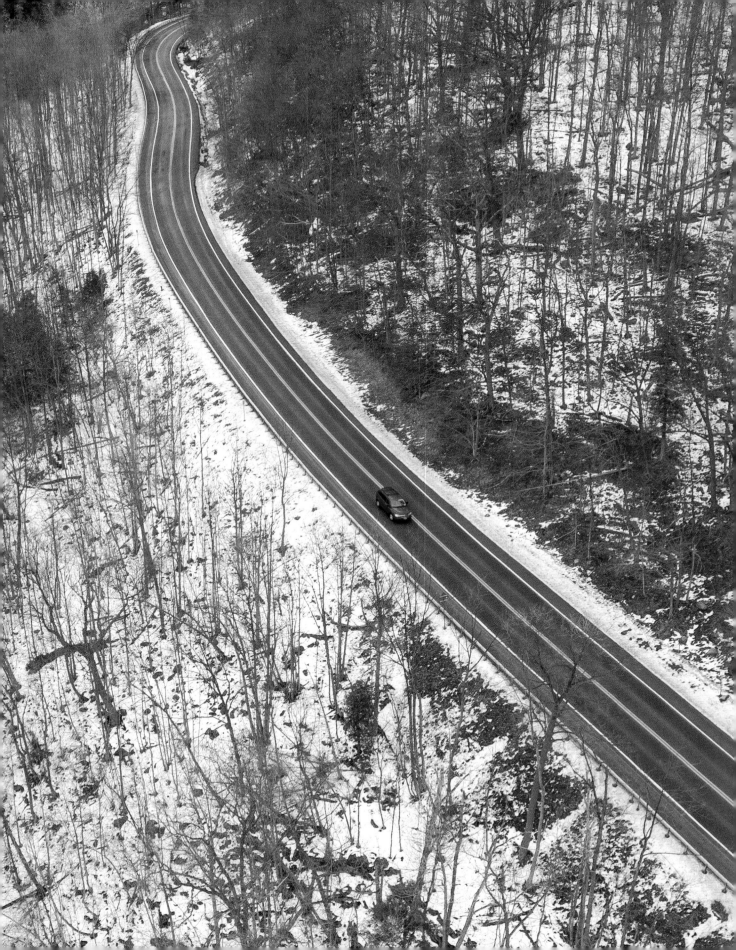

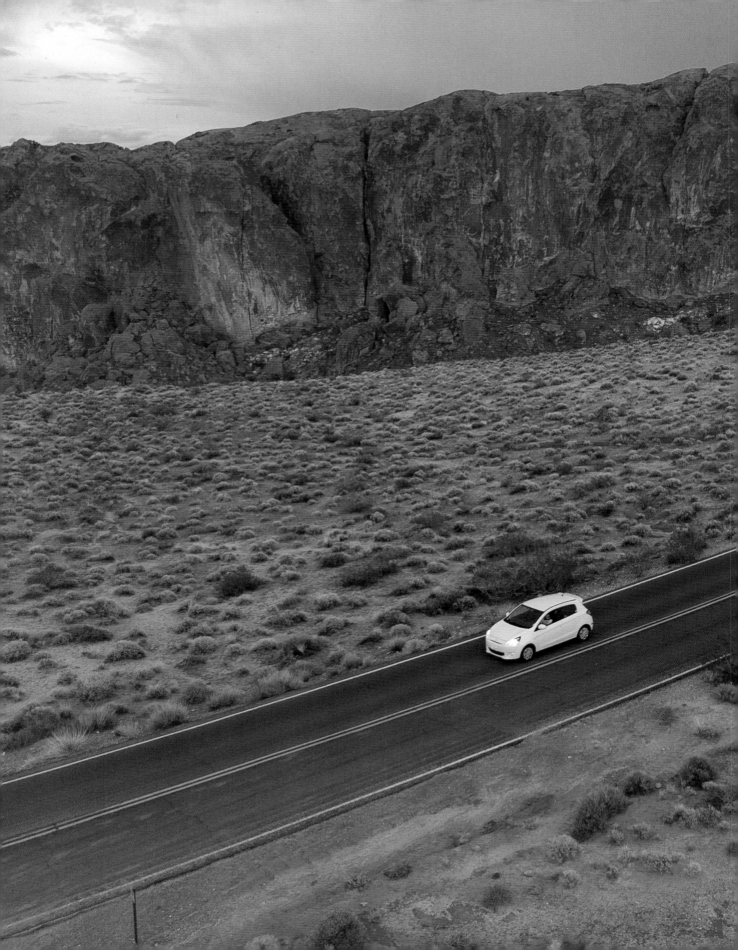

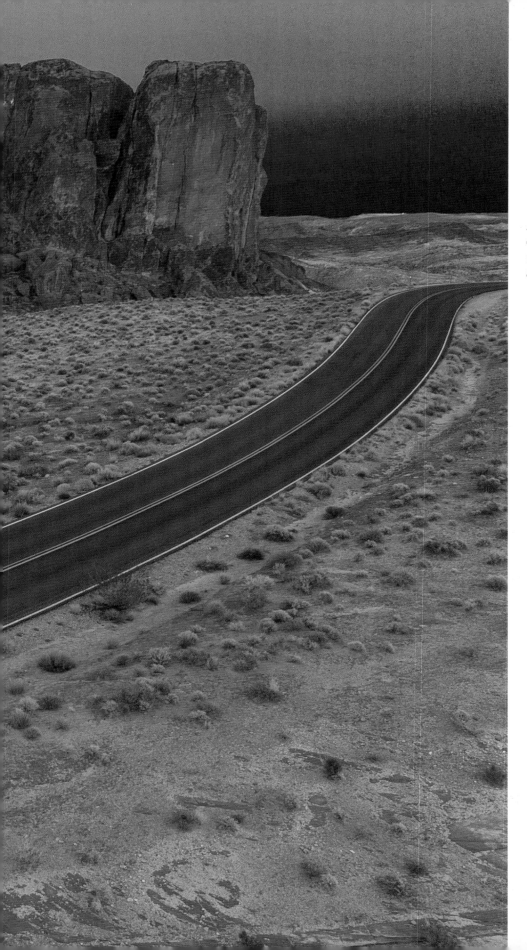

A lone car navigates circuitous Nevada roads past massive rock structures and water-deprived plant life.

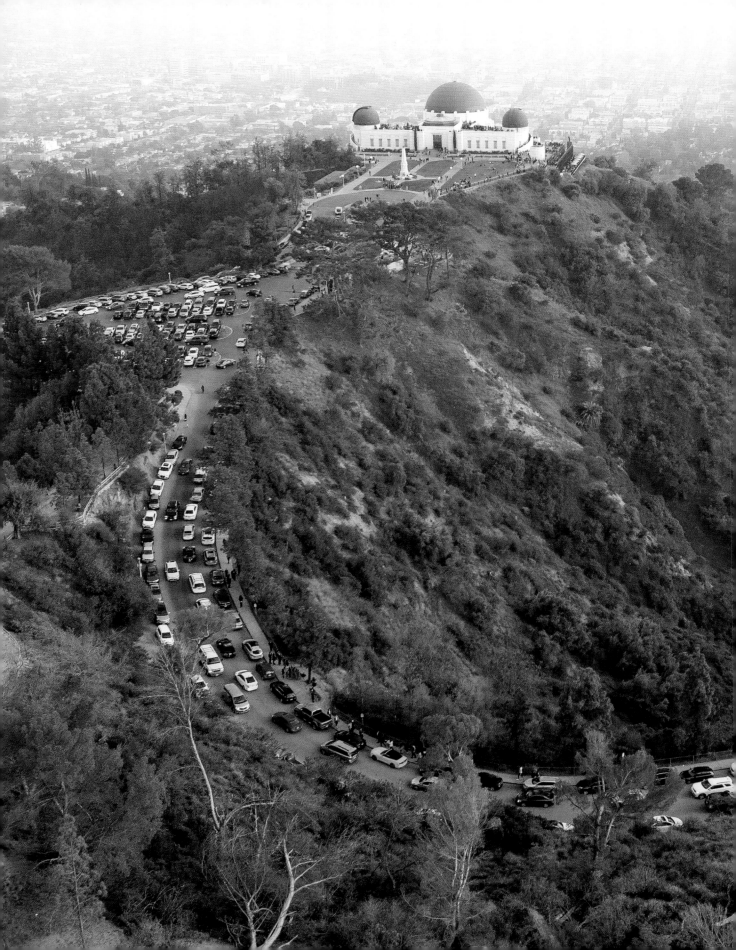

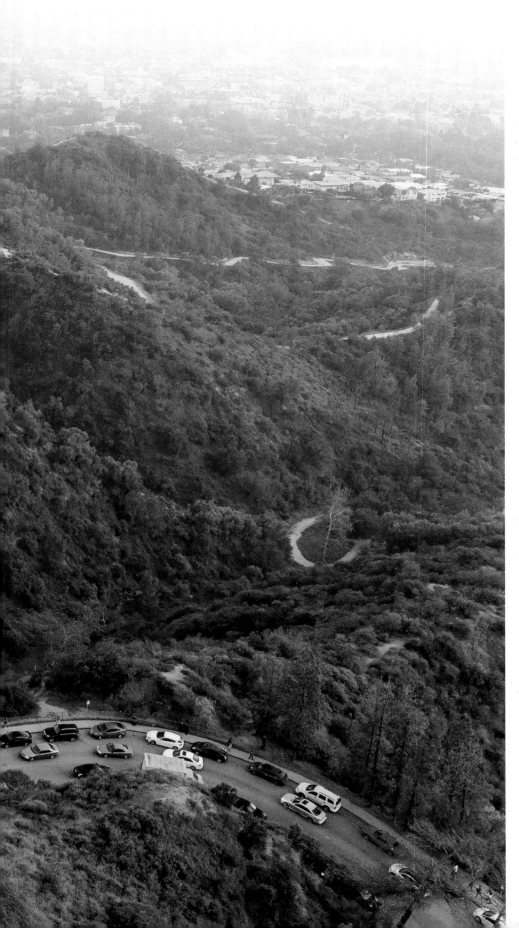

Conspicious traffic chugs through the Hollywood Hills as fog rolls toward the Art Deco Griffith Observatory.

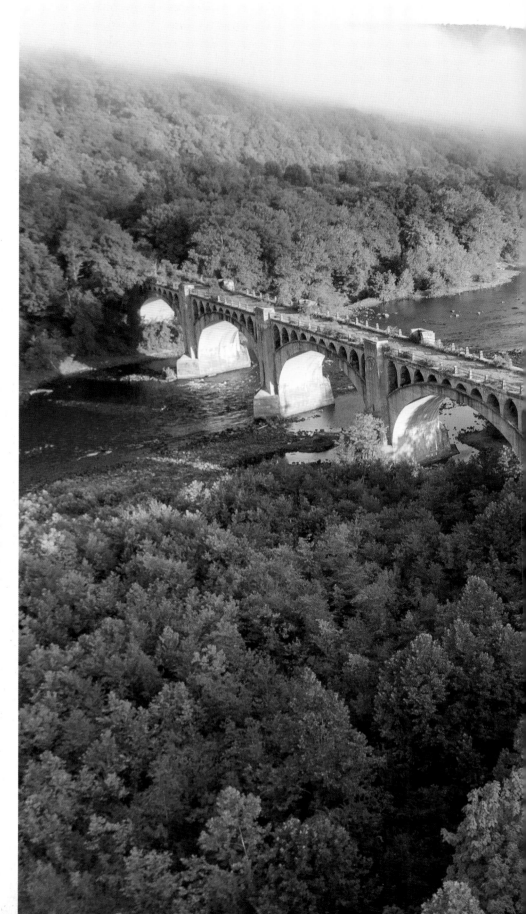

Dawn's mist blankets
the Delaware Valley
as morning traffic
whooshes past a
decrepit viaduct.

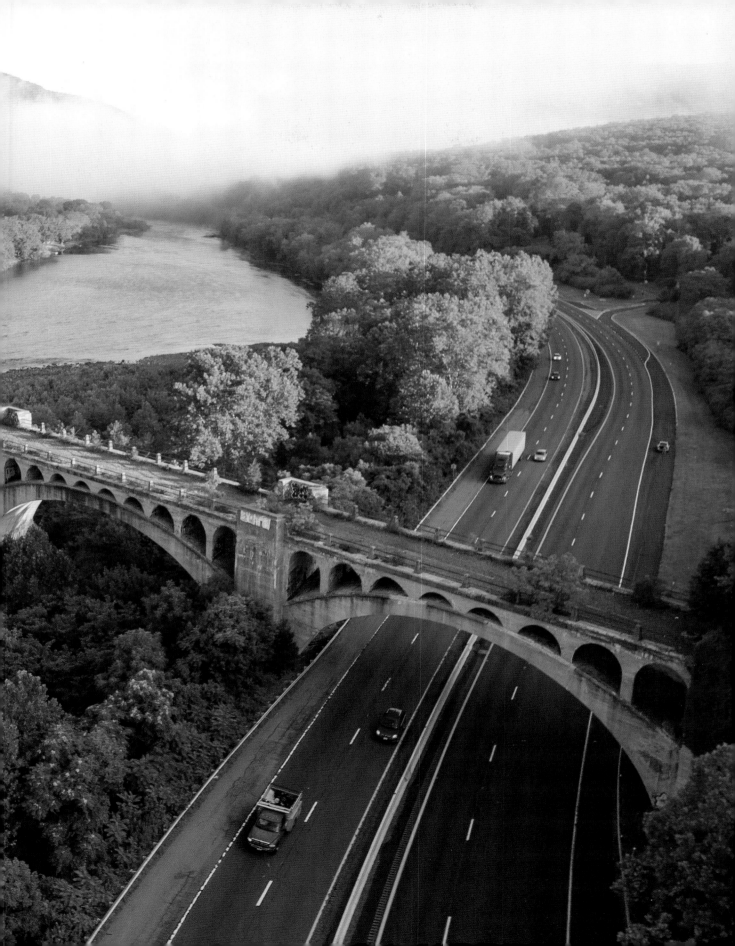

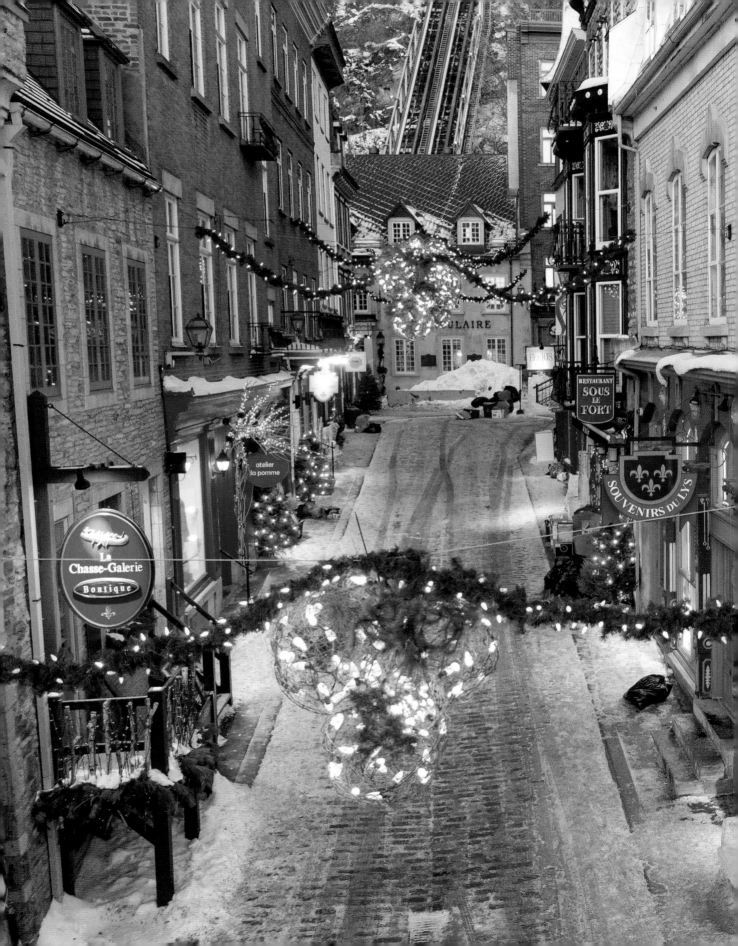

Snow dusts the quaint alleyways of Old Quebec, a UNESCO World Heritage Site founded by Samuel de Champlain in the 17th century.

On the outskirts of Los Angeles proper, a lone biker slithers through the chaparral-lined trails of Cherry Canyon.

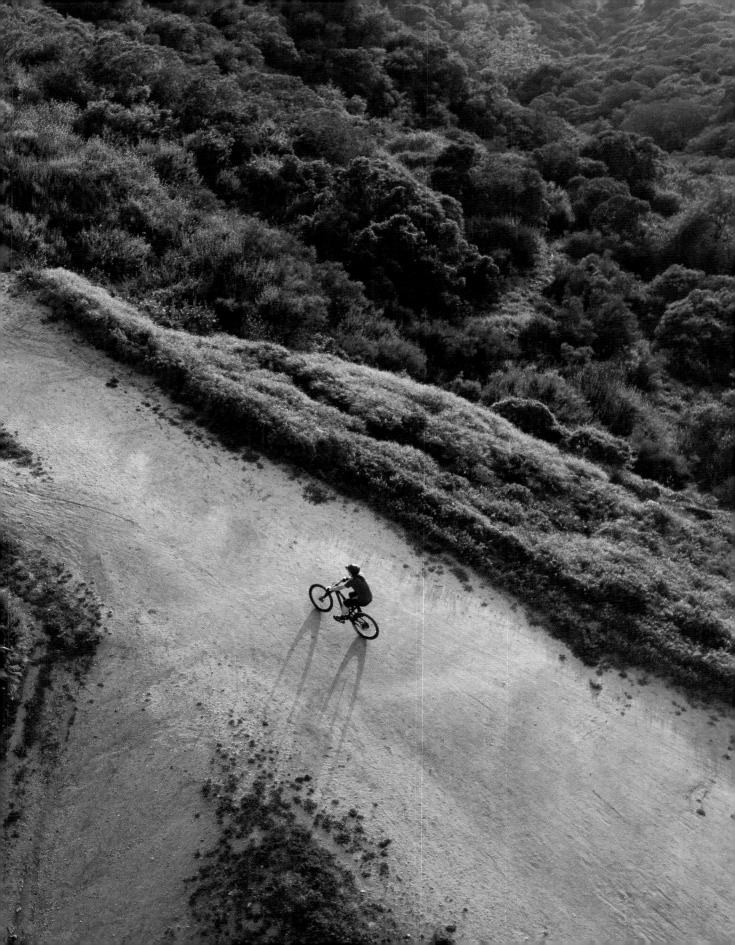

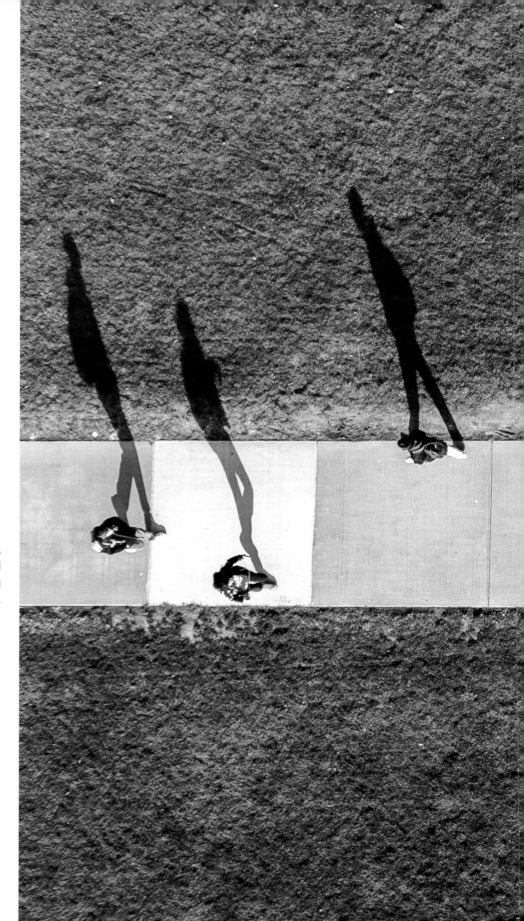

Lengthy shadows
give chase to hurried
pedestrians stepping
in mimmicked strides.

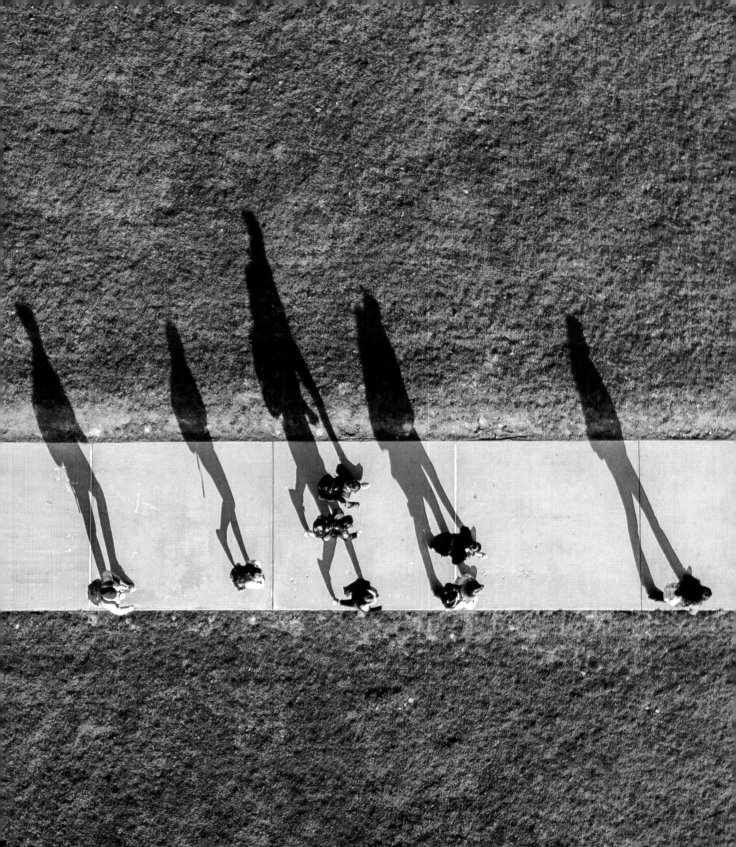

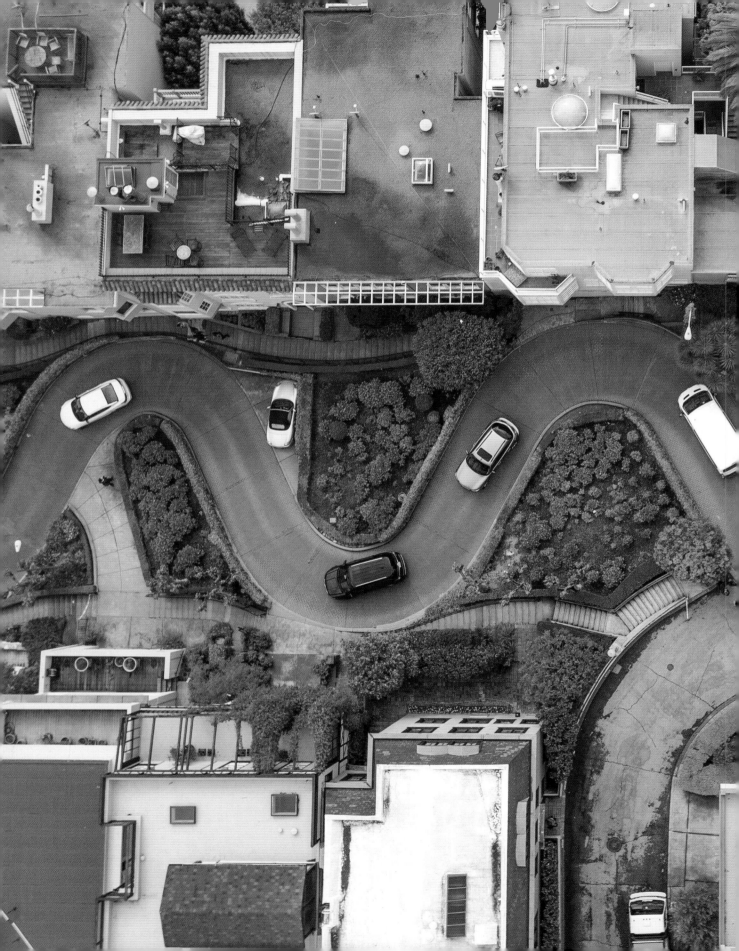

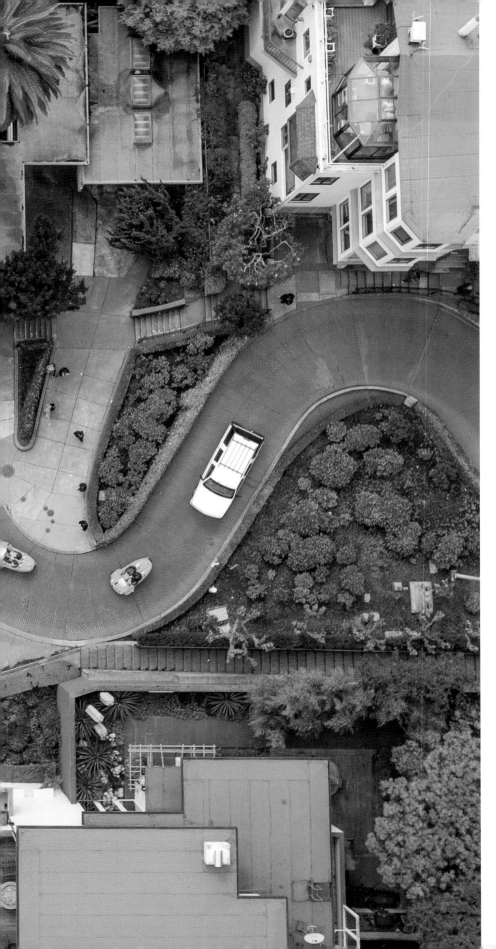

Vehicles negotiate a series of dramatic hairpin turns along San Francisco's Lombard Street—one of the crookedest lanes in the world.

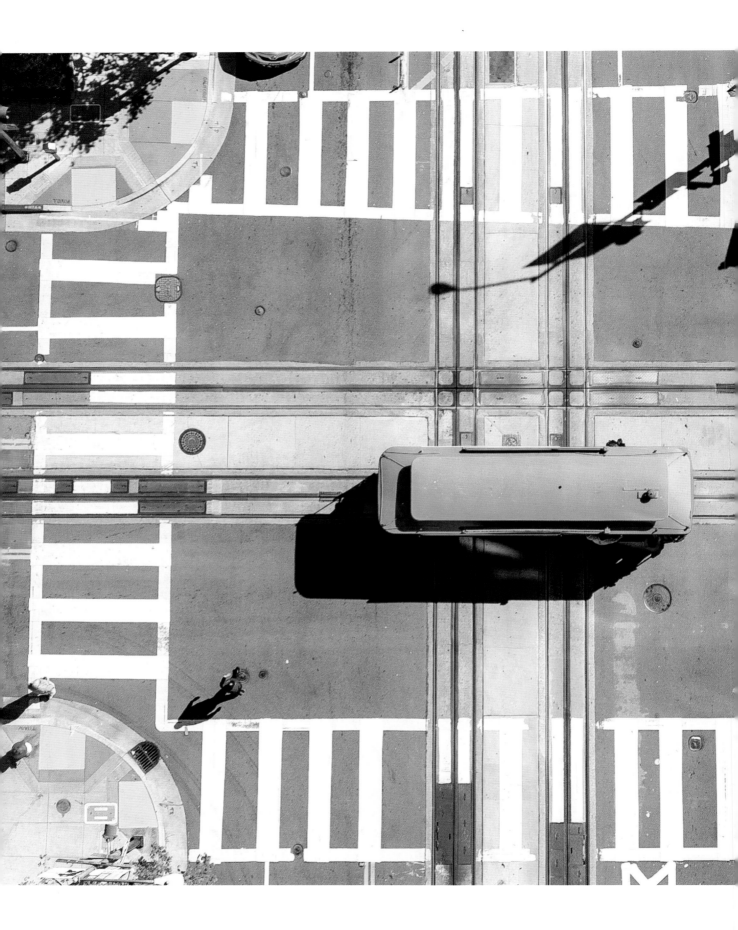

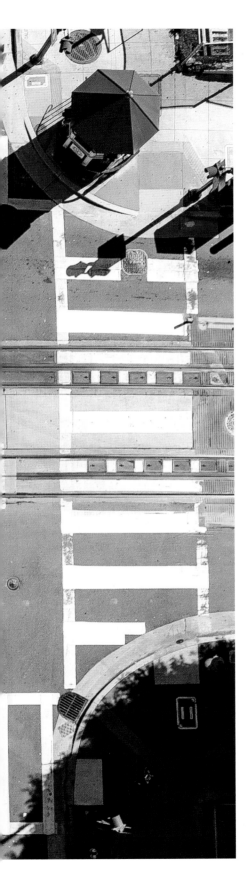

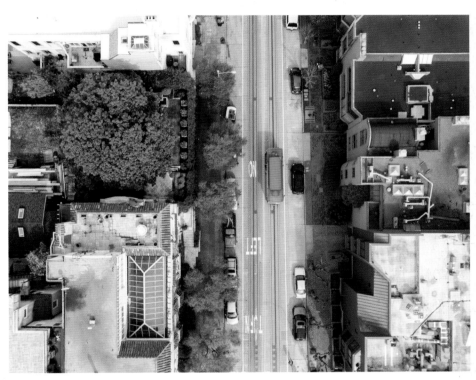

(above) Approaching a steep boulevard, a crimson vehicle is part of the last manually-operated cable car system in the world.

(left) Rumbling through a four-way intersection along San Francisco's California Street, a cable car begins its final descent toward the bay.

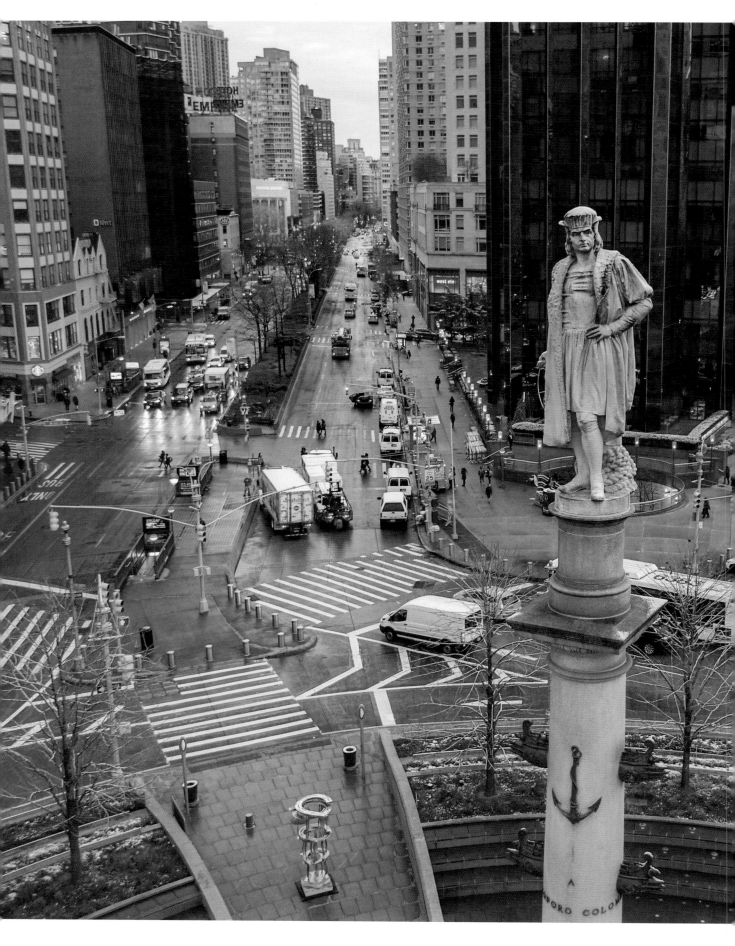

Taxis circumnavigate Columbus Circle, as avenues from every direction converge at this historical intersection.

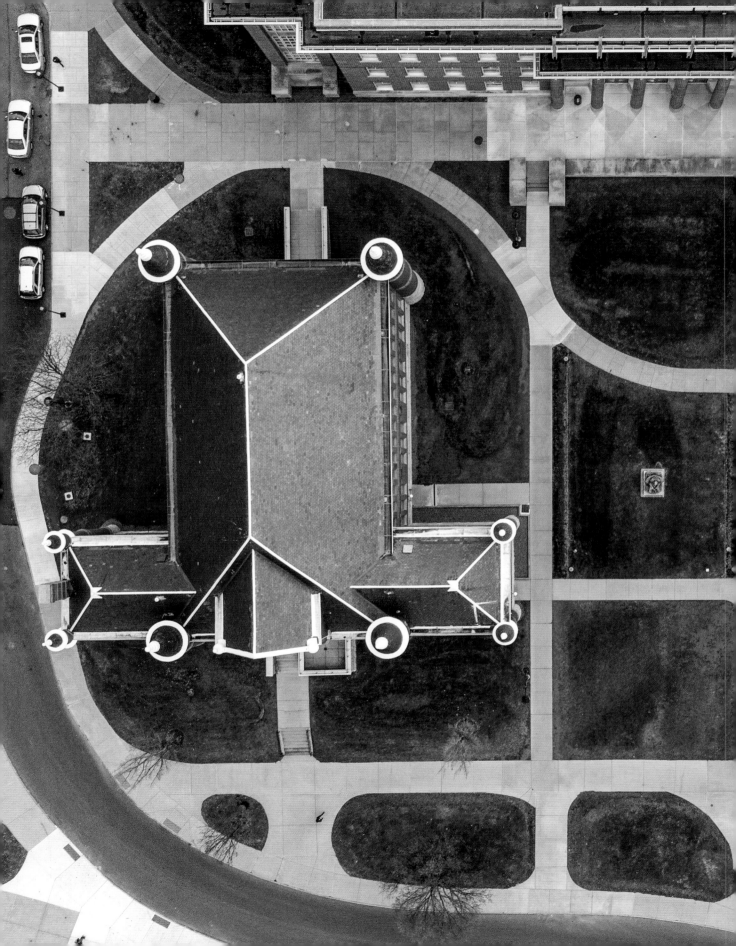

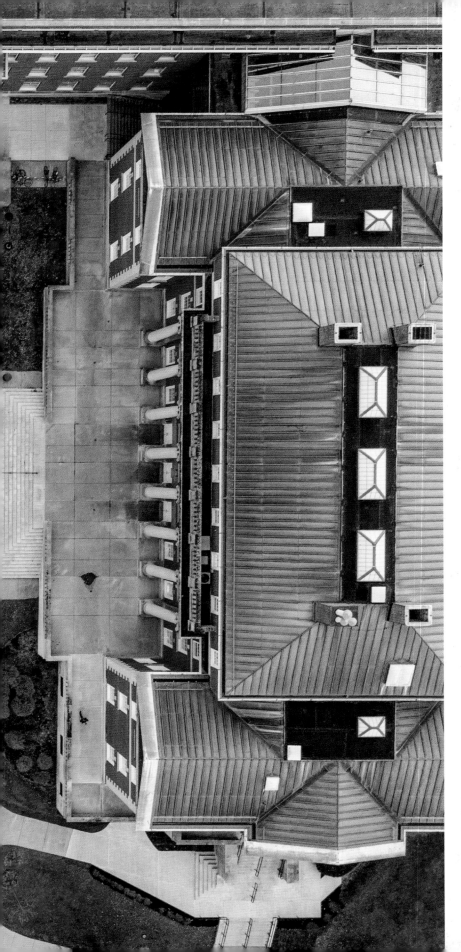

A winding system of pathways connect ornately-styled academic buildings.

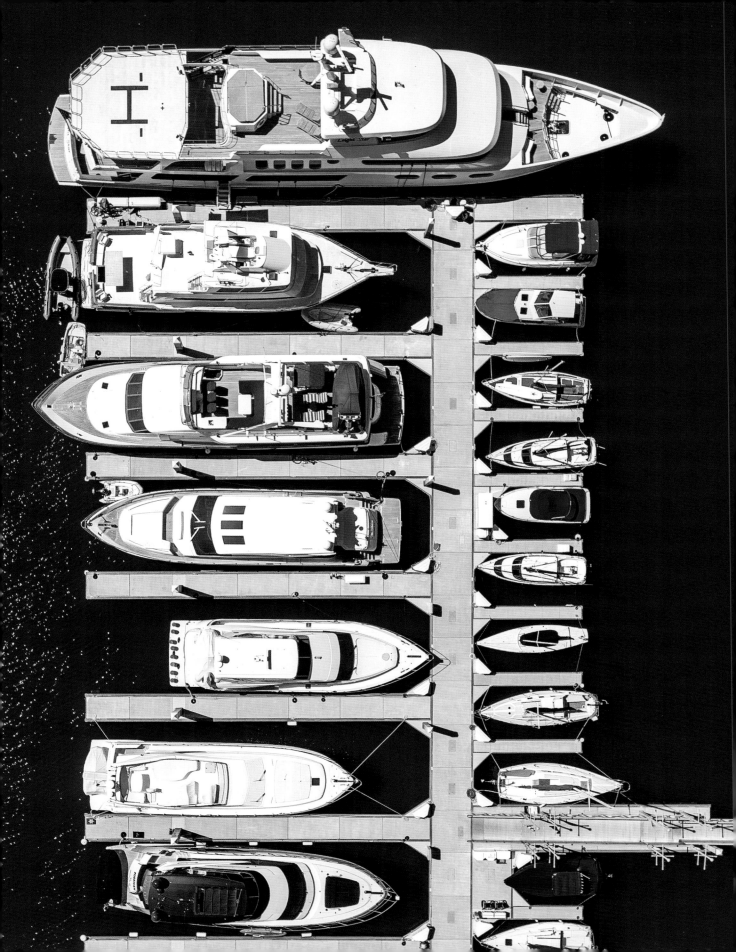

COMPOSITION IN DRONE PHOTOGRAPHY

VISUAL STORYTELLING

Composition is paramount. The interplay of aesthetically pleasing focal points is what often culminates in a successful and complete photograph. With drone photography, the pursuit of compositional excellence begins before you even take flight. You must understand the visual nuances of the world in front of you, so that you're able to use your aircraft to extenuate a scene's finer subtleties. Scan the horizon for patterns. Identify rich textures. Seek out visual drama that only a different perspective can bring to life.

The ultimate goal of a photographer is to tell an engaging, visual story. Our ability to accomplish this objective depends on the way we orchestrate our canvases. Composition is all about the process of visually organizing the essential elements of an image within the deliberate framing of a camera. Composition is what anchors a person's vision as they scan an image, and as a result, it enables photographers to direct the eyeballs of their viewers. In short, the way our visual artistry is aesthetically received is dependent on how a scene is organized, framed, and composed. This is why composition is often the main pillar of captivating photography.

An effective composition simplifies a complicated environment by isolating specific portions of the scene and bringing forth visual order. Unlike how our eyes experience a scene, where the cornea is able to analyze every inch of our surroundings and periphery, photographers must squeeze a visual experience into the confines of a miniscule rectangular-shaped frame.

FOCAL POINTS

The type of visual experience that we craft is very dependent on the use of focal points. Focal points are emphasized elements within a frame that are designed to grab a viewer's attention and are destined to become a major area of interest. They are central to an effective visual narrative because they can compel your viewer to delve deeper into your photograph. If an image lacks a dominant focal point, its visual message is likely being

lost to clutter or lack of artistic clarity. Strive to create an intentional visual hierarchy that elevates focal points that are key to your story and eliminates elements that detract from your message. Visual hierarchy is established by the size of your focal point, its positioning within the frame, focus, color, and lighting (whereby the brighter portions of the frame commands the eye's attention first). By giving certain elements greater visual weight, you're directing how your viewer scans the frame and progresses through your narrative. Moreover, you can use focal points of varying visual weight to create a layered frame. Photographs with foregrounds, middle grounds, and backgrounds tend to be more visually tantalizing than one-dimensional images because there's significant depth to them. Often times, establishing that depth is a matter of having multiple focal points situated at different distances away from the camera. Lastly, pursue a series of focal elements that work to form visual balance. Visual balance is the idea that a photograph can become compositionally lopsided if its focal points are not purposefully positioned throughout the frame. It's our instinct as visual beings to try and create "balanced" frames, but most go about this the wrong way by trying to slap their subject in the dead center of the image. This is an unsophisticated approach to creating visual balance and intrigue. Rather, seek out complementary focal points that can be paired with

your subject without having to build your frame from the center outward.

FRAMING

Framing is another fundamental pillar of composition. In simple terms, framing is the way you contain all the focal points that you wish to capture within your canvas. Essentially, effective compositions include just the key elements of your image while omitting objects that don't advance the purpose of your photograph. Each element within the borders of your frame should be meaningful. Assuming your UAV system has a live view screen option, scan the edges of your image for unwanted distractions before you snap the shutter. Remember, what you decide to exclude from your frame can be just as important as what you choose to include. Your framing should help create visual hierarchy and lead your viewers to your main focal points. When you're whisking through the sky, be mindful of your aircraft's surroundings. It's incredibly easy to develop "tunnel vision" as a drone operator, where you get so fixated by a certain subject or composition that you ignore all the magnificent beauty that exists in the scene behind or below your UAV. Don't waste any opportunity you have in the air—evaluate your surroundings for superior stories, frames, and compositions and you might find something serendipitous where you never imagined. In my mind, framing comes down to two

things—focal length or lens choice and location. Lens choice and focal length work together to influence the size of the vista that you're able to capture with your camera. Lens choice is an option for a small group of camera drone models that permit interchangeable lenses. DJI's latest Inspire iteration makes lens changing feasible, but the current selection of lenses that work with the Inspire platform are still limited in their focal range. Focal length is a technical term but it essentially refers to the optical zoom that your lens is capable of, whereby a higher focal length indicates a greater crop. In other words, a high focal length (as is typical with telephoto lenses) allows you to zero in on individual components within your frame, while a smaller focal length (found with wide-angle lenses) helps add greater context to your scene. Location or distance to subject will be elaborated on when discussing other compositional concepts such as perspective.

PERSPECTIVE
The main compositional advantage that you control with your UAV is perspective. Soaring hawks use height to identify miniscule prey dashing for cover far below them. As a visual storyteller, you must think like a bird and use the sky as your creative edge. Altitude allows you to survey the scene below and pick out details that need greater visual emphasis. The angle you use to portray a scene can dramatically impact its effectiveness—seeking

unusual perspectives can help expand the visual repertoire of your frame and often presents distinctly graphic designs and patterns. To me, perspective is what separates an average snapshot from a strong visual statement.

There is no better demonstration of the importance of perspective than the story of the iconic V-J Day photograph of a couple's loving embrace in Times Square at the conclusion of World War II. Two photographers were on the scene on that faithful August 14th day and they both managed to capture the exact same moment unfolding. One photographer, named Alfred Eisenstaedt, took an image that would grace the cover of Life Magazine and define the century. Another photographer, Victor Jorgensen, would also go on to get his image published, but would never reach the same acclaim and recognition that Eisenstaedt received for a similar frame. What visual difference helped eventually elevate one photographer to master status in his profession, and allowed another photographer to be lost in the obscurity of photographic history? Perspective. Eisenstaedt shot the couple head-on, capturing the iconography of Times Square and framing the full limbs of the affectionate couple. By contrast, Jorgensen's side-view captured an unrecognizable and distracting backdrop that wouldn't resonate with audiences outside of New York City.

Perspective can really make all the difference in your images and stories.

The ability to control the height of your camera is one of the most revolutionary aspects of this emerging genre of photography. Most drone models have incredible range, which gives you phenomenal flexibility in orchestrating your photographs. Your drone's altitude is crucial to the vista you're able to capture and the story that you're capable of telling. Drone photography allows you to organize what might otherwise be a busy frame by playing with the height of your camera. As you ascend upwards, you'll notice that you can better capture the geometry and visual rhythm of a vista when the elements of the scene aren't stacked one on top of another.

As you look down from high above, you can better isolate focal points within the landscape, creating pronounced visual hierarchy and cleaner compositions. However, there reaches a certain altitude when your focal points can lose their depth. As you move to higher elevations, scenes can quickly become compressed, particularly when your scene lacks elements of varying height. This becomes most pronounced when the background and the foreground seem equidistant to the camera. Often times, the best drone images are built around focal points of varying heights, as they can help create more layered photographs. At 400-feet (maximum flight altitude as outlined by the United States Federal Aviation Administration), your drone can provide unbelievable context to the universe around you. At that height, people and objects become miniaturized, and you can play with their size to create a sense of scale within your images.

Yet, the best photographs aren't always taken at maximum flight altitude. The drone photography sweet spot exists a matter of feet above your head. At this height, you can create clean, but nuanced imagery with foregrounds, middle grounds, and backgrounds capable of guiding your viewer through a unique visual experience. It's also at this height where you can best capture the unseen. Airplanes and helicopters are legally obligated to operate above a certain altitude for the safety of everyone. Drones thrive at the very altitude range that helicopters and airplanes are prohibited from exploring because UAVs are nimble, easy to maneuver, and are ultimately controlled by a totally different set of rules. From ten to one hundred feet, drones can capture what no other technology is typically allowed or capable of capturing.

In a world where 350 million photographs are uploaded to Facebook daily, it's liberating to know that you can claim a slice of the sky that no other medium is capable of reaching with a rather

modest piece of technology. You know what's equally refreshing? With drones, you have exposure creativity that simply doesn't exist with other types of aerial photography technology. Most aircrafts subject their passengers to so much shake and vibration that long exposure photography is simply impossible. UAVs make the impossible possible with incredible positioning technology and anti-vibration mechanisms that keep the drone and your camera stable and still in mid air. Drones own the visual world that's just out of the reach of the longest selfie stick and the lowest hovering helicopter.

Location or distance to a subject has many of its own visual implications on perspective. By photographing your subject at close proximity, you can create a deeper sense of intimacy and connection with your subject. By contrast, distance can also signify a disconnect between the photographer and the main subject of the image. At high altitudes, an isolated focal point can elicit feelings of loneliness or melancholy by depicting the subject's tininess in the greater scale of the world. Because in drone photography distance to subject is typically a matter of height, be careful to hover at an altitude that allows you to capture just what you intend to depict and nothing more. Moreover, location has a unique impact on the kind of backdrop that you're able to depict. Maneuver your

UAV not only with the intention of framing a central focal point, but also with your ideal background in mind. Scan the edges of your frame for distractions and alter your composition to eliminate the superfluous.

"RULE" OF THIRDS
The "rule" of thirds comes from the idea that putting your focal point in the dead center creates uninteresting, one-dimensional imagery. Taking the time to find a pleasing and effective placement for your main subject is crucial to adding depth and intrigue to what could otherwise be a lackluster frame. The "rule" of thirds is based on a photo being divided into nine equally-sized sections like a tic-tac-toe board. By placing a subject along the intersecting lines of these sections, you can capture more alluring imagery and create visual intrigue, as the eye is naturally drawn to each of these sectors. The "rule" of thirds is simply another means of creating visual emphasis within your frame.

When you're airborne and operating with limited battery life, it's tempting to place your primary subject in the center of the frame. Yet, the "safe" approach is rarely the best approach. Images shot dead center are deprived of visual balance, as there's typically too much unused photographic real estate surrounding your main subject. Construct visually harmonious images by carefully laying out

different focal points throughout your photograph, and paving a clear path for your viewer's eyes to travel throughout the frame.

You never want your viewer's eyes to get stuck in your composition by emptiness, a distracting element, or a blown out highlight. In addition, make sure to employ your gimbal's panning capabilities to experiment with different placements of your focal points within the frame. You don't want to be left feeling should have, could have, would have, when your drone once again touches down. Most integrated drone models have companion apps for your smartphone that enable you to display a "rule" of thirds grid on your live view screen. If you're flying a DJI Phantom or Inspire product, the DJI Go App has the grid option under the settings menu. If your UAV of choice has this feature, I would also recommend using image playback to review your compositions without all the map and indicator overlays interfering with your view of the photograph. With image playback, you can better evaluate your compositions, easily discovering distractions or determining if a better photograph can be found by moving your aircraft slightly.

PATTERNS
Patterns are a paramount aspect of drone photography, as height allows drone operators to discover visual rhythms that can easily go unseen from the ground. Mother Nature's glorious designs become drastically more potent when they're multiplied in vast patterns. Repetition contributes to alluring photography by tricking the eye into seeing more than what is really present within an image. With strategic framing, a photographer can make a pattern appear like it's infinitely repeating. Whether a line of parked cars or a forest that stretches the length of an expanse, patterns are amazing to marvel at from high altitudes. There's a certain point in a drone's ascent when the world below becomes toy-sized. Concentrating on nature's vast and extravagant rhythms by flying at such great heights makes for dynamic imagery.

GEOMETRY
Geometry isn't only for the mathematically versed—it's a vital aspect of building an aesthetically pleasing frame. Various visual patterns help form the geometry of an image. Many of the most awe-inspiring photographs have geometric shapes and repetitions that aren't immediately noticeable—they operate subconsciously by keeping our eyes bouncing around the frame. Geometry is a pillar of thoughtful compositions because it means different pieces of the frame are interacting with one another to form a series of shapes. These shapes help direct the eye from one focal point within the frame to the next one. Sometimes, when a frame lacks these geometrical interactions, the image can

feel loose or empty. Remember that the rectangle that contains your entire image is its own shape and you can use the elements within it to form distinct shapes with the frame itself. Furthermore, look to create engaging visual abstractions with an array of rhythmically arranged geometric shapes.

LINES

Lines are among nature's most alluring and enchanting patterns. So often, we think of lines as a man-made construction, but they're marvelously bountiful all throughout our universe—they exist in magnificent forests and immense metropolises. Lines are another prominent aspect of our visual world order. No matter how your line is formed within the frame, it can be used to your artistic advantage. Lines have incredible implications for the compositionally aware, as they have the power to transport the human eye from the foreground to the background of your photograph. Lines act as a director of traffic for your viewers' eye, often leading them on a visual journey to a point of interest. This furthers your goal of keeping your audience focused on the key points of your image. Whether they're converging, curving, diagonal, horizontal, zigzagging, or vertical, lines can help create layered imagery when strategically employed. The shape and direction of the lines in an image also impacts the mood of the photograph. For instance, is the line getting

larger as it gets closer to the lens, or is it disappearing into the distance? These types of distinctions can influence the message of your imagery. Wide-angle lenses have the phenomenal power to exaggerate lines and exaggerate their compositional impact as well. Finding a vantage point close to the beginning of a line can create a pattern within the image that cannot be missed.

SYMMETRY

Similarly, symmetry can create a feeling of repetition within a photograph. Symmetry is the height of visual balance, as all the parts of the frame interact and work together to create a cohesive mirrored image. Symmetry is a marvelous element of composition that requires the eye to wander all across an image, echoing your scene and giving emphasis to the visual story that you're endeavoring to tell. The geometrical interactions that symmetry creates are also key to its compositional success. Some of the greatest symmetrical designs can be found in surprising places. For example, symmetry is an essential aspect of city and road planning, as it allows for efficient traffic and pedestrian flow.

SIMPLICITY

Some of the most blissful photographs that UAVs can capture are simplistic in nature. By building your frames around the notion of simplicity, you can better assess the value of different focal points

within your frame and tweak your compositions if they become too cluttered. In addition, when you're concentrating on the most basic elements of your image, your story can be told successfully without any other distractions. Great drone photography often starts from a notion of simplicity. For instance, you may have identified a building from ground level that might look compelling from the air and you launch your drone to frame its architecture with an interesting perspective. You may not, however, have seen distant elements of the frame that could function as additional focal points or compelling backdrops. By utilizing your compositional toolbox, you can use these newfound elements of visual intrigue to elevate your story and its accompanying composition. Recognize that paring your compositions down to their bare bones begins with the mental process of constructing your narrative. Once you understand where one focal point belongs within the image, you can start sprinkling more prominent elements inside the frame to complement that central subject. Maintaining visual hierarchy is a key aspect of simplicity. Meanwhile, depth of field, focus, and contrast can help drown out all of your image's background distractions. Negative space is also an important feature of simplistic composition as it draws the eye away from emptiness and towards your subject by giving your central focal point room to breath. However, when used in excess, negative space can cause the eye to wander across the frame aimlessly, creating a less than desirable photographic result.

TEXTURE

Texture is a unique visual feature that promotes sensory exploration by giving a two-dimensional image a three-dimensional appearance. As our memories of how things feel are so ingrained in our consciousness, the mere sight of texture brings a vivid sensation of touch. In that manner, texture can create incredible depth within a photograph, even making the viewer feel as if they are present within the scene. Think about how prominent you want to make texture within your image. Wide images will de-emphasize the textural patterns within the landscape, while telephoto shots will allow you to isolate details and amplify sensory perceptions. There's an unbelievable breadth of textures that inhabit our world, from the coarse grains of desert sand and the rugged edges of alpine rocks, to the milky flow of river water and velvety woodland greenery. With soft end-of-the-day or beginning-of-the-day light, you can better capture the fine surfaces on the gentler end of the texture spectrum. Strong, direct light is best utilized to convey rugged and rough textures. Finally, search for places where these contrasting textures may collide, as it can make for its own type of rich imagery.

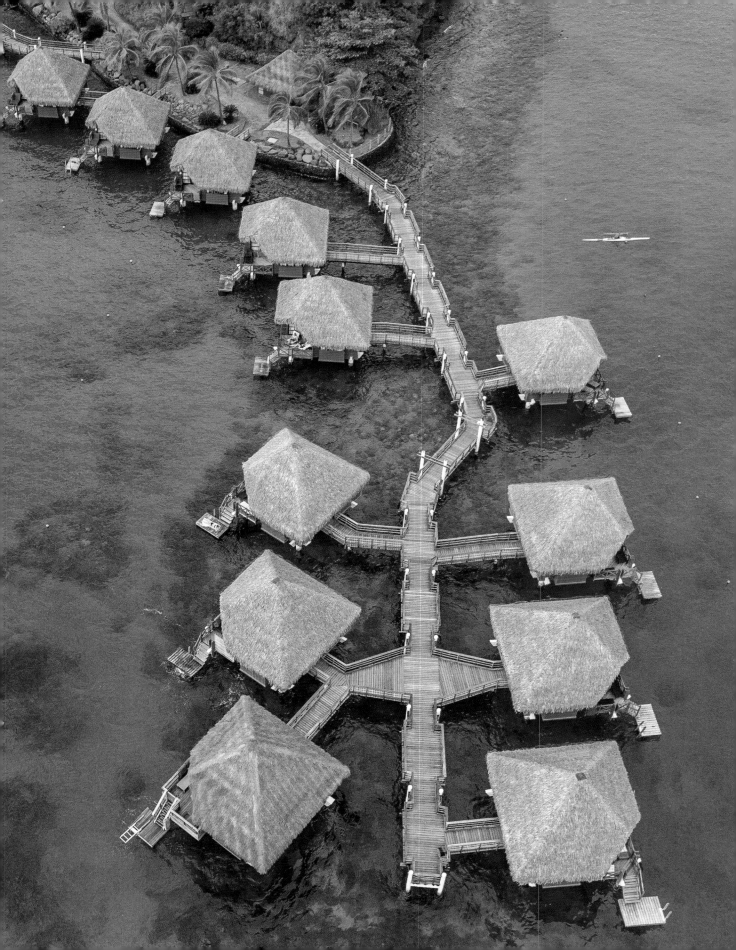

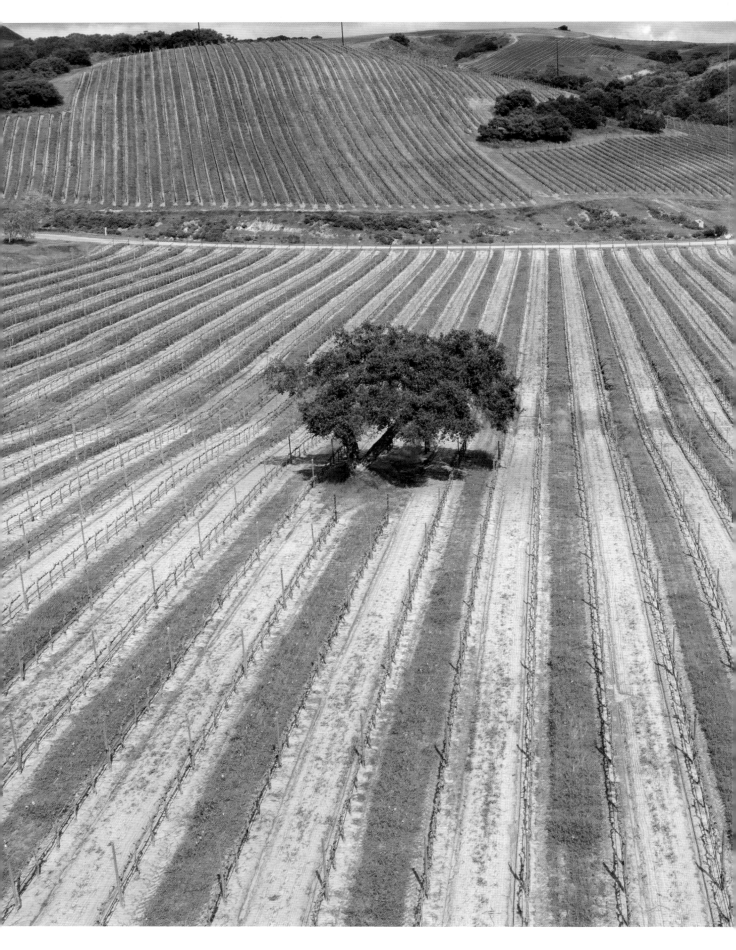

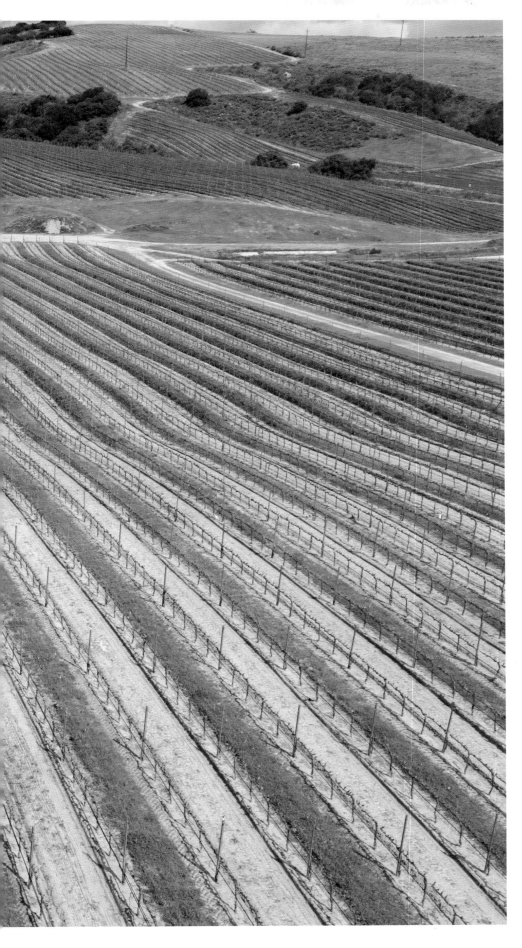

Vineyards twist through verdant pastures and stretch as far as the eye can see in the flower seed capital of the world.

Topiaries frame manicured shrubs and the sunbaked footpaths that connect the collegiate buildings of Rice University.

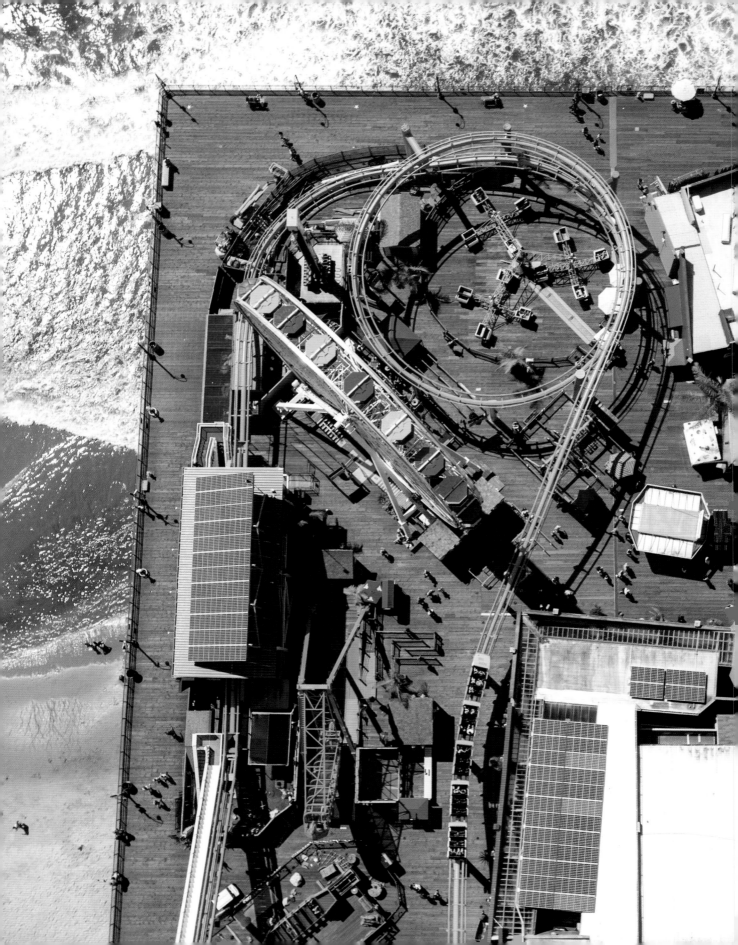

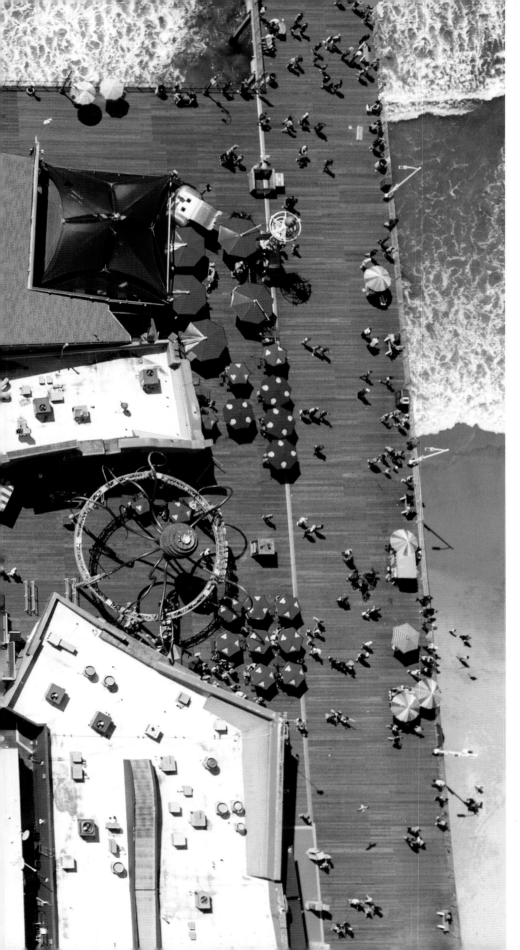

America's Mother Road abruptly ends at the tip of the Pacific, where roller coasters twist and turn above dancing waves.

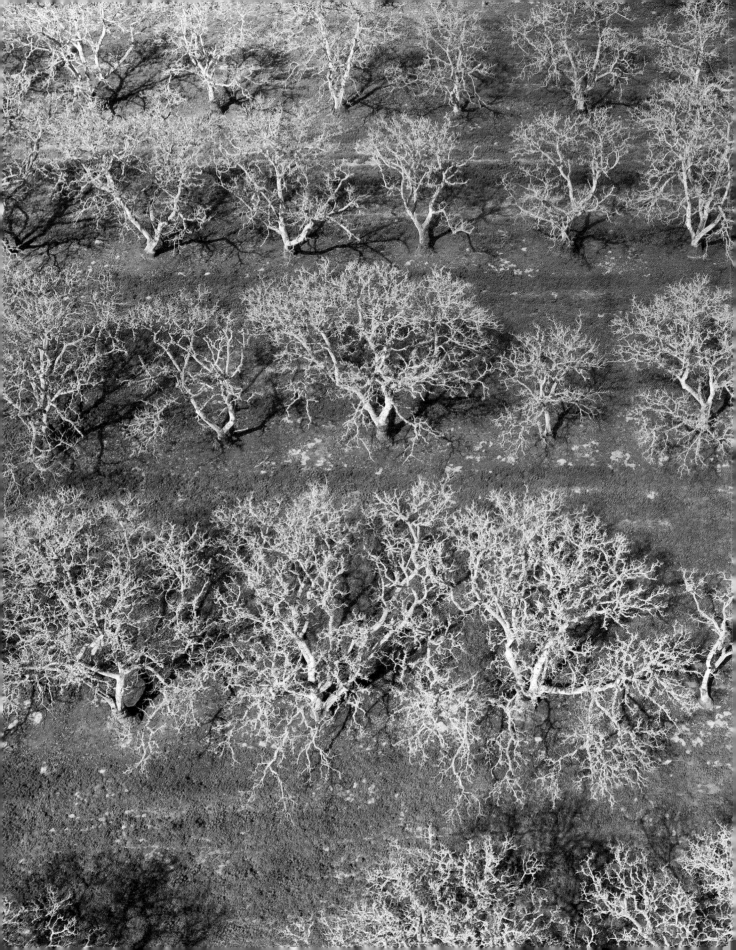

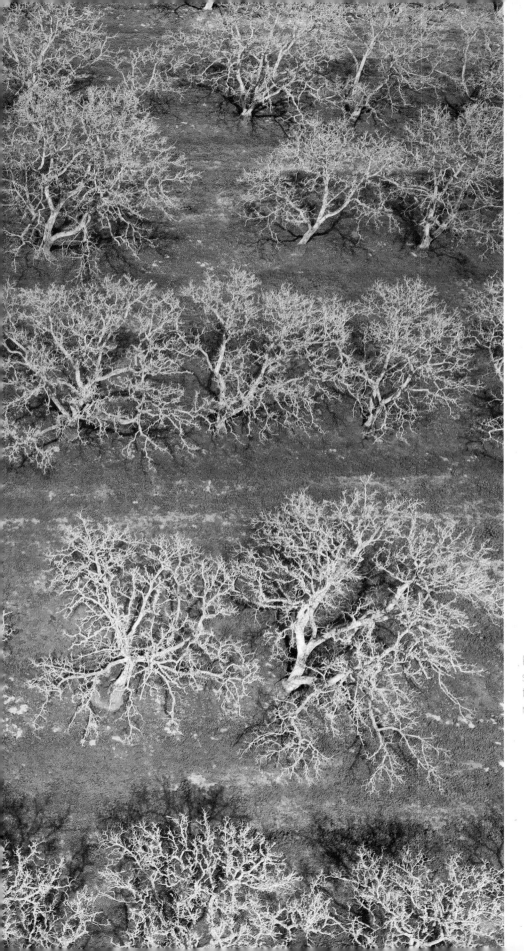

Rows of trees bear their seasonal emptiness, waiting to sprout in springtime unison near Lompoc, California.

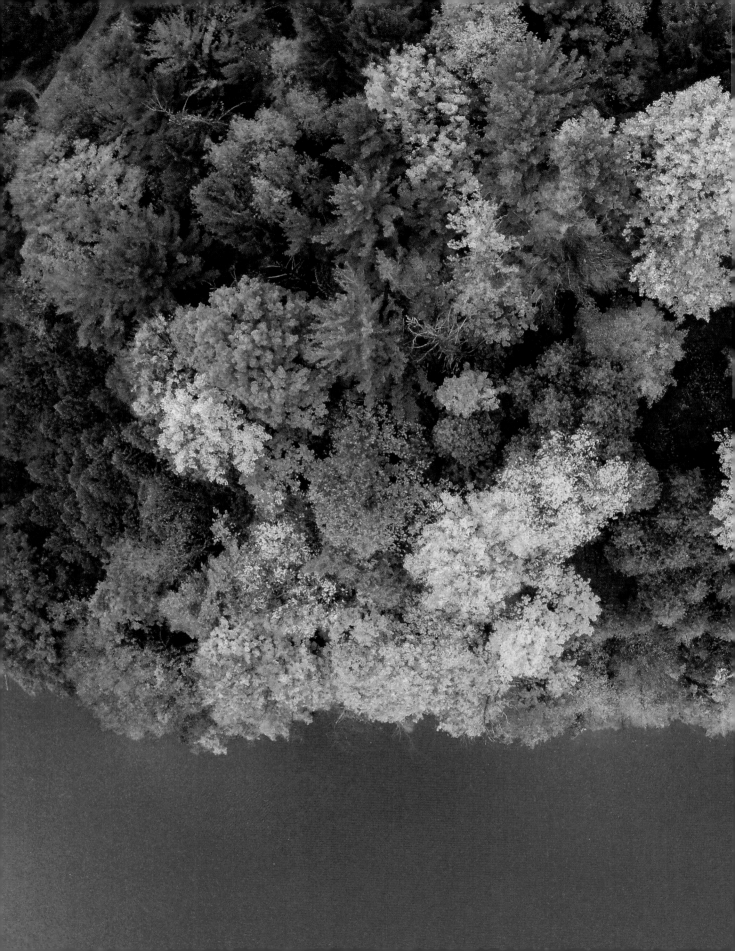

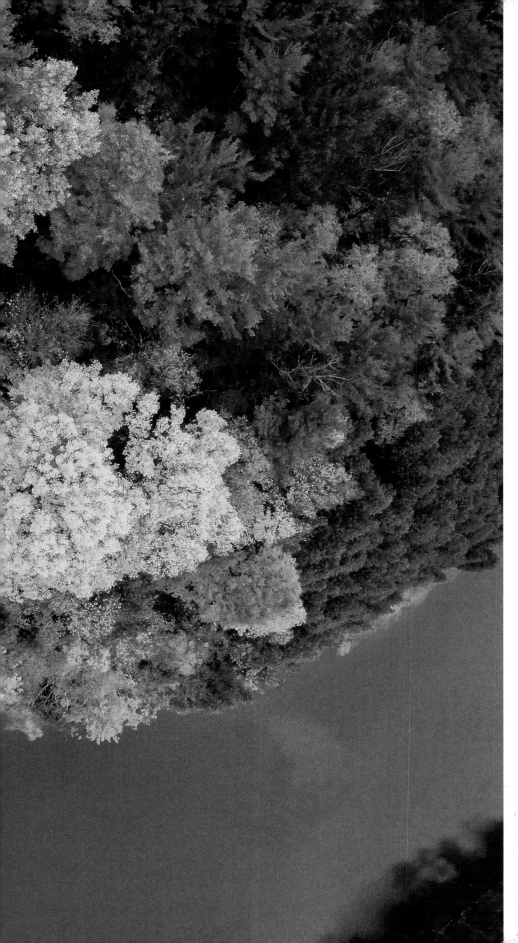

Autumnal hues enliven the turquoise tinged waters of a rare, glacially carved, meromictic lake.

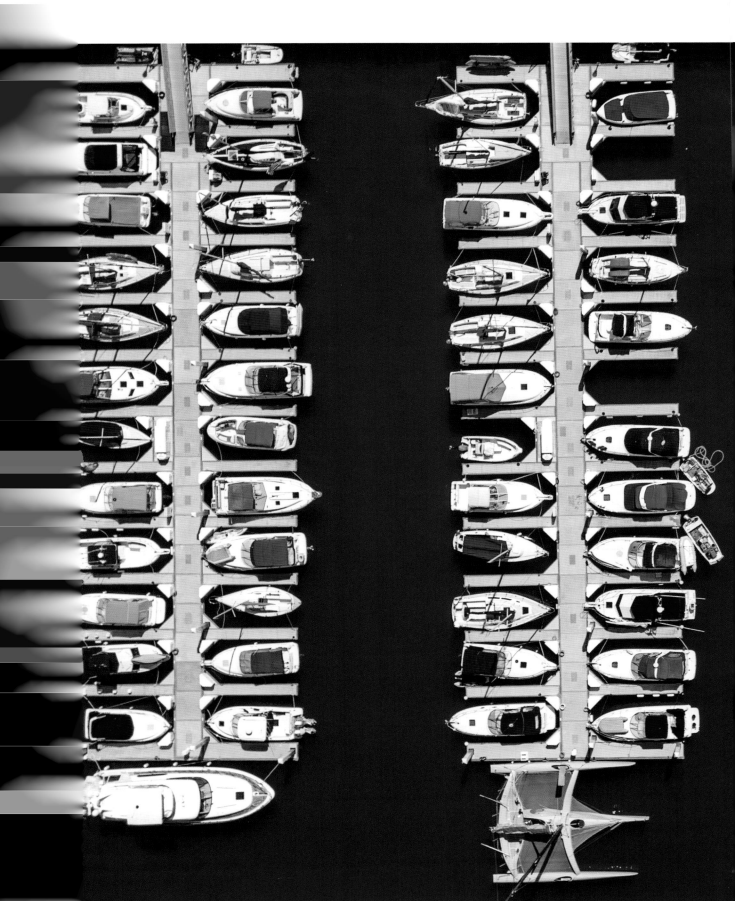

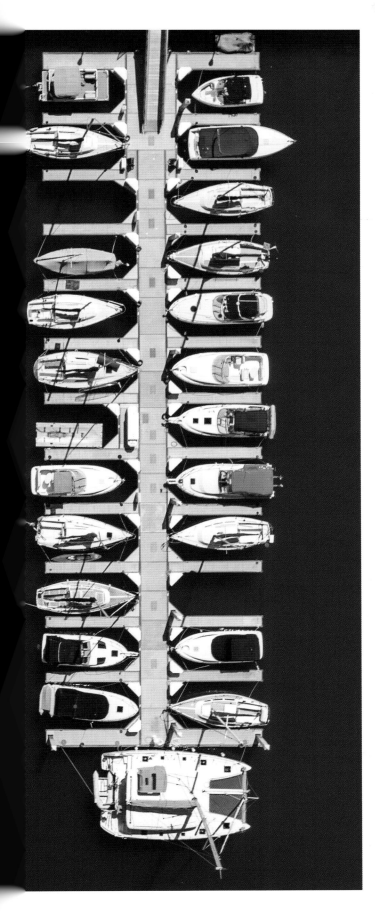

A jigsaw puzzle pattern
of boats fills a bustling
Los Angeles marina.

139

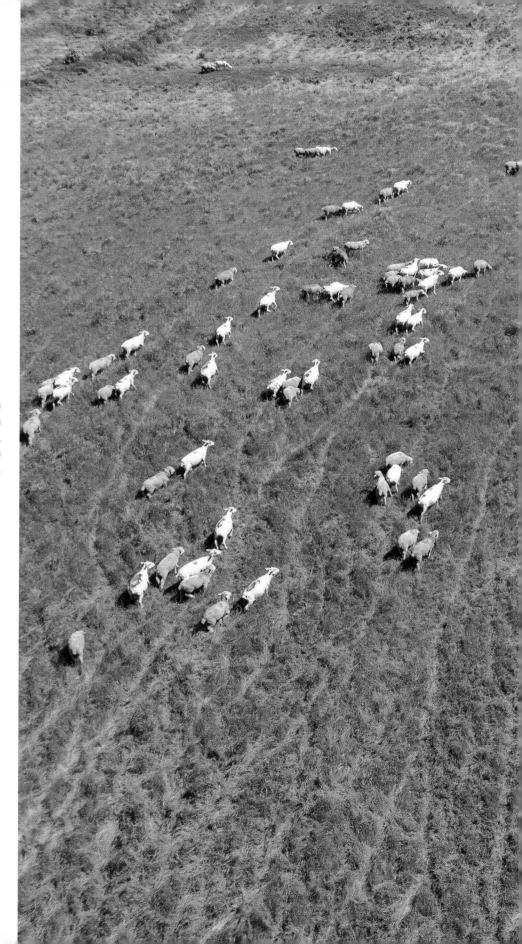

Herds of sheep brazenly graze green California pastures, leaving long trails in their hooved wake.

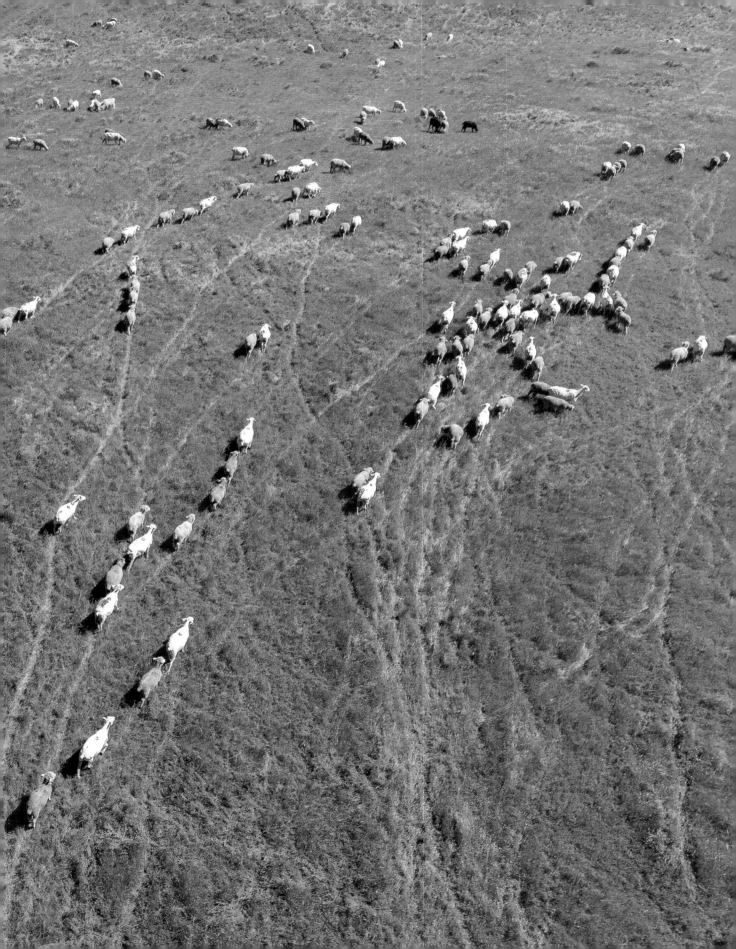

Crops and their shadows
are blurred together in
a striking pattern that
stretches as far as the
eye can see.

143

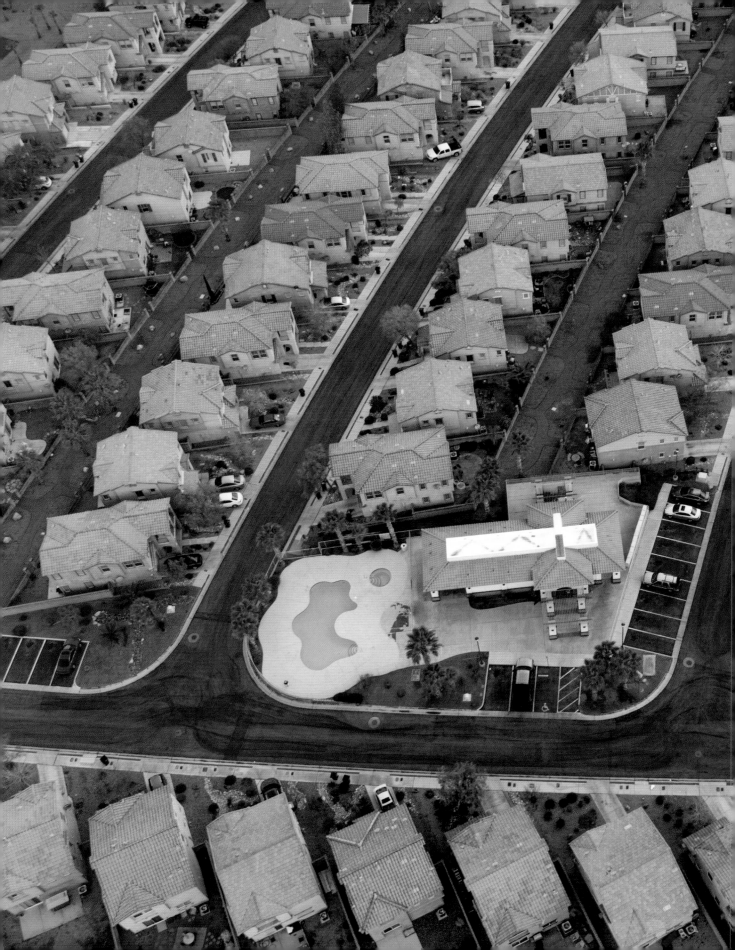

Rows of austere
suburban residences lay
on the edge of a desolate
Nevada desert.

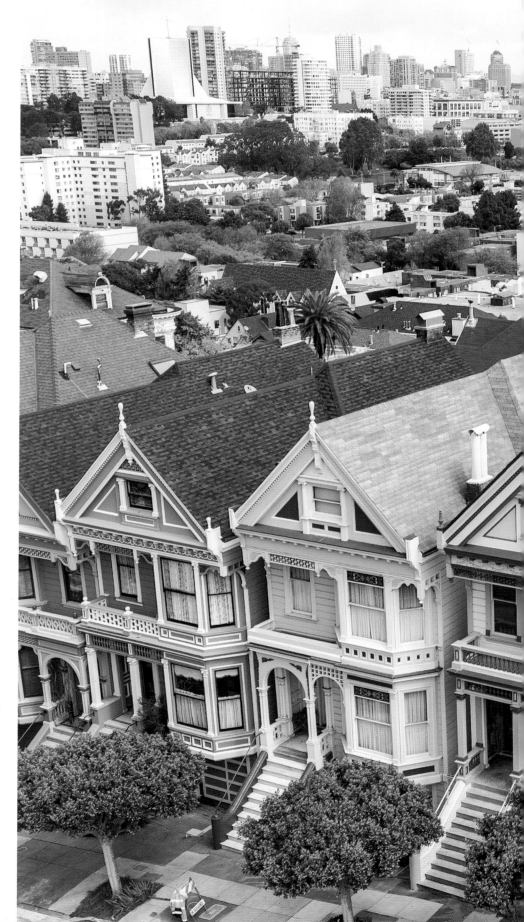

Festooned Edwardian row houses fill a steep stretch of San Francisco's Steiner Street.

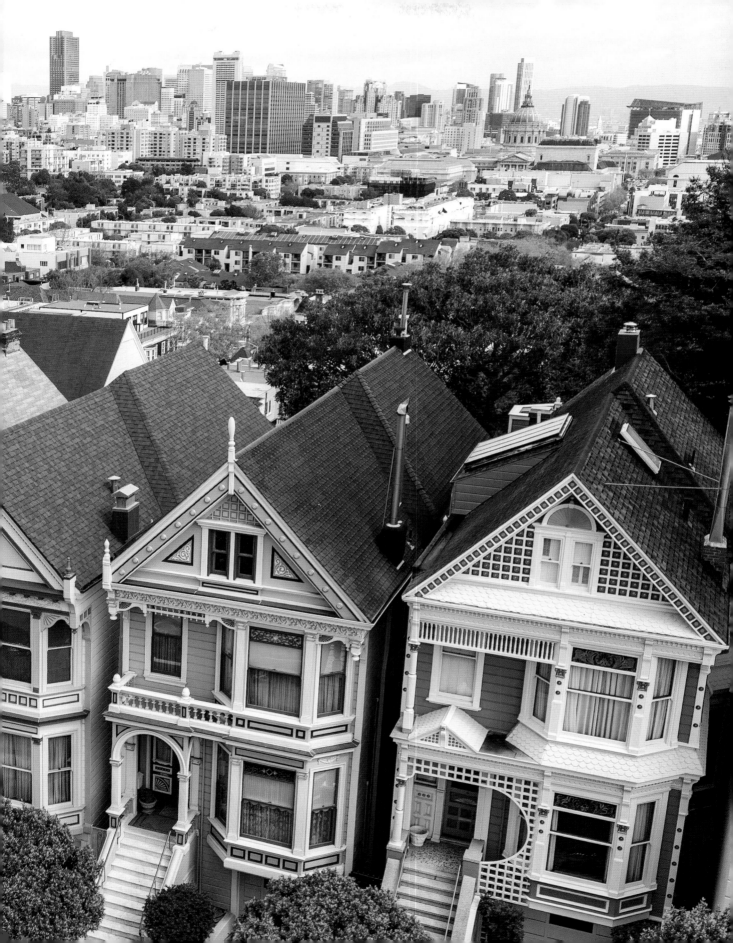

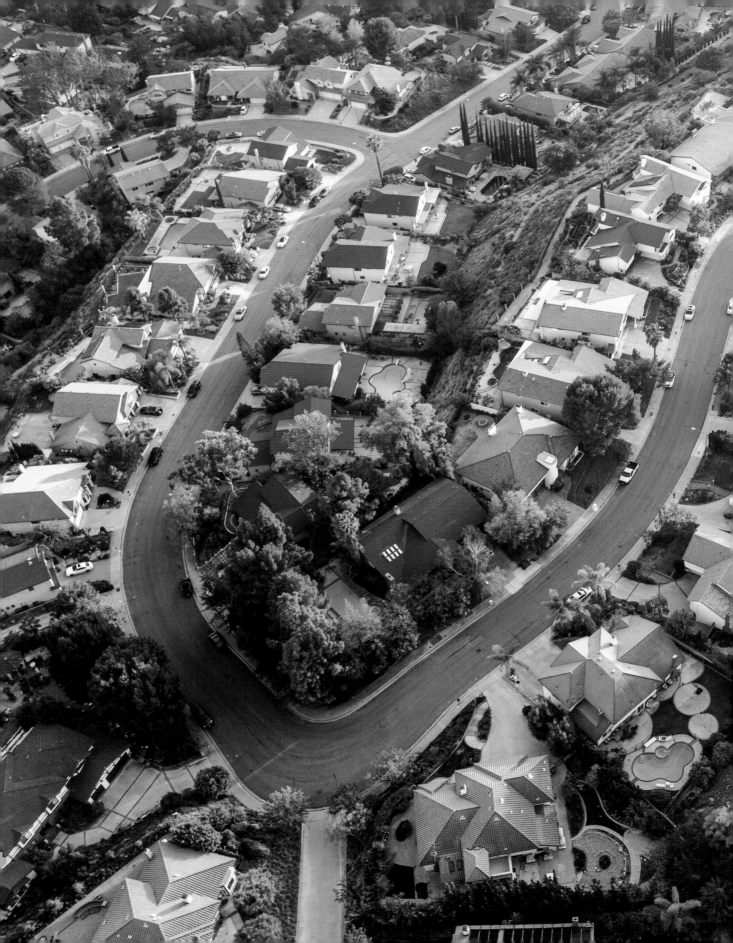

Lavish residences snake
through the sloping rim of
the San Gabriel Mountains.

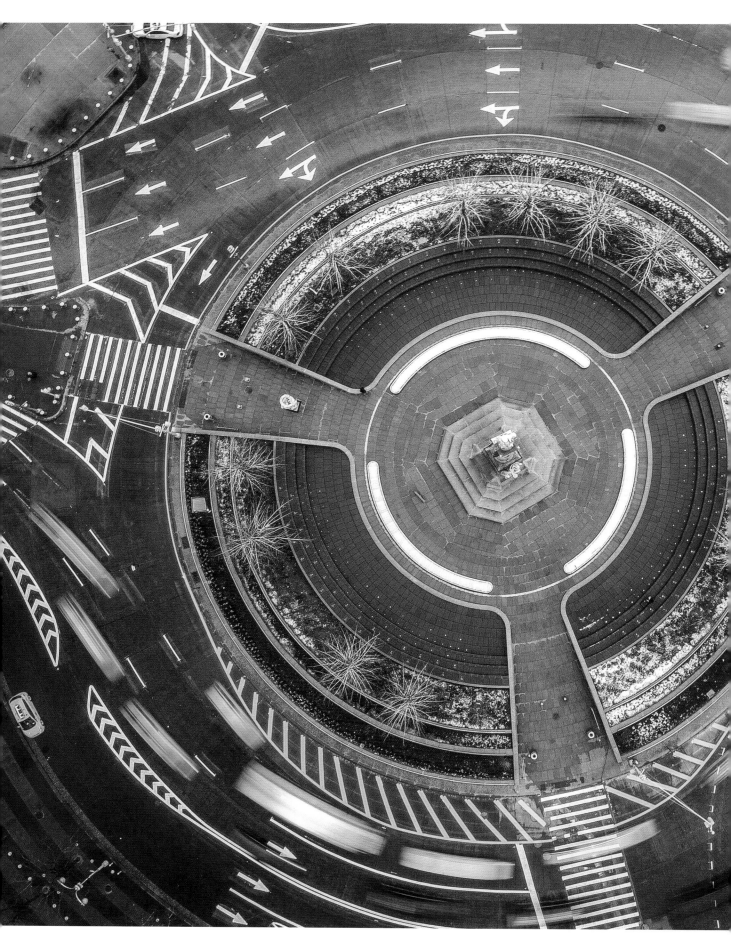

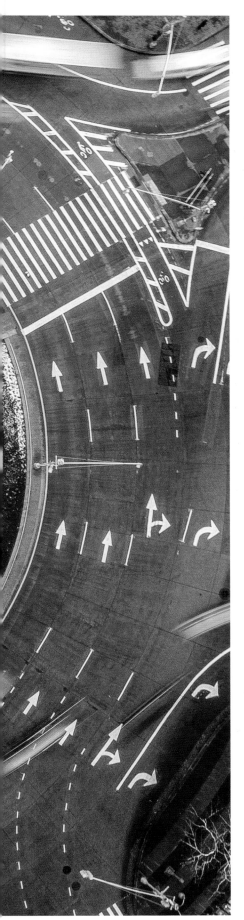

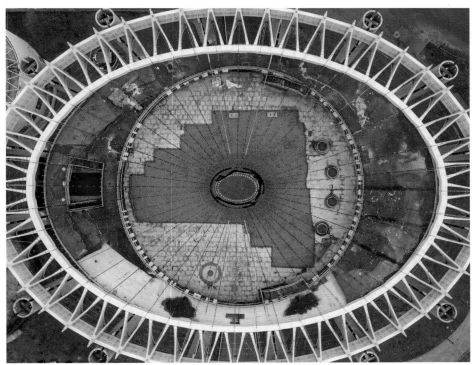

(above) A concrete remnant of the 1964 World's Fair, the now abandoned Tent of Tomorrow integrated a map of New York State into its terrazzo flooring.

(top right) An icon of the 1964 World's Fair, the Unisphere casts an indigo shadow over Queens's Flushing Meadows Park.

(left) Overnight snowfall dusts a quintessential Manhattan roundabout, where Christopher Columbus presides over the spot where all official distances to New York City are measured.

151

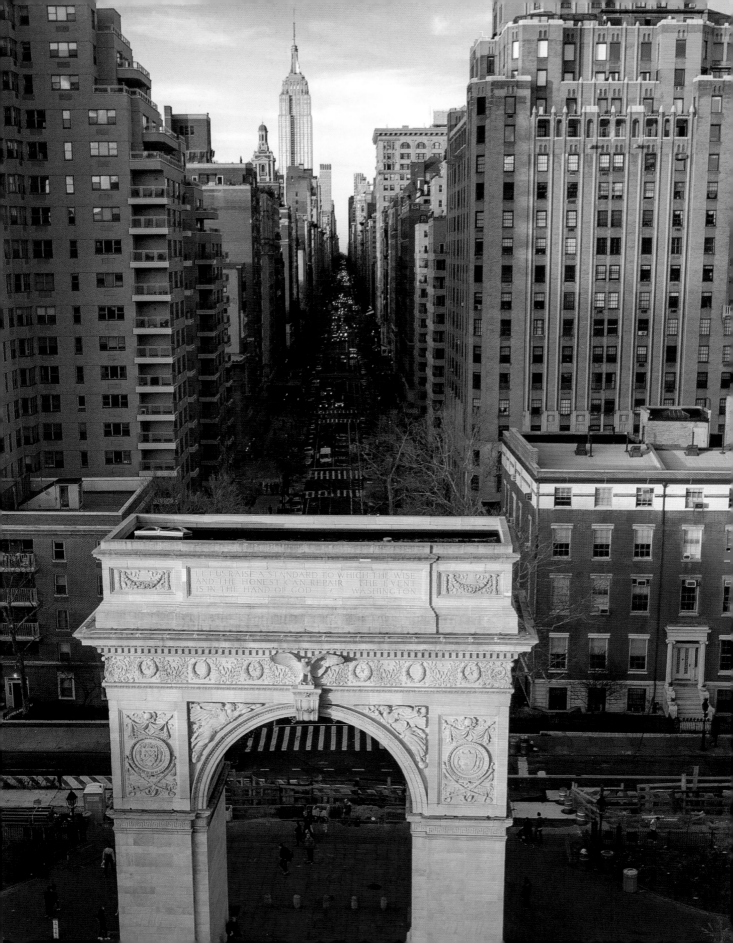

THE PROCESS

In this visual pursuit, finding drone photography locations is half the artistic battle. As with most great photography, splendid UAV imagery comes down to a matter of preparation. Research is something that I am all too familiar with as a travel photographer. When I set out on an assignment, I need to know every detail about where I am going and the culture that I am documenting. In order to carve out my own artistic voice, I have to become very familiar with the range of images that have been taken at a destination and think about how I intend to frame similar subjects with a different vision. Aerial photography is no different.

Start from a place of inspiration. Follow aerial photographers on Instagram and find images through 500px, Flickr, or Google—look at the aerial imagery that stimulates your brain or even disappoints your eyes. Determine what works and what fails. Are there recurring themes in marvelous aerial imagery? What kind of pitfalls do aerial photographers fall into with their compositions or subject matter that you don't find enjoyable? After evaluating enough imagery, you'll begin to see like an aerial artist even when your drone isn't airborne. Once you start asking yourself, "why didn't the photographer do this instead?" You'll realize that you're truly seeing photography with artistic intention.

Next is finding a location worthy of your drone's battery life. Start in your own backyard and with locations of familiarity. Think about where you spend your leisure time. Parks, for one, are tremendous places to take flight, as they're typically picturesque, open areas. In addition, what's a draw in your region or unique to your county? Is the place dynamic enough to make for intriguing aerial imagery? Would you be the first person to capture it from the air?

Google Maps is an essential tool in assessing the worthiness or feasibility of any of your ideas. When you're really zoomed in, Google Earth can even reveal precisely what a drone image might look like. On the other end of the spectrum, Google Maps might also show that there isn't a wide enough area for your drone to safely take off or that there isn't a flight path that you're capable of navigating. Google Images then gives you a

sample of the imagery that has already been made of your subject. Make a list of attractions, iconography, or features (both manmade or natural) that engages you and use the tools at your disposal to determine which ideas are worth acting upon. Curvy roads, busy harbors, powerful waterfalls, interesting architecture, and sizeable skylines are especially alluring. If you're planning a trip, think about what makes a region special or different. Trace your route and research each city you pass through. Scan your planned route for possible detours or interesting natural features. If you have an idea and want to build a frame around something in particular like a lighthouse or a bridge, don't be afraid to go and pursue it. Sometimes the most worthwhile ideas require an extra effort or drive. Lastly, just get out and go. In front of a computer, you can easily be subjected to information overload. There's far too much content at our disposable for us to digest everything.

While there's immense practical value to these research tools, a drone does you no good collecting dust beside your computer. At the end of the day, the images that will make you the giddiest are the ones you never expected to create. In many respects, powerful photographs are the result of innate and genuine curiosity. When you're willing to investigate things that pique your interest or venture off the well-trodden path, you'll find worlds that you would never expect to discover.

Now that you have a feasible location in mind, start by visualizing the photograph in your head. How many focal points am I working with in my frame? Where can I fly my drone to get the best compositional opportunities? What is the background going to look like? Are there any distractions I need to be vigilant about? Where is the light coming from? Are there multiple light sources? Is the light changing? Where can I position my UAV to best capitalize on current lighting conditions? These questions bring clarity to your artistic mission without wasting critical drone battery power. Once you're up in the air, prepare to hunt for the image that you envisioned, but be nimble and flexible enough to adjust your vision on the fly. Be sure to use your UAV to see the totality of the scene around you.

Once you have real time visual feedback, identify your central focal point and find the angle that best accentuates your subject's qualities and captures its nuances. Try to tell your story from a variety of different angles, remembering that perspective has a powerful effect on what you're able to say about your focal point. For instance, shooting upward emphasizes height and shooting downward diminishes size. One way to understand the breadth of angles at your disposal is to journey 360 degrees around your subject. If you have enough battery life, drone models like the Phantom 4 have built-in features that allow

you to encircle any defined subject at a set height. Whether you can achieve this automatically or manually, the purpose is to thoroughly survey your surroundings. Make a few different passes around your focal point, observing where the light is most delightful and the background most meaningful. Tinker with the direction in which your camera's gimbal is pointed to have an even greater holistic understanding of your visual options. Once you find a desirable angle, explore your vertical plain and see how height enhances or detracts from your narrative. Situations such as these make having multiple batteries particularly beneficial. With more than one battery, you can explore the entirety of your environment and envision a shot list of notable perspectives, compositions, and frames. You even have time to discover the unexpected and venture to distant scenes that show visual promise. Then, you can devote your entire second battery to executing your shot list to perfection. If you aim to capture moving imagery as well, snag a third battery so you can fully devote your efforts to captivating cinematography.

Pedro and his sombrero
have lured generations
of road-weary motorists
to hours of Vegas-like
diversions between the
Carolina borders.

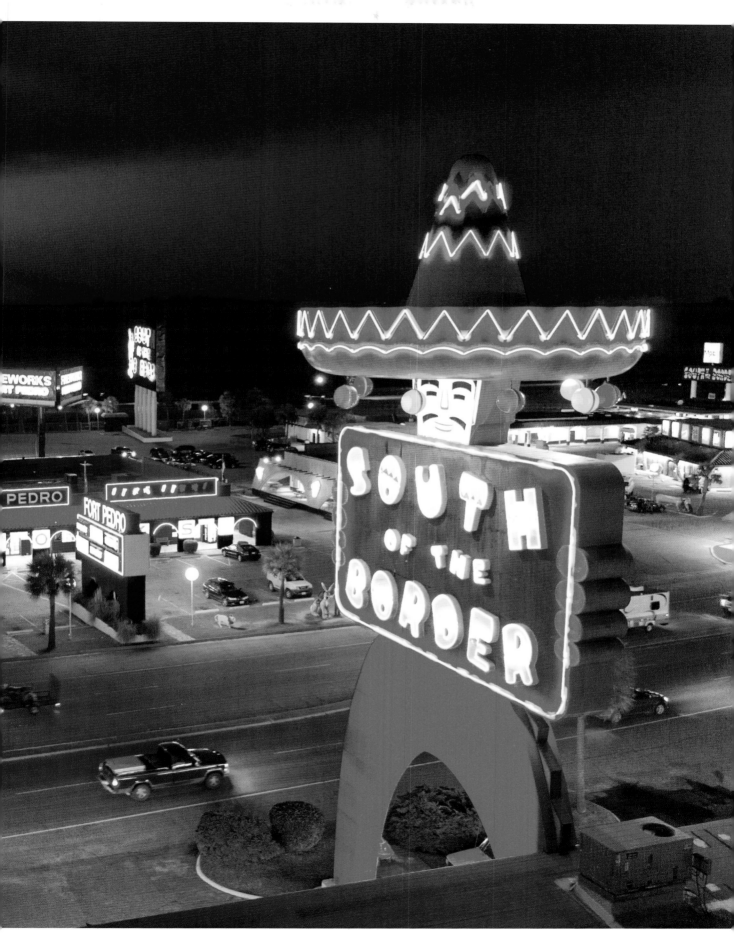

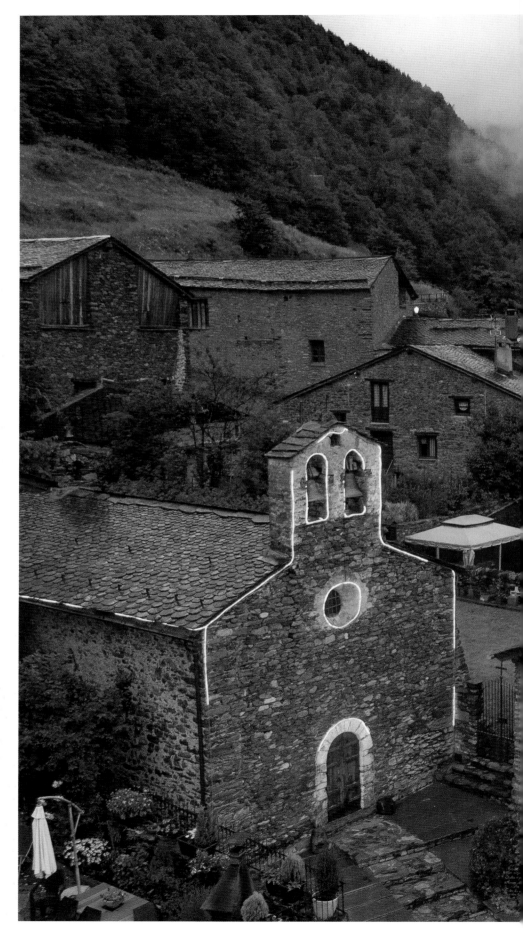

A cloudy veil hangs over an historic Andorran enclave hidden along a winding Pyrenees Mountain pass.

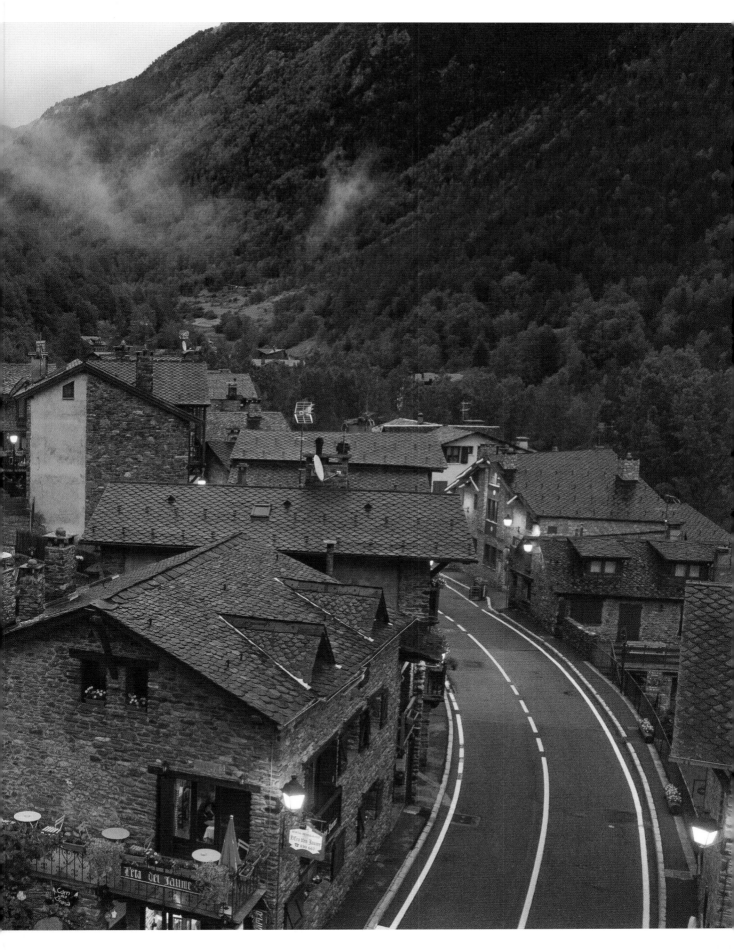

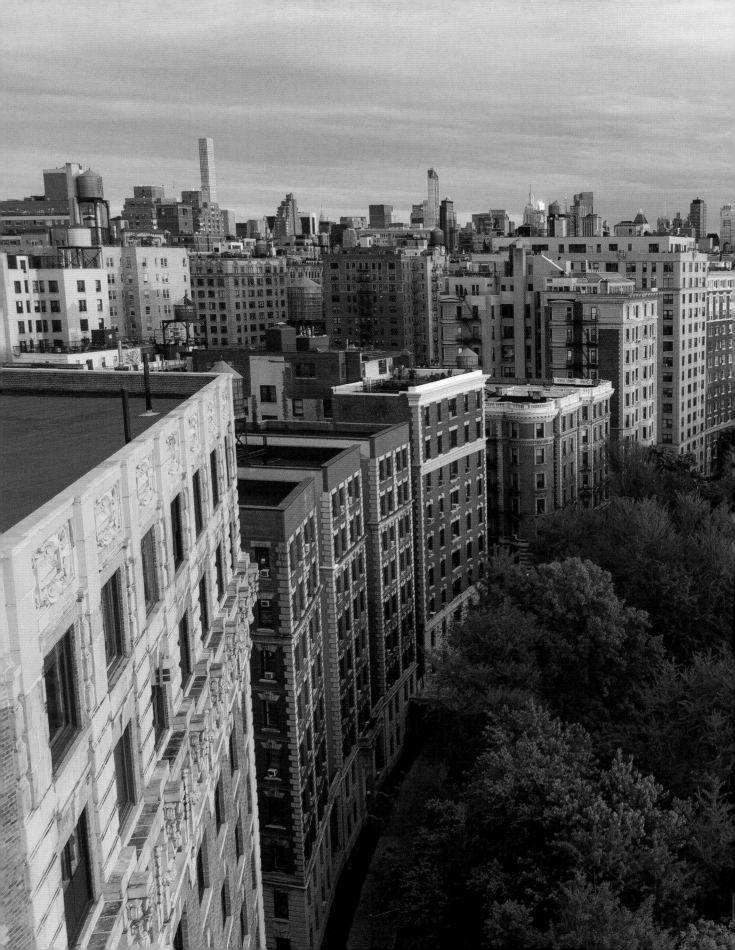

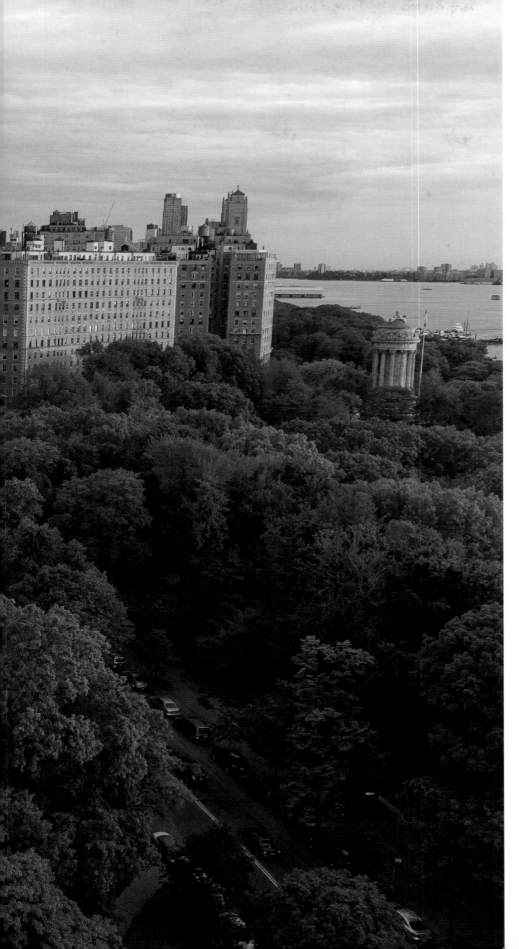

On Riverside Drive, a dwindling sun illuminates the Western edges of Manhattan island.

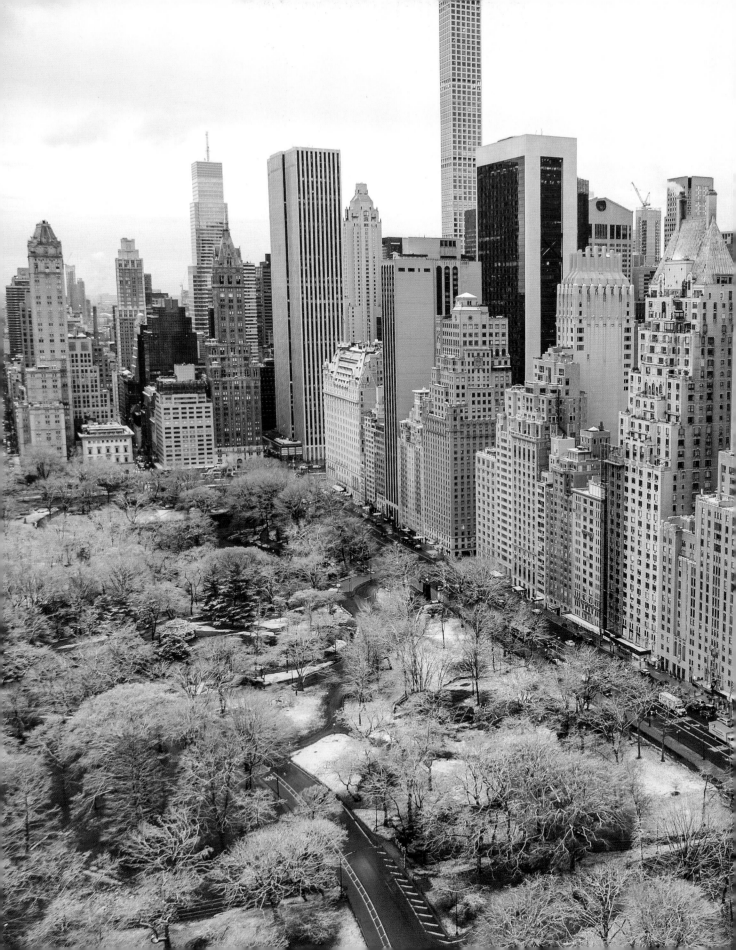

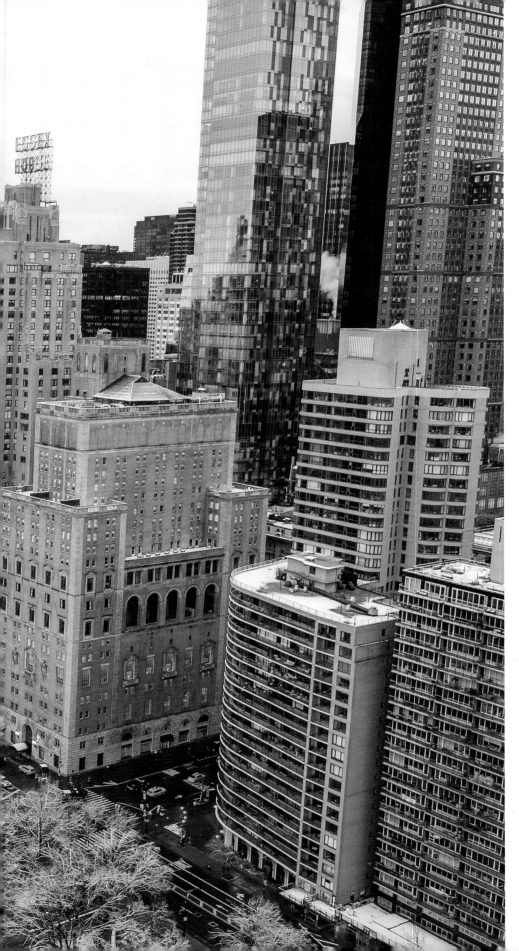

The seasons tint
branches that dangle
over quiet Central Park
pathways just feet from
the hustle and bustle of
midtown Manhattan.

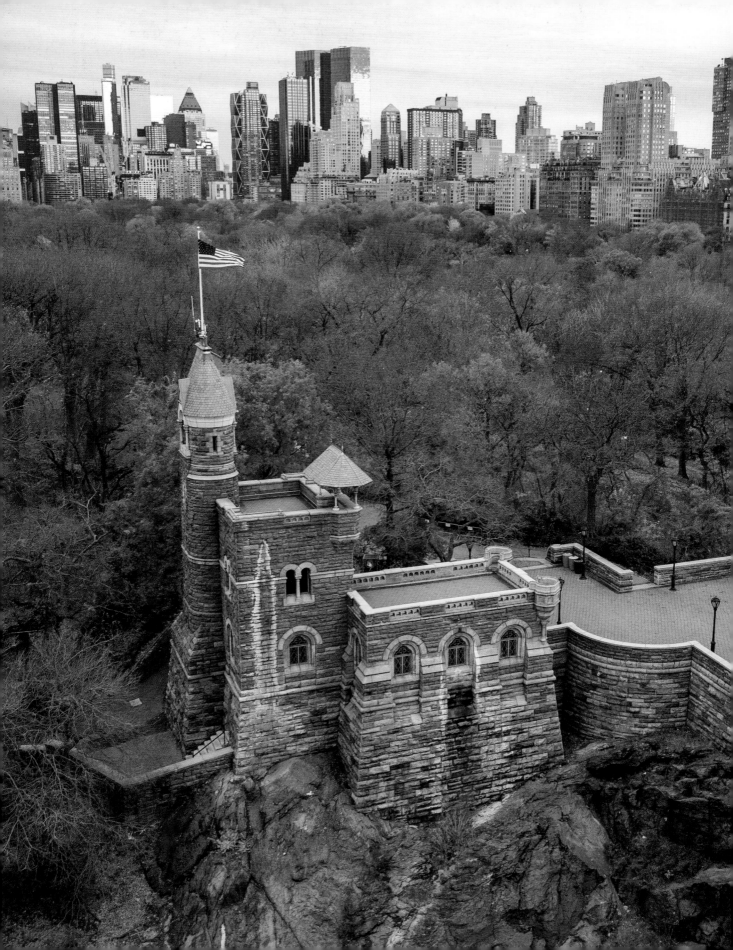

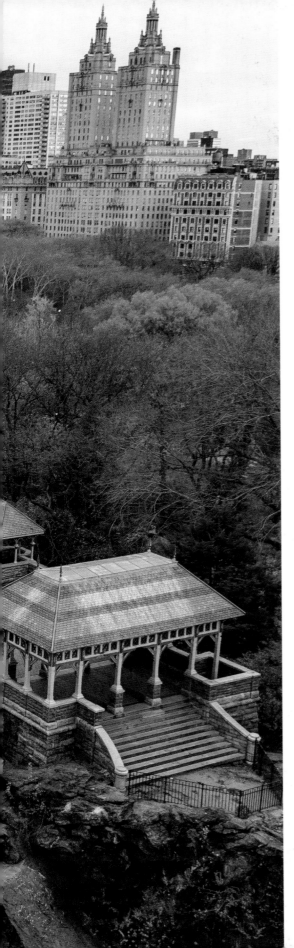

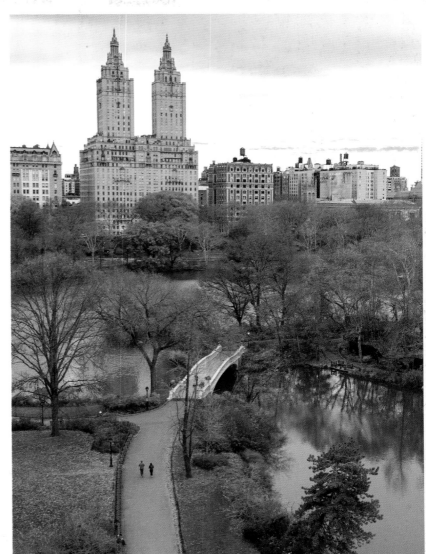

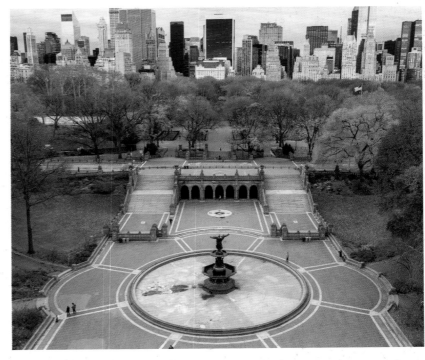

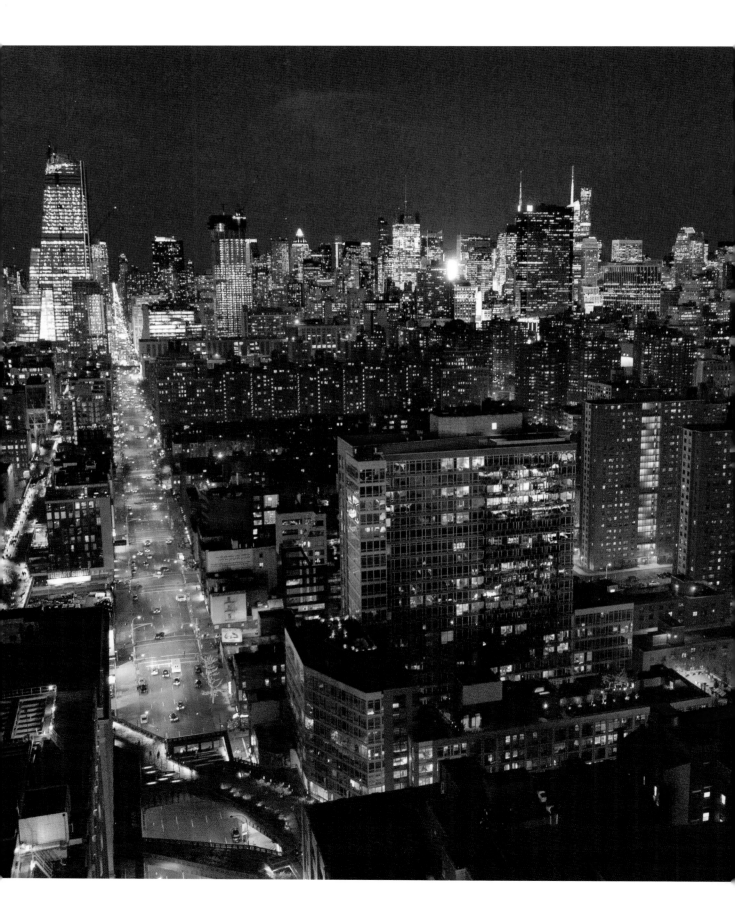

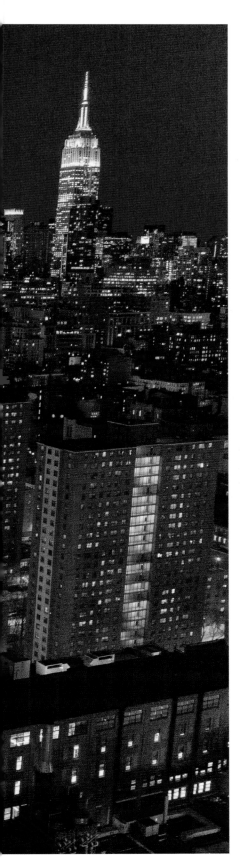

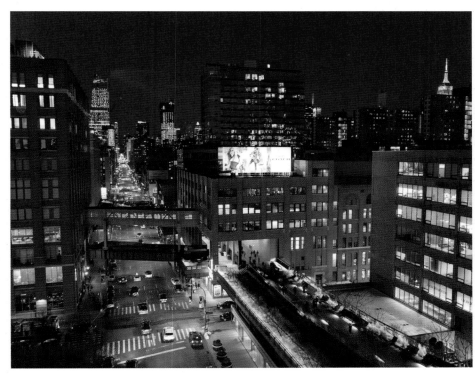

(above) Threading sleek office buildings and aging industrial warehouses, the Highline provides an elevated urban greenspace for a population of jaded New Yorkers.

(left) Times Square sparkles and shimmers in the distant city skyline, as the Empire State Building stretches 1,454 feet skyward.

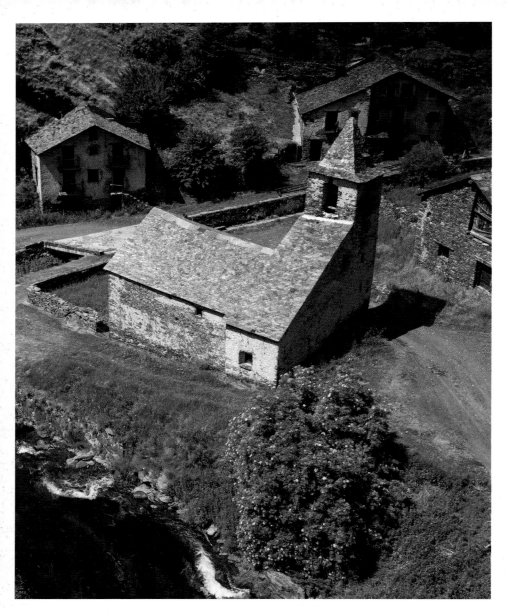

On the edge of the Spanish Pyrenees, the hard-to-reach Catalonian hamlet of Tor houses a population of just 25 people.

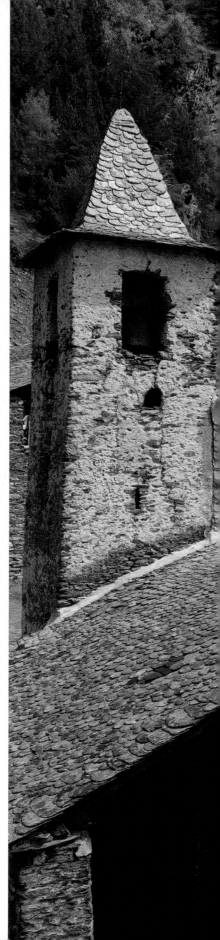

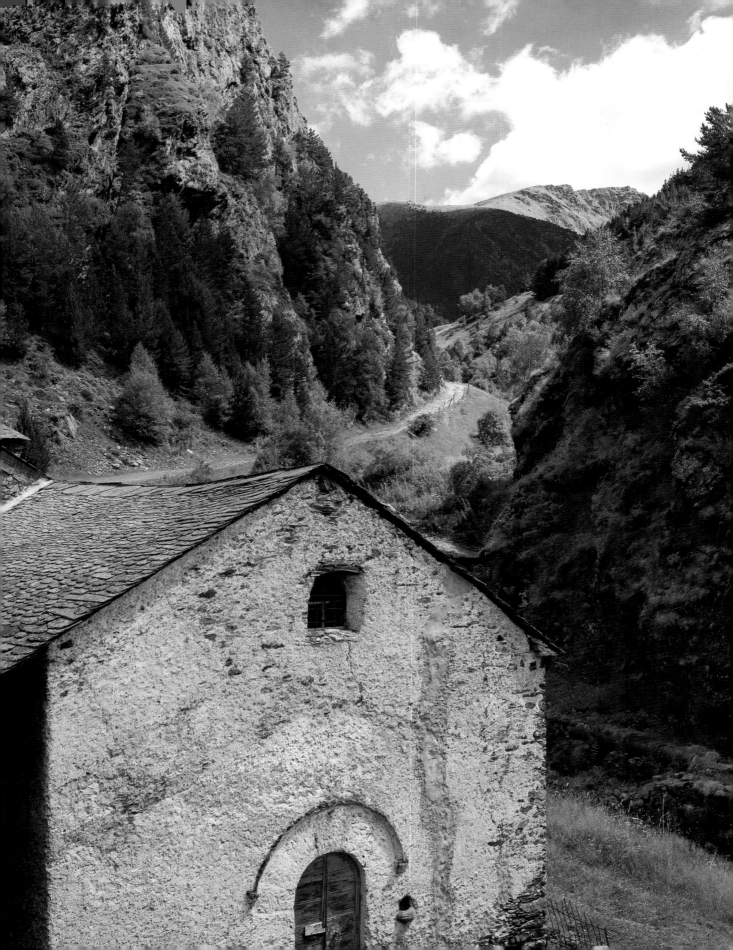

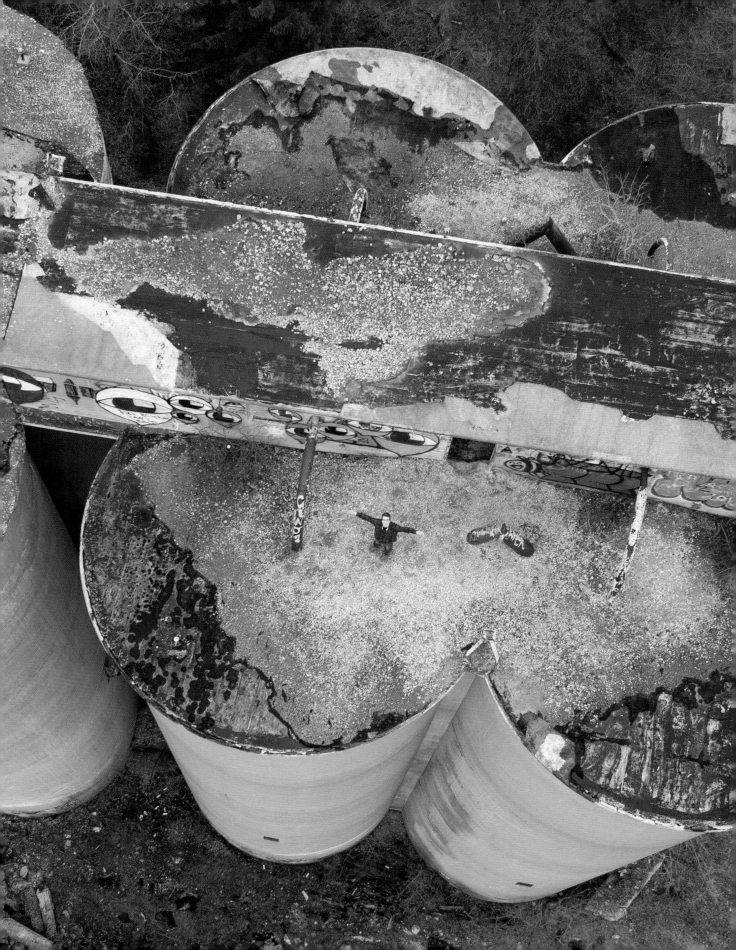

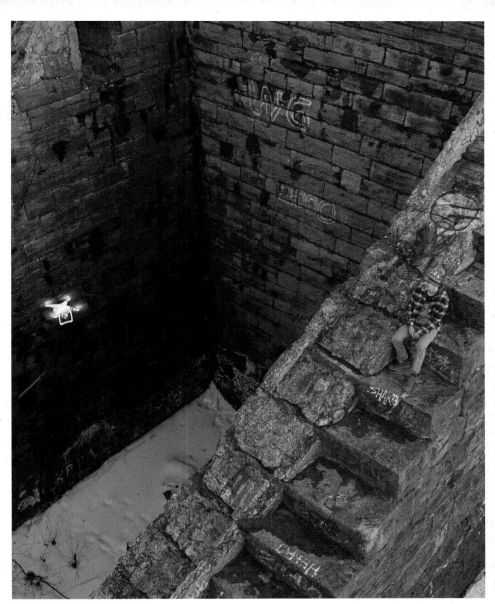

An urban explorer summits a graffiti-strewn storage silo at an abandoned Jamesville, New York cement factory.

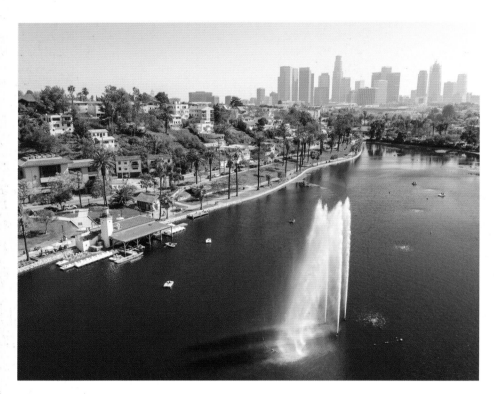

(above) The Los Angeles skyline stands guard over a palm-tree-lined lake once known for its high rate of fatal drownings.

(right) Encircled by morning commuters, the Sam Houston statue is flanked by the Houston Museum of Natural Science to the East and Hermann Park to the South.

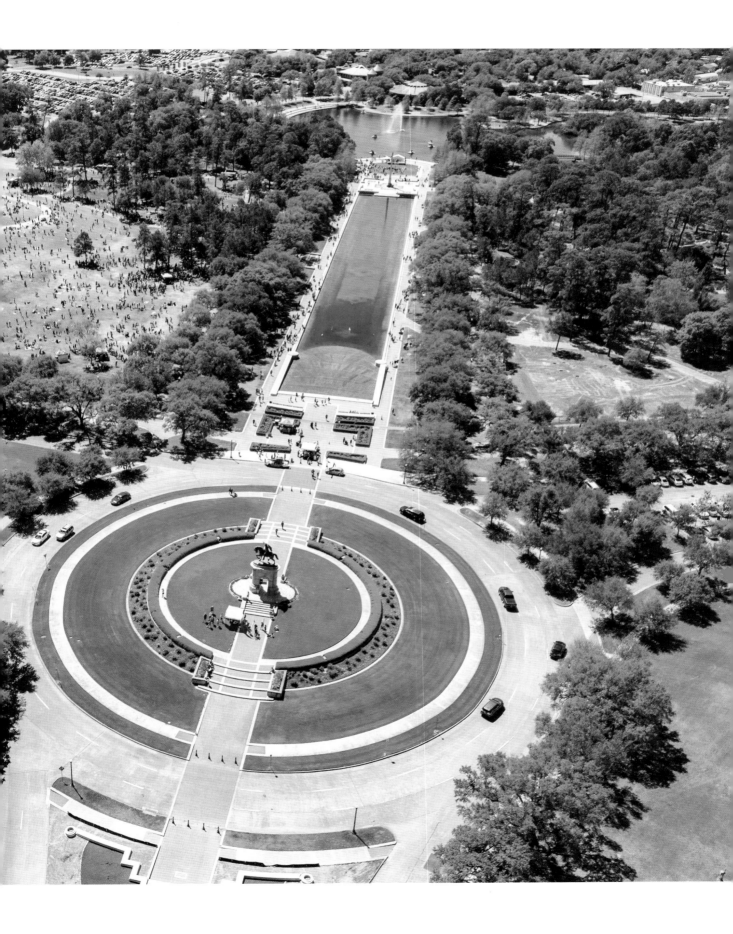

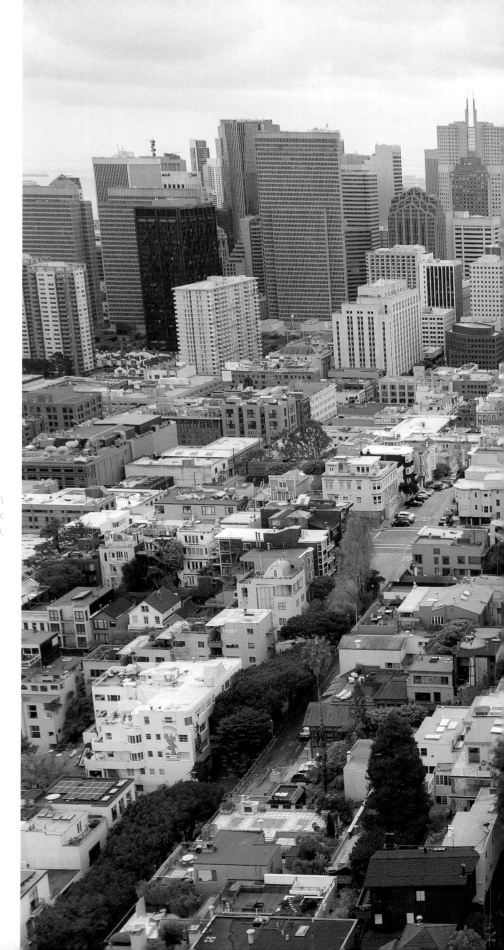

Atop Telegraph Hill, San Francisco's art deco landmark stands out aside the city skyline.

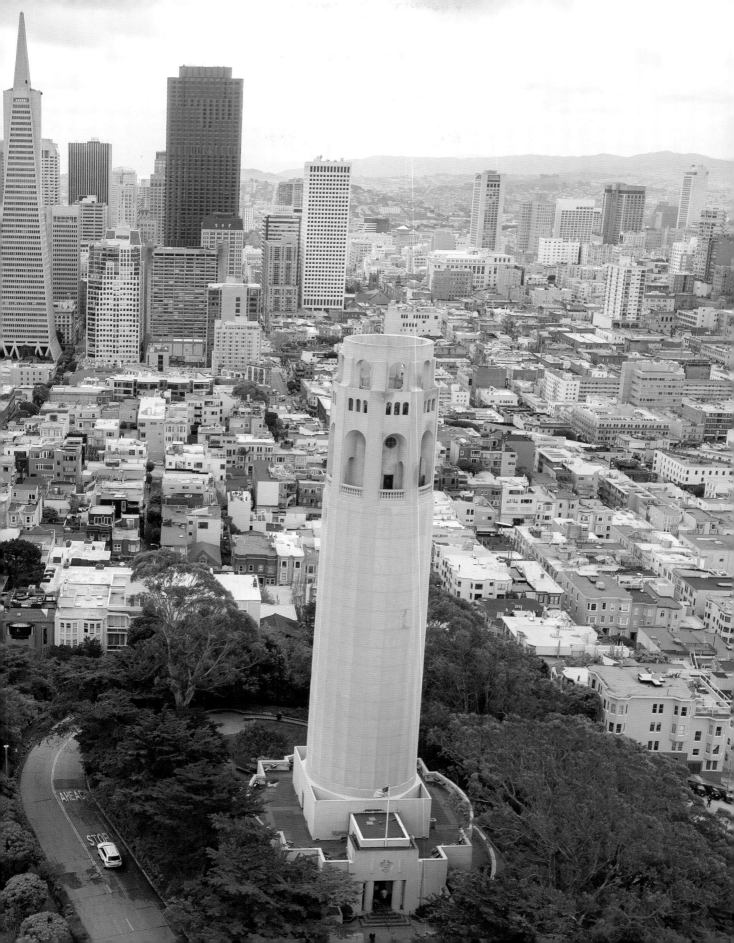

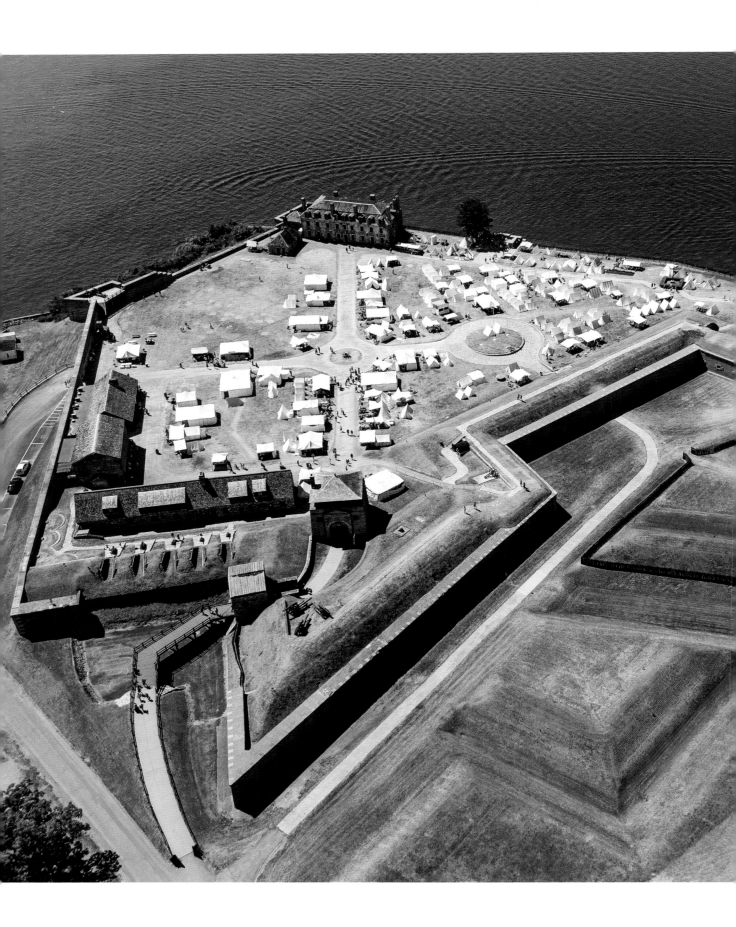

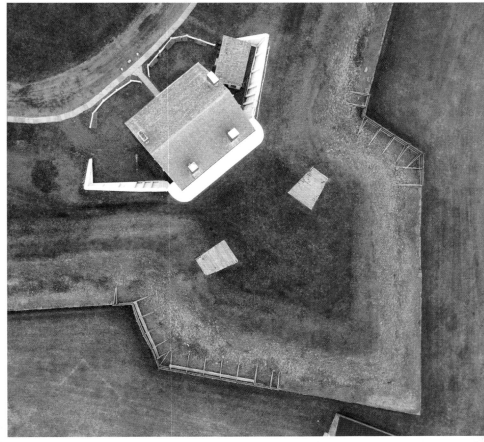

(above) Fort Ontario, a vestige of colonial history, was rebuilt by the British in the aftermath of the French and Indian War, only to change hands and be destroyed by the British in the War of 1812.

(left) Fortified in the 17th century to protect French colonial interests on the Great Lakes, Fort Niagara wasn't controlled by the United States until the Treaty of Ghent.

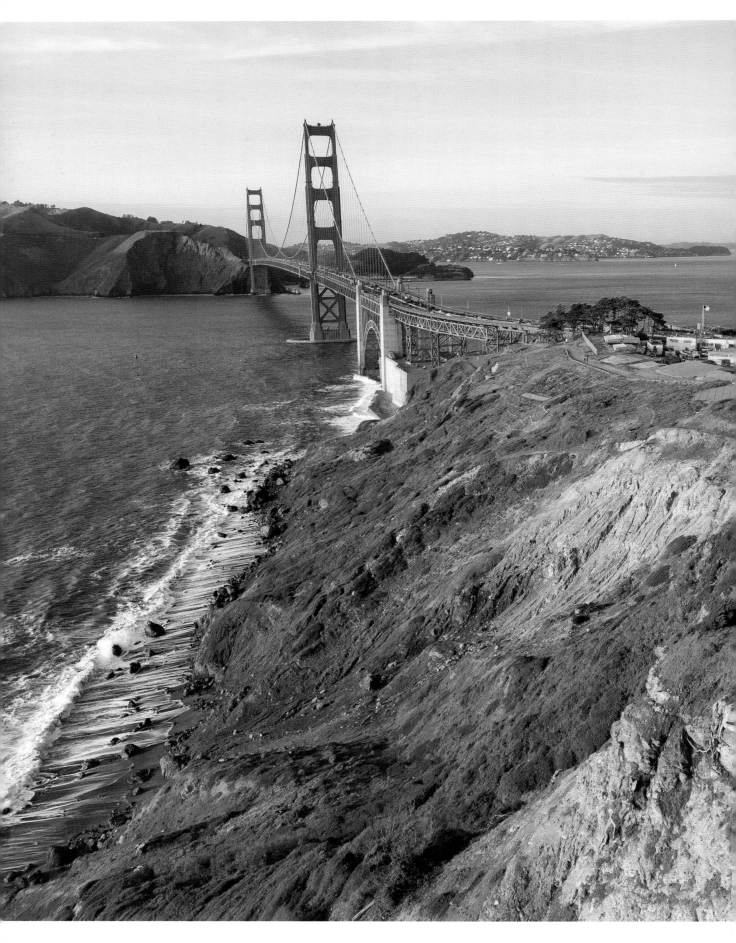

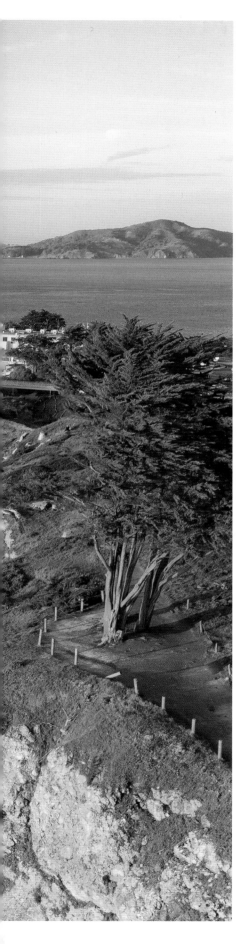

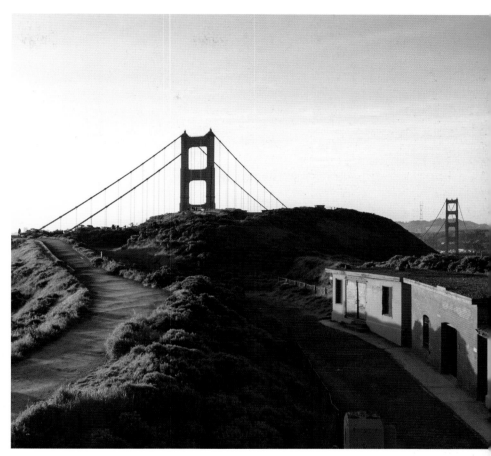

(top right) Dark shadows and soft sunlight intermingle as the iconic Golden Gate Bridge peeks out over the meadow.

(left) The Golden Gate Bridge's vibrant span, once the longest in the world, is seemingly transformed by the dwindling sun.

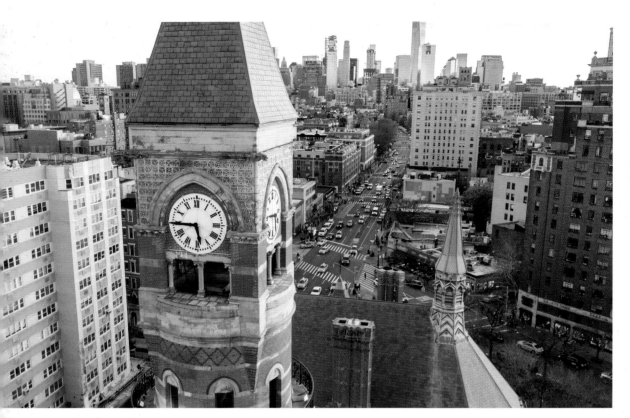

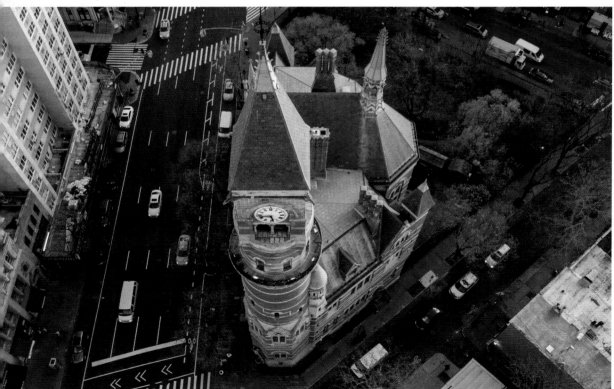

Manhattan's grid-system becomes rather obscured as a curving
Sixth Avenue intersects a triangular park at Jefferson Market.

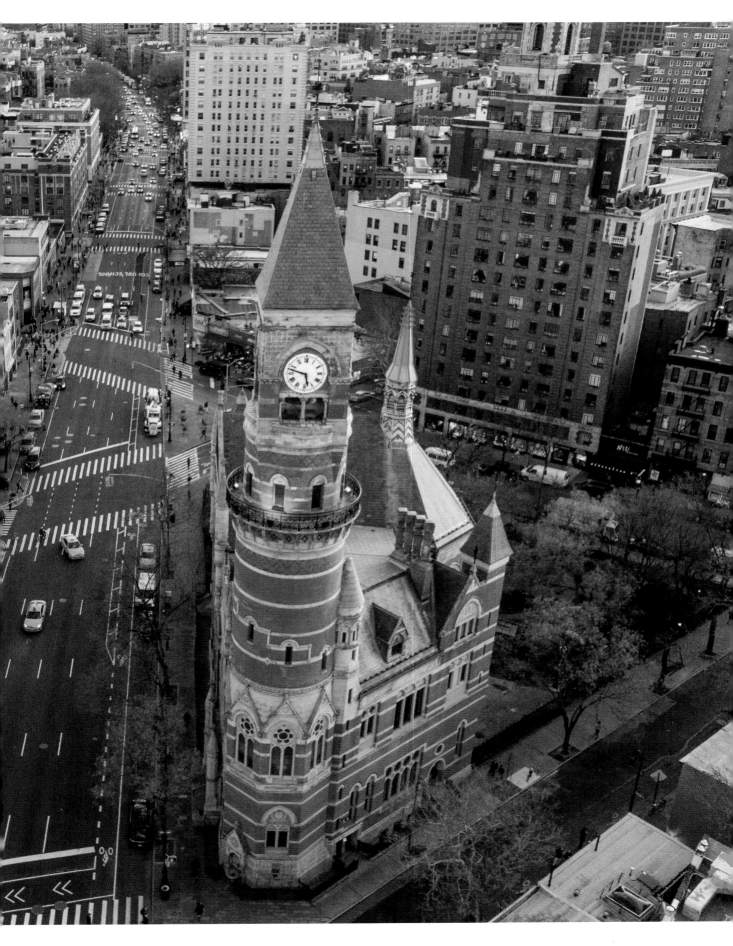

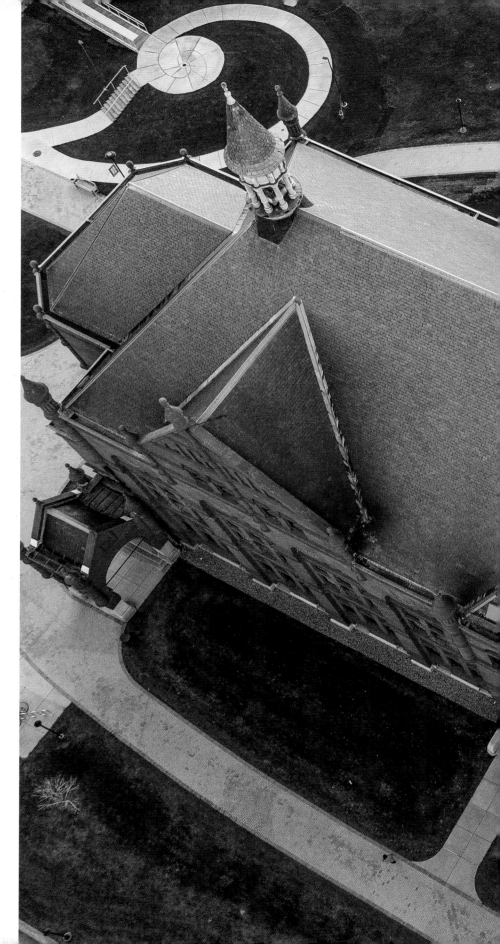

Atop a grassy knoll,
Crouse College's ornate
19th century spires stretch
high into the Syracuse sky.

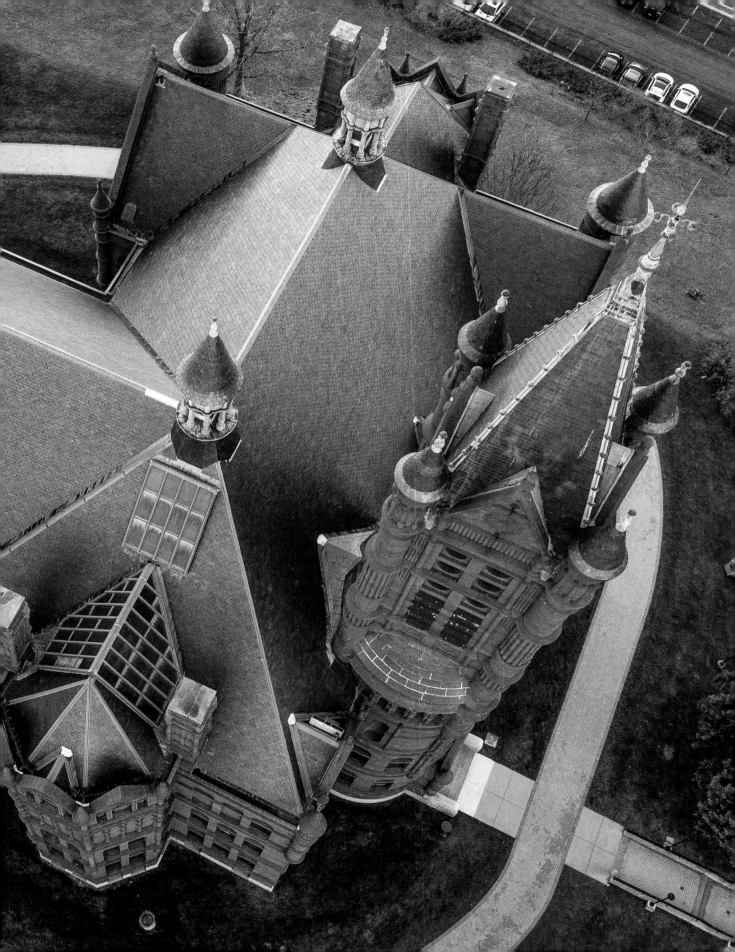

The hacking motif is echoed throughout Facebook headquarters, from the office's address to this colossal call-to-action stamped at the center of campus.

Sinister storms carry foreboding clouds toward Empire State Plaza and the New York State Capitol building.

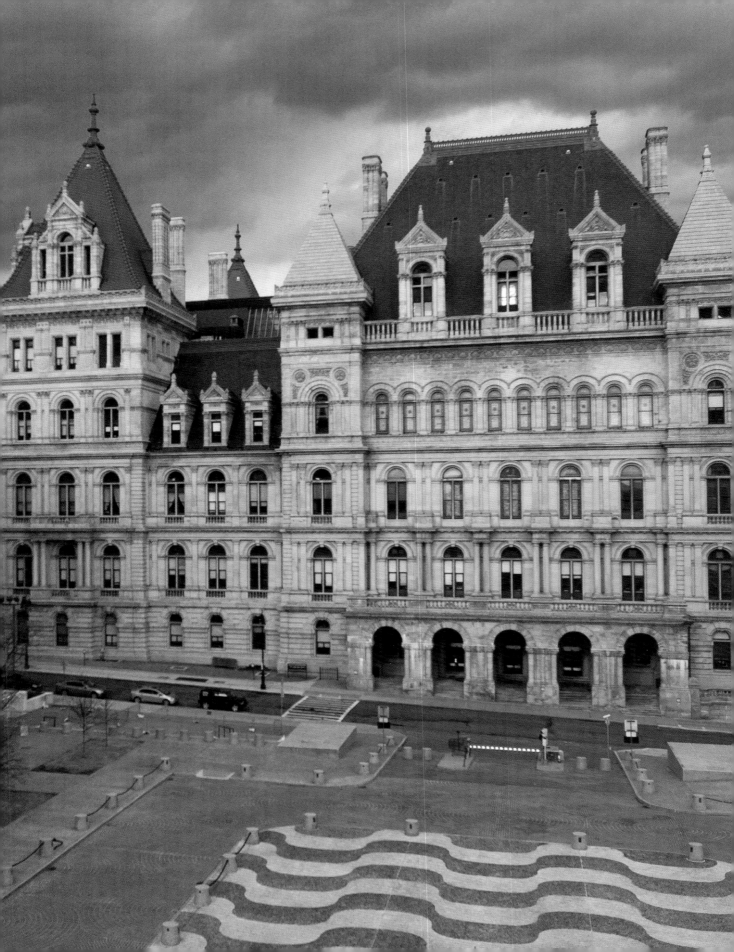

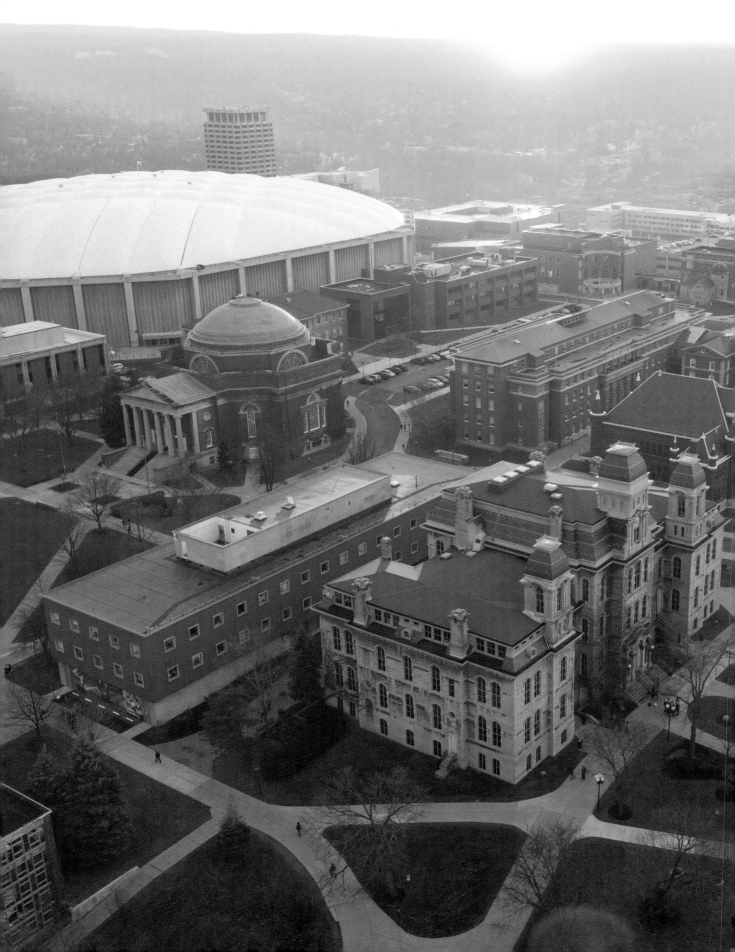

The heavens radiate with color
as the sun's lingering glow slowly
dissolves into the evening sky over
the imposing Hall of Languages

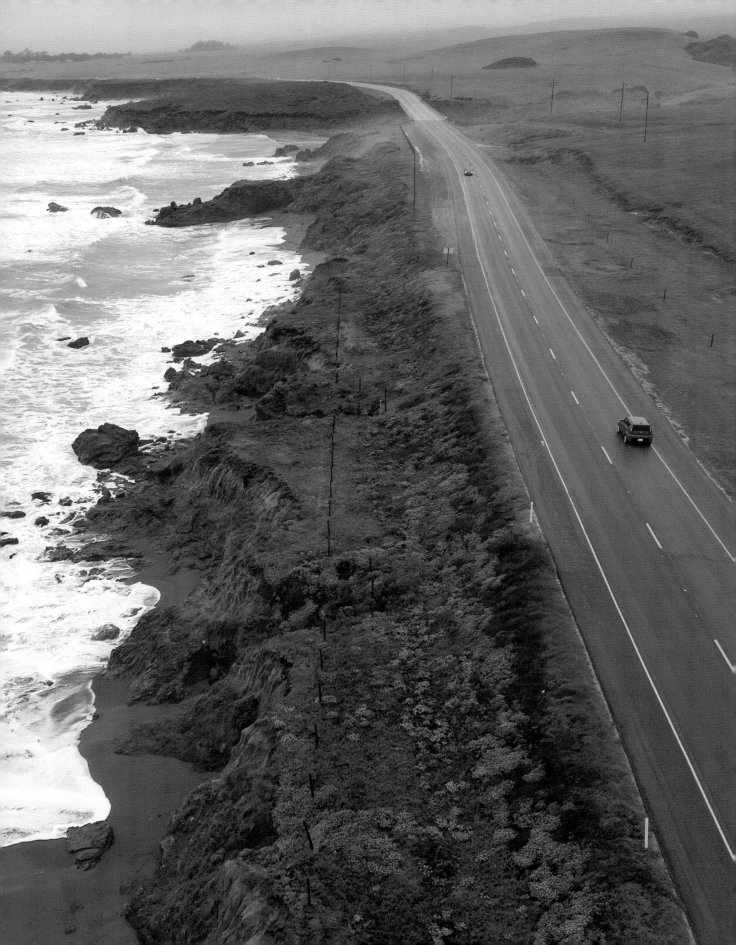

IN THE KNOW

CAMERA MODES

There are a variety of other settings to be aware of depending on the camera that you're operating with your drone. Camera modes are something that I briefly touched on when discussing the "Exposure Triangle," as they function together to create your exposure. Advanced camera drone models have a full range of camera modes that allow for increased artistic flexibility. Like on a DSLR, there a few basic camera modes and each of them have different implications on your resulting frame. Automatic mode (also denoted as 'Auto') is used to you give your camera's meter total control over your exposure settings. This setting is there for beginners who are in the process of learning how to properly expose a frame on their own. While automatic mode is always an option for amateur photographers, the quicker you make the switch to manual mode, the sooner you can learn from your exposure errors and the sooner you can master the art of exposures.

Automatic is a function on nearly all commercial camera drones, whereby your camera's internal electronics attempt to make a competent exposure for you. Program mode is an offshoot of automatic mode and it gives an UAV operator slightly more control over the amount of light in their images. In program mode, you can use exposure compensation to tell the camera how you would like it to expose a scene for you, be it overexposed (brighter) or underexposed (darker). Exposure compensation is a common feature on an increasing number of integrated camera drone systems, as it gives UAV operators visual flexibility without needing to introduce a spectrum of other camera modes. Exposure compensation becomes particularly important when dealing with certain types of scenery. Even the most advanced camera models tend to underexpose snowy scenery and overexpose watery landscapes. In these scenarios, you should either flip to manual mode (we will get there in a second) or use exposure compensation, so you can properly adjust for the camera's miscalculations. With exposure compensation, you would dial in a +0.3 or more to compensate for a frost-laden expanse that is rendered on the darker side and -0.3 or more for a crashing ocean wave that appears on the brighter

side. Exposure compensation serves the same function when your camera is creating undesired exposures in any of the priority modes too.

There exists two priority modes, aperture and shutter priority, and they're there to help you create specific visual effects around these settings. Shutter priority mode (denoted by an 'S') means you specify a specific length of time for which the shutter will remain open and the camera will automatically build an exposure around that setting. Aperture priority mode (denoted by an 'A') does the same thing, except with a precise aperture dialed in. Shutter priority mode should be employed if you want to build the exposure around a specific feeling of motion, be it a long or short exposure.

Aperture priority mode is for when you wish to build an exposure around a specific depth of field. Of course, you can always further refine your camera's exposures with exposure compensation. Lastly, there's manual mode (denoted by an 'M'), which gives you total control over your image's final appearance by having you dial in your desired shutter speed, aperture, and ISO. It's recommended that you shoot in manual so that you can create your exact artistic vision and think more strategically about what that vision is. Don't be afraid to experiment in the air or on the ground. Get a sense of how your camera system works so you can

use the most relevant settings when it matters most.

FILE TYPES

File type impacts how your image files are saved to your memory card or drone. JPEG is a compressed, but universally readable file format that permits for quick and easy photo sharing. JPEG files are typically small and thus flexible in nature. However, the central drawback with the JPEG file format is its compression or loss of image quality. Professional photographers prefer to shoot in RAW because it is an uncompressed file format that preserves the best quality image possible. RAW files allow an artist to edit their photographs extensively through post-processing programs. Nonetheless, RAW has its own set of drawbacks as well. First, RAW means larger sized file outputs. Second and most importantly, RAW isn't a universally readable file format. In other words, you need specific programs such as Adobe Photoshop or Lightroom to convert these files for viewing, making it a more difficult process to share. Thankfully, most camera systems that allow you to choose between JPEG and RAW formats also have a RAW+JPEG option, which enables you to record your images in both of these two formats. By shooting in RAW+JPEG, you have the advantages of both of these file formats, but are forced to use up a lot more space on your memory card to record these two types of files. I would personally recommend

shooting in RAW+JPEG and packing a few more micro SD memory cards for all of your UAV adventures. You can toggle between all these settings through your drone's companion mobile app.

RELEASE MODES

Release modes are another consideration when flying your drone. Depending on the camera that you're operating, there are a variety of release modes at your fingertips. Let's take a DSLR like the Nikon D5 for example. With Nikon's latest professional body, you can capture a single photograph (known as single mode), multiple images in quick succession (known as multiple, continuous, or burst mode), shoot in quiet mode, launch a self-timer, or lift the camera's mirror up. GoPros, on the other hand, allow you to choose between single, continuous, or time-lapse photography modes. Lastly, DJI products allow you to choose between single, multiple, timed, and auto exposure bracketing options. Bracketing is the process of taking the same photograph at various exposures. Bracketing should be employed if you don't trust the accuracy of your exposure settings. Moreover, it's something you should get in the habit of doing if you hope to create HDR (high dynamic range) images in postproduction.

ACCESSORIES

There is an expanding market of accessories designed for increasingly complex UAV systems. Filters are one of those key submarkets, intended for photographers and videographers looking to further enrich their visual stories. A polarizing filter is one such accessory that creates richer color and higher contrast imagery by reducing the reflectiveness of certain surfaces and revealing the underlying colors that have been masked by glare. Polarizing filters are most potent when shooting the water or the sky on a bright, sunny day. There are also ND, or neutral density filters, designed to lower the amount of light entering your camera's lens. Remember that most integrated camera drones have low fixed apertures? ND filters make it possible to take longer exposure photographs with those low fixed aperture cameras on very bright days. With a ND filter affixed to your camera's lens, you can fight bright, overexposed imagery in those types of scenarios. Both drone manufacturers and third party retail outlets sell these specific filters.

Propeller guards, a piece that encircles the drone's propellers to prevent the spinning motors from causing injury or damage, are also commonly added to aerial photography systems.

The most fun drone accessory of the bunch is FPV goggles. FPV, or first person view goggles, enable you to experience your drone flight from the perspective of the aircraft's camera. While these goggles

might give off a nerdy appearance, it's truly exhilarating to feel like you're flying through the air. The tricky part is learning how to fly from this view. Legally, you need a spotter to maintain a line of sight on your drone as you fly FPV. I would not recommend it if you're just starting out, but flying FPV is an awesome challenge you can eventually learn to master.

MAINTENANCE

Drones require very little by way of maintenance and upkeep. To keep your drone in tip-top shape, avoid collisions as best you can, steer clear of moisture, handle with care, and safely store your drone when it's not in use. Crashes will happen, but if you take the time to practice with your trainer drone in the beginning, those collisions shouldn't be costly. Propellers are the most commonly damaged drone part—in essence, they're the fender benders of drone crashes. Many a time, drone models will come with additional propellers for this exact reason. My general recommendation is to purchase extra parts for your drone. Not only are they inexpensive, but when you travel with a set of parts, small issues that come up in the field can be easily fixed. The last thing you want is to have a drone that's unusable for the length of a trip because of a few missing parts.

Batteries also require a different type of care to ensure their longevity. The majority of drone batteries are lithium, which you should ideally "power cycle" every ten or so charges. Power cycling is the process of completely depleting a battery (10% or less) and immediately charging it back to capacity. To fully deplete a battery, you can either hover the drone at a very low altitude (to ensure no damage is done to the drone as the battery approaches 0%) or opt to keep the drone on for a long period of time. The DJI Go App is one mobile companion app that provides a slew of pertinent information on battery cells and their usage. Also, don't keep your batteries plugged in for longer than needed, and be sure to completely deplete your batteries if you know you will not be using them for a lengthy period of time. Never use a battery that looks damaged or is bulging—defunct batteries pose all sorts of safety problems. Be aware that batteries have limited durability and their life span, which is typically a couple of years, is shortened the more you use it. If you're shooting in the winter, be mindful that lithium batteries do not like the cold and that those frigid temperatures can limit your flight time. As a result, keep your batteries as warm as possible before you launch your drone. You can even purchase battery heaters from some UAV manufacturers.

Lastly, keep your drone up-to-date with the latest firmware updates. Firmware updates are released by drone manufacturers intermittently to ensure there

are no bugs in the drone's onboard computer system and to provide its customers with up-to-date features. The process of updating firmware differs from model to model, so consult your drone manufacturer's website.

ON THE ROAD

The greatest fun you'll have with your drone is on the road. Gazing upon a new sight for the first time ignites your creative fire and tantalizes your sense of discovery. Aerial photography forces the eye to see in unique and innovative ways, while a drone allows you to approach storytelling from a fresh perspective. Whenever you're venturing long distances, it's essential to have an accessible hard case that can defend your drone from the elements. Traveling with your UAV is simply a matter of practicality and protection.

There are two types of cases that you should consider for your aerial photography toolkit. First, there are drone backpacks. Depending on the size and weight of your UAV, backpacks allow you to conveniently and comfortably carry your drone for long distances. This is ideal for hikes, adventures, or whenever you need optimal drone portability. At certain sizes, drone backpacks can also be used as a carry-on item when flying commercially. Second, is a hard shell rolling case—perfect as a checked bag when flying, or for long-term storage.

No matter which case or cases you prefer, you should evaluate the practicality and protection each case offers. Whether it's a backpack or a roller, your case should be able to take a bruising without allowing its internal cargo to get damaged. To keep the body of the drone secure, your case should have a hard exterior that won't allow its inner contents to get mangled. In addition, the interior of the case should have a foam or material lining that separates your UAV's various parts and further safeguards the case's contents. On the practicality side of things, ask yourself how quickly you can go from opening your case to getting your drone into the air. Having a case with a foam lining that is designed for your exact model of drone allows you to utilize space efficiently as each part of the drone should fit inside the case like a glove. Furthermore, you'll be able to access each part needed in your drone's assembly easily and quickly.

Ultimately, your aerial photography workflow should be streamlined as much as possible. Having both types of cases is ideal, as your roller can be used for long term storage or checked baggage and your backpack can be used as a carry-on or for outdoor adventures. Often times, drone manufacturers will offer a variety of cases specifically designed for your model that you're able to purchase directly from them. However, if you look beyond your drone manufacturer and do

some digging, you'll often find a greater variety of case options at reduced prices online. ThinkTank and Pelican typically offer excellent cases for common drone products. The case that your UAV ships in can also be phenomenally useful, yet most complimentary drone cases aren't built to last and are simply short-term solutions to your drone's protection, transportation, and storage.

Another relevant consideration when traveling is battery safety. Whenever you fly commercially, you must place your lithium batteries in your carry-on bag. Not only are lithium batteries not allowed in checked baggage, but they may be confiscated by security if tagged for storage under the plane. Likewise, because of the pressurized cabin your lithium batteries will be traveling in, it's wise to discharge each of your batteries before you board. On road trips, I like to set-up my drone a bit differently. Whenever I hit the road, time is typically of the essence and I want to experience as many things as I can in a short time frame. Frequently, I place my assembled and ready to fly drone in my car trunk, ensuring that my drone can't shift around on the road and nothing else can fall on top of it. When I come across a scene with aerial photography potential, I pop open my trunk, place my drone just beyond my rear bumper and can take off in a matter of seconds. However, as soon as my day on the road concludes, my drone goes right

back into its case where it can be safely stored overnight.

RULES AND REGULATIONS

Drones are governed by an increasingly complex and ever-changing web of laws. This technology is so new that regulators on all levels—local, state, and federal are desperately trying to modernize their rule books. Drone rules will obviously continue to evolve as the technology moves forward. Often times, there's confusion about what is legal and what is prohibited, and it's difficult for regular drone operators to keep up. To make matters worse, law enforcement is often as confused as pilots are about what is considered legally acceptable. It's a genuine challenge to keep all of your drone operations legal in this regulatory climate. In this chapter, I will do my best to guide you through drone rules with a primary focus on the United States and how it has gone about governing unmanned aerial aircraft. In addition, I will assess what the future of drone regulations might look like.

No matter where you choose to take flight, the general rule of thumb at play is common sense. Simply put, by evaluating your actions through a lens of safety, you can better protect yourself and everyone around you. In the United States, the Federal Aviation Administration (FAA for short) manages all aspects of aviation and air traffic. Drones fall into

the agency's purview, and the administration's primary concern is keeping the skies safe for both unmanned and manned aircraft.

Currently, the FAA requires that all drones are registered before they're flown. Registration, which can be completed online, is a $5 process that gets your UAV or UAVs a unique identification number. This number applies to all drones that you own for a span of three years (at which point you need to re-register) and must be visibly marked somewhere on each of your drones before they're flown. I recommend using a label maker to place your unique registration number and pertinent contact information (in case your drone ever gets lost) on a flat area at the rear of your UAV. Alternatively, you can engrave your number or mark the drone's exterior with a permanent marker.

When you register your drone, the FAA asks for you to complete a profile with your name, contact information, and physical address. The agency also has you acknowledge its safety guidelines before you pay the $5 registration fee. Upon confirmation of registration, you will receive your own distinct registration number. The purpose of this system is to hold UAV operators accountable for their actions. In instances where your drone has crashed, your registration number can be used to help trace the aircraft back to you. Failing to register your drone can lead to significant penalties and fines. If you're caught flying an unregistered UAV, you can be assessed a $27,500 fine or be hit with an even more serious fine if you're caught doing something criminal with an unregistered UAV. In order to register, you must be a U.S. citizen or a resident that is 13 years or older, and your model drone must weigh between 0.55 pounds and 55 pounds (all commercially purchased, ready-to-fly drone models should fall within that range). You can register your drone at: registermyuas.faa.gov/.

The FAA has also put forth a series of safety guidelines to keep unmanned aerial vehicles away from manned flight. For one, keep your drone below 400 feet (or approximately 121 meters). Any drone companion app that you employ will provide an altitude reading (and any number of additional readings) to keep the pilot consistently informed about the status of their aircraft. In fact, some UAV platforms will restrict you from climbing above 400 feet unless you adjust specific app settings. Outside the United States, beyond the reach of the FAA and in legal jurisdictions, your drone can fly above the clouds. Sophisticated drone models can soar thousands of feet in the air, so long as the controller's signal can reach the ascending aircraft. While it may be fun to think about, drone flights above 400 feet have little practicality. Artistically, image

depth is compressed the higher up you go. Furthermore, beyond 400 feet, helicopters and airplanes may be your preferred mode of aerial photography transport.

Next, don't fly within a five-mile radius of an active airport (at least without first coordinating with the airport's control tower) and steer clear of other sensitive infrastructure such as military bases, stadiums, and prisons. National Park Service entities including National Parks, National Forests, National Monuments, and more have also outlawed the use of drones in the airspace above their conserved properties with a serious penalty for violators. Companies like DJI have implemented geo-fencing across all of their product offerings to try and keep their users drone operations within safe, legal bounds. In essence, geo-fencing uses your smart phone to place your exact location and it will use this information to keep your drone out of pre-determined no-fly zones. While geo-fencing is one tool you can use to help determine the legality of a flight, don't become too reliant on this technology—geo-fencing often lags behind the rules and it's ultimately your responsibility to keep all of your drone operations legal.

Moreover, the FAA encourages pilots to maintain a line of sight with their aircraft. As mentioned in previous chapters, this serves a significant safety purpose. You can avoid crashes and ensure consistent controller-drone communication by keeping your UAV within view. Lastly, be smart and leave space between your drone and any and all obstacles, including people and buildings.

You should also be aware of temporary flight restrictions (or TFRs)—no-fly zones that the FAA puts in place under special circumstances. For instance, the FAA will put in place a TFR in the airspace over the Super Bowl, a wildfire, or the presidential motorcade. There are also special, heavily restricted no-fly zones such as in the airspace over Washington D.C. There may also be drone regulations unique to your local area. Some states and municipalities have different rules regarding UAVs and where they can be flown. For example, in a handful of states, state parks are considered off limits while in other states, state parks are fair play for drone operators. Whenever in doubt, consult with local governing bodies or authorities to ensure the legality of your flight plans.

COMMERCIAL USE

The FAA and a handful of other aviation bodies, divide drone pilots into two different camps—the hobbyist flyer and the commercial flyer. The majority of UAV operators will be hobbyists or individuals who are using their drone recreationally. The hobbyist drone operator is expected to follow the previously defined set of

rules, but is prohibited from profiting from their aerial exploits. The commercial flyer, a pilot, or business that aims to utilize drone technology for financial gain, has another set of hurdles to jump over.

At the time of this writing, you are not permitted to receive compensation for flying a drone or creating drone content without a remote pilot certificate. Until recently, a Section 333 exemption was the only means by which an operator could fly drones commercially. A Section 333 exemption allowed operators to petition the government for a blanket certificate of authorization (or COA). A COA gave a drone operator or business the right to use defined legal airspace for commercial purposes. This long and arduous process typically required legal assistance from a drone law expert (a burgeoning legal segment), as the petition precisely defined how you or your business would utilize a COA. This severely backlogged system has since been phased out and as of August 2016, the FAA has implemented Part 107 in its place.

Part 107 is intended to further streamline the integration of commercial drones into the nation's airspace. Through Part 107, a UAV operator can earn a remote pilot certificate. A remote pilot certificate allows an individual to profit from drone operations conducted in legal airspace. In order to receive such a certificate,

an applicant has to pass a 60-question, multiple choice aeronautical knowledge test every two years. These knowledge exams cost $150 and are administered at FAA-approved locations throughout the United States. The exam touches on a very wide range of topics including regulations relating to UAVs, airspace classifications, operating requirements, flight restrictions, aircraft operation, aviation weather sources, UAV loading and performance, emergency procedures, crew resource management, radio communication procedures, determining the performance of a drone, the physiological effects of drugs and alcohol, aeronautical decision-making and judgment, airport operations, preflight inspection procedures, and maintenance. Some of these topics are well beyond the scope of UAVs, and require a degree of general manned aviation knowledge. For those without a background in aviation, the FAA's aeronautical knowledge test might require significant preparation. Thankfully, there's a growing list of test prep options for those hoping to ready themselves for this relatively new examination. For example, there are pricey in-person and online training courses offered by companies like DARTdrones and the Drone Pilot Ground School. In addition, you can purchase the FAA's *Pilot's Handbook of Aeronautical Knowledge* or download a mobile application such as the FAA Drone Pilot Test Prep app. However you choose to study, you

must schedule an appointment for your test and bring government-issued identification to your testing center. Once you pass the exam, you must complete and submit a formal paper or online application to the FAA. Next, you will be subject to a TSA background check and once that check is completed, you will be mailed a permanent remote pilot certificate.

If you're already a licensed pilot, you can bypass the examination entirely if you have recently completed a flight review and are willing to take an online training course prepared by the FAA.

With Part 107, you are expected to follow specific preflight and post-accident protocols, but you can circumvent most drone restrictions by directly applying for a waiver from the FAA.

While Part 107 is considerably less cumbersome than its legal predecessor, aspiring commercial flyers must take the time to ready themselves for the FAA's information-heavy aeronautical knowledge test. The FAA has once again lowered the barrier of entry for those hoping to utilize the sky for commercial needs. With the industry exploding at an incredible clip, the FAA will be under great pressure to continually adjust its protocols and keep drone technology accessible for a wide range of applications and uses.

INSURANCE

Whether you aim to use your drone commercially or recreationally, you may want to consider insurance for your aerial photography investment. Most particularly, I encourage you to research liability insurance options. In case of an unfortunate crash, liability insurance protects you from property damage and physical damage to individuals up to a certain dollar amount. If you already have home-owner's insurance, your home insurance company may be able to insure your drone under your existing policy. Otherwise, there are a few independent companies that are providing insurance just for drones and equipment like it. I was able to get my drone insured for just a few extra dollars a month under my current home insurance policy. The policy protects me with up to one million dollars in liability coverage and also has me covered in case of theft and certain types of damage. Through these independent providers, you can also insure your drone for "hull damage" or damage to your actual aircraft, but that's frequently more costly.

FLYING INTERNATIONALLY

Outside the United States, each aviation administration enforces its own set of rules and regulation. As you explore drone rules around the world, you'll find that many countries share similar UAV restrictions—particularly across the developed world. Resources such as

dronelaw.in attempt to aggregate information from many of the world's aviation administrations in one location. When in doubt, contact your government's civil aviation body and ask what its UAV policy is. If you plan to travel abroad, due diligence is required to abide by local laws and keep yourself out of trouble. A significant group of developing nations lack standardized drone policies, but that doesn't mean that flying is legal or wise by default. When I was planning a trip to Swaziland on a photography assignment, I learned of a case where the Swazi government equated drones with an act of witchcraft, ominously foretelling the possibility of fairly unpleasant consequences if caught. Obviously, it would not be advisable to fly a drone in such a cultural climate.

RESOURCES

There are an increasing number of educational resources available to drone pilots. AirMap.io attempts to give you up-to-date information on drone no-fly zones, KnowBeforeYouFly.org can give you more information about safe flying practices, and DroneLawJournal.com discusses the legal side of the drone world in the United States.

Ultimately, most drone laws are written with the public's safety and privacy in mind. While regulators arguably err too far on the side of caution, it's our job to keep the medium as vibrant as we can by playing by the rules and not endangering anyone or anything.

The future of drone regulation is being shaped by our actions today. Drones, in and of themselves, are magnificently safe tools; it's their reckless pilots that make these devices unsafe and regulators fearful. At the end of the day, don't let legal worries or trepidations hold you back from using these phenomenal technological marvels. The hope is that drones will eventually be accepted like every other piece of technology that has come before it. When that time arrives, this medium will be less restricted by fear and concerns, and will be fully open to a diverse market of individuals who are able to explore a world of exciting aerial possibilities. It's a well-documented fact that many individuals fear the notion of change. No matter people's thoughts or feelings on drones, this amazing new change is coming, its coming full force, and it's here to stay. So get out there and take flight, have fun, be safe, and bring home some amazing images.